MSM

The Definitive Guide

The Nutritional Breakthrough for
Arthritis, Allergies and More

Stanley W. Jacob, M.D., F.A.C.S.
Jeremy Appleton, N.D.

About the Authors

Stanley W. Jacob, M.D., F.A.C.S., is an investigator, teacher, and professor at Oregon Health & Science University in Portland, Oregon. He is a board-certified surgeon and has served as instructor of surgery at Harvard Medical School. Dr. Jacob has worked with methylsulfonylmethane (MSM) for 25 years and is the world's foremost expert on its research and clinical applications. He estimates that he has used MSM with at least 18,000 patients in his practice. Dr. Jacob is the co-author of *Structure and Function in Man*, 5th edition (W.B. Saunders, Philadelphia, PA, 1982) one of the major anatomy-physiology texts used in modern medicine, and currently is the medical director of Cardinal Nutrition, a U.S.-based firm and the world's leading manufacturer of MSM.

Jeremy Appleton, N.D., is a naturopathic physician, writer, and educator in the field of evidence-based complementary and alternative medicine. He received his doctorate in naturopathic medicine from the National College of Naturopathic Medicine (NCNM) in Portland, Oregon, and completed his residency at Bastyr University of Natural Health Sciences in Kenmore, Washington. Dr. Appleton is the nutrition department chair at NCNM and director of scientific affairs at Cardinal Nutrition. He lectures internationally on topics in clinical nutrition and botanical medicine.

Acknowledgements

STANLEY JACOB I dedicate this book with love to my children Stephen, Jeffrey, Darren, Robert, Elyse, and my grandson MacKinley.

JEREMY APPLETON I would like to thank Stanley Jacob, Michael Levin, George Bergstrom, Jane Duvauchelle, David Steinman, Jenny Morrison, Tom Freeman, Rod Benjamin, Robert Herschler, Dick Brown, Harvey Claussen, Eve Rossmiller, Diana Daniels, Rita Randall, Virginia Hillson and the late John W. Metcalf for their contributions to this book. I began this project as an independent writer and editor. I was so impressed by Dr. Jacob's work with MSM and by the integrity of the people at Cardinal Nutrition that I decided to join the Cardinal team as director of scientific affairs. I lovingly dedicate this work to my wife Deah and to my son Xander.

In the interest of supporting ongoing clinical research on MSM, a portion of the authors' proceeds from the sale of this book will be donated to the MSM Research and Education Alliance.

Disclaimer: This information is presented by independent medical experts whose sources of information include studies from the world's medical and scientific literature, patient records, and other clinical and anecdotal reports. The material in this book is for informational purposes only and is not intended for the diagnosis or treatment of disease. Please visit a medical health professional for specific diagnosis of any ailments mentioned or discussed in this material.

ISBN 1-893910-22-9
Printed in the United States
Published by Freedom Press
1801 Chart Trail
Topanga, CA 90290
Bulk Orders Available: (800) 959-9797
E-mail: info@freedompressonline.com

Table of Contents

Introduction

by Jeremy Appleton, N.D.

Therapies in complementary and alternative medicine (CAM) are increasingly validated by scientific and clinical research. In the eyes of skeptics, however, dietary supplements are a fringe element: unproved, ill regulated, ineffective, and possibly dangerous. Many supplements have a great deal of double-blind research to back them up; others do not. Unfortunately, the amount of research on a given supplement is not an unfailing indicator of its therapeutic efficacy. There are many dietary supplements with tremendous therapeutic value, yet still in need of increased study.

Approximately half (48%) of all Americans take some type of dietary supplement.[1] The Dietary Supplement Health and Education Act (DSHEA) of 1994 preserved consumers' over-the-counter access to nutrients, herbs, and other dietary supplements—even ones with clear effects on human health and disease—without those agents being regulated as drugs. The advantages and disadvantages to DSHEA are largely beyond the scope of this introduction. However, the Food and Drug Administration's guidelines for the types of statements used on product

9

labels and supporting literature are worth mentioning. Dietary supplement labels may contain statements that describe the role of a nutrient or ingredient intended to affect the structure or function of humans, or the mechanism whereby it exerts its effect, provided that the statements do not suggest that the agent is in any way intended to prevent, treat, mitigate, or cure any disease entity. The final rule governing these so-called "structure/function statements" was published in January 2000.

The DSHEA limitations on label claims are ostensibly intended to protect consumers from harm. They also, however, place those who market dietary supplements in a difficult position with respect to what they can and cannot say about their product. The result is that informational literature on dietary supplements is rife with frustratingly vague circumlocutions. For example, a manufacturer or distributor of methylsulfonylmethane (MSM) would not be allowed to state that MSM is effective for seasonal allergic rhinitis, despite its documentation in third-party literature. Instead, they would have to say, "supports normal nasal airflow during pollen season" or some other vague construction. The consumer looks at this and wonders, "Why can't they just say it will help my allergies?" But, if manufacturers or distributors could say that, then anyone could say it about any product, regardless of whether or not there was "significant scientific agreement" as to the truth of the claim.

The question of significant scientific agreement is another contentious issue, construed by the FDA in one way, by researchers in another, and by dietary supplement manufacturers in yet another way. Most people will agree that multiple, well-controlled, randomized, and double-blind trials demonstrating efficacy and safety of a nutrient for a particular condition constitutes significant scientific agreement. The process of scientific validation, from *in vitro* studies up through randomized controlled clinical trials, is long, laborious, and expensive. Most supplements and drugs must ascend this hierarchy of evidence before they are fully accepted by doctors and scientists. However, many agents are not subjected to extensive clinical study, but are nevertheless considered highly effective and safe based on traditional use, extensive clinical experience of practitioners, or from types of evidence that do not easily conform to the reduc-

tionistic model of the double-blind trial. Dimethyl sulfoxide (DMSO), for example, cannot be effectively studied by a double-blind method because it is impossible to duplicate its side effects with any kind of placebo. Moreover, people in pain sometimes don't have time to wait for significant scientific agreement.

What we have in the case of MSM is a dietary supplement with a compelling theoretical basis and the beginnings of a sound body of research. This research includes many *in vitro* studies demonstrating its physical and chemical properties; several *in vivo* and animal studies elucidating its effects in mammalian tissues and systems; a few unpublished toxicity studies performed within the MSM manufacturing industry; one acute and subchronic toxicity study published in a peer-reviewed scientific journal (at press at the time of this writing); extensive clinical data in the form of case histories and testimonials; a limited number of small, unpublished, uncontrolled clinical trials; one abstract of a double-blind trial (for osteoarthritis) published in a now-defunct journal; and one published multi-center, open-label trial of MSM for seasonal allergic rhinitis. To date, there have been no large, randomized, double-blind trials of MSM for any condition. Randomized, controlled trials of MSM will likely provide welcome validation for this under-recognized therapeutic agent.

MSM is widely available as a dietary supplement. The mixed reliability of the marketing for products containing MSM is a frustration to practitioners familiar with its true therapeutic potential. In the absence of published clinical trials, separating fact from hype with regard to the therapeutic efficacy of MSM is difficult. It requires access to someone with extensive clinical experience using MSM.

There is no greater expert on the clinical uses of MSM than Stanley W. Jacob, M.D., F.A.C.S. His clinical experience with MSM (and its metabolic precursor, dimethyl sulfoxide [DMSO]) is unparalleled. In this book we will describe the clinical evidence collected on MSM, drawing heavily upon the experiences of Dr. Jacob. The magnitude of suffering alleviated with MSM in Dr. Jacob's clinic alone is evidence enough for many people, particularly those in pain. We sincerely hope the preliminary studies and clinical experience presented in this book

will convince investigators around the world that MSM deserves serious, reproducible, clinical study.

Dr. Jacob recognizes the limitations of the research with respect to MSM. On the other hand, he has treated more than 25,000 patients with either DMSO or MSM in the 43 years he has been in the Department of Surgery at Oregon Health & Science University in Portland, Oregon. During this time, Dr. Jacob has developed a deep understanding of how to properly use MSM to treat a great many diseases, including refractory conditions such as scleroderma, systemic lupus erythematosus, and interstitial cystitis.

I've been familiar with Dr. Jacob's pioneering work on DMSO for many years. He wrote the first reports on the use of DMSO as a pharmacological agent in 1963, and they were published amidst a storm of enthusiasm the following year. In 1965, the *New York Times* called DMSO "the closest thing to a wonder drug produced in the 1960s." Indeed, the introduction of DMSO was the introduction, not of just another therapeutic agent, but of a therapeutic *principle*. A new route of administration had been discovered, and that therapeutic principle made possible the subsequent development of transdermal drug administration (e.g., nicotine, estrogen, progesterone, and scopolamine).

In spite of research scandals and early FDA opposition, a tremendous literature has amassed demonstrating the therapeutic effects of DMSO. Thousands of published articles and several major medical symposia attest to the broad therapeutic utility of DMSO. In 1980, DMSO and Dr. Jacob were featured on *60 Minutes*, with an estimated audience of 70 million people. Unfortunately, little clinical research has been done on DMSO since the 1980s.

Dr. Jacob is a Harvard-trained surgeon, fellow of the American College of Surgeons, and former director of research of the Department of Surgery at the University of Oregon Medical School (now Oregon Health & Science University [OHSU] where he holds an endowed chair). He received his bachelor's degree at age 21 (Phi Beta Kappa) and his doctorate in medicine (cum laude) at age 24 in 1948. Dr. Jacob then completed an internship, residency, and three-year research fellowship at Harvard

Medical School and its teaching hospitals. Dr. Jacob soon became chief resident in surgery, Harvard Service, at Boston City Hospital.

During his early years as a surgeon, Dr. Jacob held a five-year Markle Scholarship in Medical Sciences. He is a retired full colonel in the U.S. Army Medical Corps Reserve and served in Japan during the Korean War. From 1957 to 1960, he was the Kemper Foundation's Research Scholar for the American College of Surgeons. To date, he has written 170 scientific articles and 15 books. In 1983, the National Health Federation named him Humanitarian of the Year.

In the late 1970s, Robert Herschler of Crown-Zellerbach Corporation suggested studying the properties of DMSO's metabolites. Some information was already known about MSM (also known as $DMSO_2$), the primary metabolite of DMSO. For example, it was known that 15% of DMSO was oxidized *in vivo* to MSM. It was also known that MSM persisted longer than DMSO in the body prior to being excreted. Dr. Jacob began using MSM with his patients, hoping it would demonstrate the therapeutic properties of DMSO, without DMSO's troubling side effect of breath and body odor. Indeed, he found that MSM produced many—though not all—of the DMSO effects.

The wide availability of MSM, its relative lack of toxicity, and its enormous therapeutic potential for clinically challenging conditions are now well known to thousands of healthcare practitioners and patients worldwide. But we have so far lacked a definitive guide, one that eschews extravagant health claims and holds to the known clinical data. That is because the most important and compelling evidence of MSM's safety and efficacy has not been published in peer-reviewed medical journals; it resides in thousands of case histories from Dr. Jacob's career.

The aim of this book is to provide the practicing clinician and the interested lay person with a practical guide for using MSM as a medicine and as a dietary supplement. Because of the nature of the available evidence, the book emphasizes case histories. The advantage of this approach is that it gives the clinician an honest idea of what to expect. The selected cases illustrate typical, rather than extraordinary, results; this reflects our understanding that MSM is not a panacea. It also reflects our confidence that

MSM is effective for a large number of health conditions, and requires neither hyperbole nor bias in case selection to convincingly argue its therapeutic merits. Controlled clinical trials of MSM for various health conditions are finally in the works thanks to growing investment in CAM research. The next few years should provide the much-anticipated scientific validation of this remarkable healing agent.

Note to readers: Throughout this book, any reference to "I" represents the voice of Dr. Stanley Jacob. Any mention of "we" indicates the views of both Drs. Appleton and Jacob, or of Dr. Jacob's clinical team at OHSU.

The information presented in this book is intended for healthcare providers practicing within their legal scope of practice. Laws governing the use of nutritional and experimental therapies may vary by locale. Practitioners are advised to consult the appropriate statutes governing their practice of healthcare. The clinical observations presented in this book should not be construed as guidance for self-treatment of any disease using MSM, or as an endorsement for any product. If medical advice is required, the services of a competent professional should be sought. The Food and Drug Administration has not evaluated the content of this book. As a dietary supplement, MSM is not intended to diagnose, treat, cure or prevent any disease.

Foreword

by Stanley W. Jacob, M.D., F.A.C.S

When taking into account my early medical background, you might think when it comes to my patients, I would be partial to surgical procedures, the most recent medical technologies, and extensive use of prescription medications. In fact, I am supportive of surgery, modern technology, and conventional drugs. I advocate much of what Western medical doctors have accomplished, and I have often worked with pharmaceutical companies to advance their drug research. But, integrity, honesty, and values mean everything to me. I have only one goal for my patients: to help make them better in the most conservative, least intrusive manner possible. I think that is what being a physician should be all about.

Although I never hesitate to use surgery or pharmaceuticals when essential to a patient's well-being, I have found through years of clinical experience that, in many cases, specific natural agents can perform as well as corresponding pharmaceutical medications without serious side effects.

MSM is one agent about which I have extensive knowledge. That is what this book is about and, in many ways, that is what my professional life has been about for more than four decades. I believe it is necessary to

pass along as many of the clinical, experimental, and scientific details of my work with MSM as possible, as well as dispel some of the common myths surrounding this agent.

I first learned about MSM in 1962, when I studied its parent compound, DMSO. DMSO was a "hot" topic of interest at that time. Major pharmaceutical companies expressed intense interest in DMSO's ability to relieve a wide range of painful conditions, in its powerful antioxidant properties, in its tissue preservation benefits, and particularly in its action as a transdermal carrier of other medications through the skin barrier. Even though once ingested, about 15% of DMSO is converted to MSM, I paid little attention to it. I simply overlooked the virtues of MSM.

Then, in 1977, Robert Herschler, a chemist and my primary research associate, suggested we should, indeed, be looking at MSM. His suggestion was practical: many people balked at using DMSO because of the garlicky or oyster-like odor it produced. We knew that MSM didn't produce the odor and suspected it might provide some of the same benefits as DMSO.

The annual sales of MSM in 2001 exceeded $100 million in the United States alone. Industry reports note that number is increasing annually, and that MSM is one of the most popular dietary supplements among baby boomers who wish to maintain active lifestyles as they age. It is clear that consumers will be demanding it more and more in the future. With this increase in demand will be an increase in questions directed to physicians, pharmacists, dietitians, and other health professionals. I would like to help health professionals answer these questions.

To better care for and serve their patients, I believe that health professionals should have a good foundation of knowledge about MSM. They should know what patients can expect in the way of health benefits and, just as important, what they *shouldn't* expect. A full understanding of MSM's safety profile and its potential for drug interactions is also important. We will explore the many clinical applications of MSM so health professionals will know when certain applications of MSM are appropriate and even necessary for the full healing potential of MSM to be realized.

When dispensed and used properly, MSM can be of true benefit to patients with many common health challenges. I have become increasing-

ly concerned, however, that overzealous marketers are overstating its benefits—and that several myths have been promulgated surrounding its uses. We do not condone marketing exaggeration. Such a strategy can lead only to disappointment and possible further regulations imposed upon the entire dietary supplement industry by federal regulators.

An accurate portrayal of the experimental and clinical research on MSM combined with clinical observations and case reports from my clinic at OHSU, should help disprove these myths and demonstrate MSM's true benefits. With MSM, the facts speak for themselves.

PART I

Basic Science of MSM

1

MSM:
The Basics

Methylsulfonylmethane (MSM) is a naturally occurring sulfur compound and nutritional component of many foods. It is found in the normal diets of humans and almost all other vertebrates. The proper chemical name for MSM is dimethyl sulfone, or $DMSO_2$. It is the primary, oxidized metabolite of dimethyl sulfoxide (DMSO), and it appears to share many of its parent compound's therapeutic properties.

MSM belongs to a family of compounds that are abundant in the food chains of terrestrial and ocean life. This sulfur-containing nutrient is the stable end product of the methyl-S-methane series of compounds that provide bioavailable sulfur to as many as 85% of all living organisms.[2] These compounds—principally dimethyl sulfide (DMS)—are among the Earth's few primary sources for sulfur.

The sulfur cycle begins in the ocean, where algae and phytoplankton release sulfur compounds, called tertiary dimethylsulfonium salts. These salts are transformed to DMS, a highly volatile compound. Oceanic DMS is the major natural source of sulfur to the atmosphere and con-

tributes both to the tropospheric sulfur burden and to particle formation and growth in the atmosphere.

J.E. Lovelock and colleagues recognized DMS in 1972 as an important component of the earth's sulfur cycle, soon after the discovery of its ubiquity in seawater. Indeed, it was Lovelock and colleagues who first provided convincing data supporting the methyl-S-methane series as the earth's dominant sulfur cycle. After sulfur dioxide emissions from fossil fuel combustion, DMS is the second most significant source of sulfur in the atmosphere.

In the presence of ozone and high-energy ultraviolet light, DMS is converted into DMSO and MSM, both of which—unlike DMS—are soluble in water. They return to the earth in rainfall and are subsequently taken into the roots systems of plants and concentrated up to one hundred fold.

DMSO and, to a lesser extent, MSM are widely distributed in nature. Both compounds are present in small amounts in selected fruits, vegetables, grains and beverages. Milk is the most abundant known source of dietary MSM, containing approximately 3.3 parts per million (ppm) as tested in 1981.[3] An earlier report indicated levels in milk of 6.1 to 8.2 ppm.[4] MSM is also found in coffee (1.6 ppm), tomatoes (trace to 0.86 ppm), tea (0.3 ppm), Swiss chard (0.05 to 0.18 ppm), beer (0.14 ppm), corn (0.0 to 0.11 ppm), and alfalfa (0.07 ppm). Trace quantities of MSM have been detected in asparagus, beets, cabbage, cucumber, oats, apples, and raspberries.

2

The History
of DMSO

by Stanley W. Jacob, M.D., F.A.C.S

Dr. Alexander M. Saytzeff, a scientist working in Kazan, a city situated on the Volga River of Central Russia, accomplished the first synthesis of DMSO in 1866. He described a sulfur-scented liquid that looked almost like water. Other than a relatively obscure article in a German chemical journal written by Saytzeff in 1867 on the synthesis of DMSO, we know little else about this simple molecule's humble beginnings.

However, from such obscure beginnings, DMSO's importance blossomed. Its increasing utility within industry led to sharp increases in production, from a few thousand pounds annually starting in the mid-1950s to greater than five million pounds by the early 1960s. DMSO was already being used to improve solvents for resins, dyes, paints, and agricultural chemicals, and to create a better breed of synthetic fibers.

DMSO combines with water and reduces ice-crystal formation; it freezes at room temperature (about 68°F) and boils at a very high temperature of 372°F. In the late 1950s, British scientists began to use DMSO as an effective coolant for the storage of blood cells. This was what initially interested me. But I was a long way from the hub of DMSO knowledge in

the United States, the Crown Zellerbach Corporation of Camas, Washington, one of the world's largest pulp and paper manufacturers.

In the late 1950s, organ transplants were transformed from the stuff of science fiction to medical reality. While at Harvard, I also worked at the Massachusetts Institute of Technology (MIT) conducting research in the cryogenic engineering lab. My surgical team, comprising people from Harvard and MIT, began some of the earliest modern transplant work, involving kidney transplants. We experimented with freezing kidneys to learn how to minimize the mechanical damage, so that we could eventually develop kidney banks; but, while at MIT's cryogenics lab, I became more interested in the possibility of preserving kidneys than in the immune-barrier aspect of transplantation. During this period, I helped to develop a process to freeze kidneys for later use to be transplanted. Unfortunately, our advancements were so rudimentary that the frozen kidneys could not be used in transplant procedures—although we were able to make puppy hearts beat briefly in adult dogs following preservation techniques.

The need to cool viable organs from newly deceased donors led to my professional discovery of DMSO, the parent compound of MSM. (With so much discussion in the media today of stem cell research, it is interesting to note that DMSO is not only used to cryopreserve stem cells, but it is also obligatorily infused into patients who receive stem-cell transplants.)[5] If we could preserve the kidneys or hearts of deceased patients and the organs could be taken out of cold storage on an as-needed basis for transplantation, this would replace our macabre need to wait for a donor to die in order to save the life of another. I thought a chemical solution would be the best way to achieve this goal.

I had been told about research by the British scientist J.E. Lovelock, who had written extensively about chemicals permitting red blood cells to be frozen "alive." DMSO was a promising candidate, and new research was being undertaken. At the time, DMSO was being produced in the Pacific Northwest from lignin (the cement substance of trees) for use as an industrial solvent.

In 1959, Dr. J. Engelbert Dunphy, my mentor in surgery at Harvard, was given the position of chairman of the Department of Surgery at the

University of Oregon Medical School (now Oregon Health & Science University). Dr. Dunphy asked me to join him for two purposes: to take charge of surgical research and to supervise the university's fledgling transplantation program.

I moved to the Pacific Northwest and became an assistant professor of surgery at the University of Oregon Medical School, where I headed transplantation research. But when I arrived, I must admit, there certainly was not any kind of workplace like my cryogenics laboratory or any institution such as MIT. At technically oriented Oregon State University in Corvallis, I didn't sense the same degree of interest in what I was trying to accomplish with preservation of organ transplants. Still, DMSO's use for transplants intrigued me. I began to look around for an inexpensive source of the compound.

In early 1962, I called Crown Zellerbach Corporation. They put me in touch with chemist Robert J. Herschler, who came to my office at the medical school to consult regarding DMSO. At the time, Herschler supervised applications research in the Chemical Products Division of Crown Zellerbach. Knowing of my medical interests, Herschler told me that Crown Zellerbach would be interested in making DMSO available to me at no cost—and that he would like to work with me.

Constrained within his own professional world, Herschler desperately wanted to reach out to the academic community. He had a substance— DMSO—for which he saw great potential. But within the pulp and paper industry, it was not customary to announce possible or contemplated scientific breakthroughs to the outside world, due to fear of competition.

Herschler's own research indicated that, in addition to protecting red blood cells, DMSO could carry other substances with it in agricultural applications. Together, we began to work with DMSO at the medical school. We published our first papers as co-authors in 1964.[6,7] These papers provided the first description of the pharmacology of DMSO. Doctors had always thought of the skin as a barrier, but DMSO was leading me to a deep appreciation for the skin as a means of delivering therapeutic agents. We both thought that the pharmaceutical giants would jump at the opportunity to patent such a compound for their exclusive use.

Today, I think of DMSO as a therapeutic principle. Over the past 40 years, more than 12,000 articles on the biologic implications of DMSO and 28,000 articles on the chemistry of DMSO have been published in the scientific literature. At this time, DMSO is an approved pharmaceutical agent in over 125 countries. Some of the well-documented pharmacologic properties of DMSO include analgesia, anti-inflammation, softening of scar tissue, hydroxyl radical scavenging, vasodilatation, and stimulation of healing.

In 1970, the U.S. Food and Drug Administration (FDA) approved DMSO for the treatment of musculoskeletal disorders in dogs and horses. In 1978, FDA approved its use in humans for interstitial cystitis.

As it turns out, the garlicky breath and body odor caused by topical, oral, intravenous and intramuscular DMSO are deterrents to its use in chronic conditions. Unless the situation involves intolerable acute pain, serious disorders of the central nervous system (e.g., head injury, stroke), or is otherwise life threatening, it is difficult for anyone who wishes to maintain social and sexual relationships to experience these side effects, which may last for several days with each dosage. DMSO applied to the skin produces a far less pronounced odor than when given orally or intravenously.

From the beginning, we knew that DMSO was metabolized to dimethyl sulfide (DMS) and dimethyl sulfone ($DMSO_2$; MSM). We were searching for a metabolite that would provide some of DMSO's therapeutic benefits without its unwanted side effects. Dimethyl sulfide, it turns out, was responsible for much of the odor associated with DMSO. So, around the late 1970s, Herschler and I began to experiment with MSM and to learn as much as possible about its potential therapeutic uses. We found that MSM did not produce discomfort when applied to the skin, nor the odor problems of its parent compound. We also discovered that MSM shared many of the therapeutic actions of DMSO. I have now been treating patients with MSM for nearly 25 years. It is a dietary ingredient with a host of benefits in man.

3

MSM as a
Sulfur Source

A great many health conditions respond to methylsulfonylmethane (MSM). Questions naturally arise concerning its mechanism(s) of action. Although methyl group donation is probably a significant source of MSM's biologic activity, the majority of attention has been on MSM as a source of bioavailable sulfur.

SULFUR IN THE HUMAN BODY

The most abundant dietary sources of sulfur are the sulfur-bearing amino acids, cysteine and methionine. MSM is also a source of dietary sulfur, comprising one-third (34%) sulfur by weight. It is therefore often concluded that sulfur donation is the primary mechanism of action of MSM. Sulfur is the fourth most abundant mineral in the body, after calcium, phosphorus, and potassium. A 70-kg human body contains approximately 0.8% (or 200 grams of) elemental sulfur.[8] Sulfur is effectively absorbed as inorganic sulfur, or in sulfur-containing amino acids. As will be discussed in Chapter 5 on MSM metabolism, the sulfur component of

Sulfur

Atomic Number: 16
Atomic Symbol: S
Atomic Weight: 32.06
Electron Configuration: [Ne]$3s^23p^4$
Sanskrit: Sulvere
Latin: Sulpur
Known since antiquity
Referred to in Genesis as Brimstone
Described by Lavoisier in 1777

Physical properties: A pale yellow, odorless, brittle solid; insoluble in water but soluble in carbon disulfide. In every state, whether gas, liquid, or solid, elemental sulfur occurs in more than one allotropic form or modification; these present a confusing multitude of forms, the relations of which are not yet fully understood. High-purity sulfur is commercially available in purities of 99.999+%. Eleven isotopes of sulfur exist. None of the four isotopes found in nature are radioactive. A finely divided form of sulfur, known as flowers of sulfur, is obtained by sublimation.

Sulfur is the tenth most abundant element in the known universe. On Earth, sulfur occurs natively in the vicinity of volcanoes and hot springs. It is widely distributed in nature as iron pyrites, galena, sphalerite, cinnabar, stibnite, gypsum, epsom salts, celestite, barite, and so on. Calcium sulfur, ammonium sulfate, carbon disulfide, sulfur dioxide, and hydrogen sulfide are but a few of the many important organic compounds of sulfur. Sulfur is commercially recovered from wells sunk into salt domes along the Gulf Coast of the United States. Sulfur also occurs in natural gas and petroleum crude and must be removed from these products. Sulfur recycled in this way may be used as a raw material to manufacture DMSO.

Sulfur is a component of black gunpowder, and is used in the vulcanization of natural rubber and of some fungicides. It is also used extensively in making phosphatic fertilizers. A tremendous tonnage of sulfur is used to produce sulfuric acid, the most important manufactured chemical. It is used to make sulfite paper and other papers, to process fumigants, and to bleach dried fruits. The element is also a good insulator.

Sulfur is essential to life. It is a minor constituent of fats, body fluids, skeletal minerals, and connective tissue. Its biological functions in humans are discussed in this chapter.

Source: CRC Handbook of Chemistry and Physics (3rd Electronic Edition).

MSM has been shown to be taken up by sulfur-containing amino acids in the body.[9] The sulfate reserve in humans is among the smallest of animal species[10] and may be depleted by a low-protein diet[11] and by acetaminophen,[12,13] which is among the most commonly prescribed analgesics for osteoarthritis.

Curiously, the physiological abundance of sulfur is not matched by an abundance of clinical research into sulfur as a therapeutic compound, nor as a nutritional requirement. And yet, sulfur is a major component of connective tissue, of sulfur-containing amino acids in body proteins, and of coenzymes (vitamins) in enzyme reactions. In connective tissue—such as skin, cartilage, and even interstitial ground substance—sulfur is a major constituent. It is abundant in the mucopolysaccharides dermatan sulfate, chondroitin sulfate, and hyaluronic acid. Sulfur strengthens connective tissue by forming cross-linkages known as disulfide bonds. These bonds are the links in chains of glycosaminoglycans that build cartilage.

In addition to its vital role in maintaining the structure of intracellular proteins, sulfur is also the site for attachment and transfer of methyl groups. Sulfur is a constituent of the tripeptide glutathione, the most important intracellular antioxidant in the body. Sulfur is part of coenzyme A, a key cofactor in the citric acid cycle; the reactive sulfhydryl (–SH) group serves as a carrier and activator for acyl groups, most notably in degradative, energy-yielding pathways in mitochondria.

The sulfur component of coenzyme A makes many biochemical processes possible (e.g., the first step of the Krebs cycle in which an acetyl group is transferred to oxaloacetic acid; ß-oxidation of fatty acids in which –SH is the recipient of acetyl units removed from the fatty acid chain; carriage of the fatty acid moiety). Reactive –SH is involved in the synthesis of fatty acids, ketones, cholesterol, acetylcholine, porphyrin, and sphingosine. It is also involved in the transfer of fatty acids or acetate to polypeptides, including some enzymes, receptors, hormones, histones, and tubulin.[14]

In oxidized forms (i.e., sulfates), sulfur is associated with mucopolysaccharides (e.g., keratan) and is used to render metabolites more water soluble for urinary excretion in Phase I biotransformation

processes taking place in the liver. The most notable examples of this are catecholamines, hydroxysteroids, and bile acids. The reactive –SH group is a common functional group on many compounds; sulfhydryl groups are exposed in Phase I, making Phase II conjugation reactions possible.

Sulfoxidation and desulfuration are among the many oxidation reactions catalyzed by the cytochrome P-450-containing monooxygenase enzymes. These occur by the addition of oxygen via cytochrome P-450 to the unshared electron pair on the sulfur atom.

Sulfation is an important conjugation reaction for hydroxyl groups in Phase II liver biotransformation of toxicants. This reaction is catalyzed by sulfotransferases, a group of soluble enzymes found in the liver, kidney, intestines, lungs, and elsewhere. As a detoxication process, sulfation effectively decreases the pharmacologic and toxicologic activity of many compounds. The products of this reaction, ionized organic sulfates, are more readily excreted than either the parent compounds or hydroxylated metabolites. Sulfation may also mask some functional groups on certain toxicants, preventing adverse interactions with vital cellular components.[15] Sulfate conjugates of xenobiotics are excreted primarily via the kidneys.

Individual variation in hepatic metabolism of drugs has been extensively investigated. Population studies have shown that there is a wide range in metabolizing ability for all detoxification pathways. Phenotypically poor metabolizers may be more susceptible to drug and environmental toxicity.[16] It has been estimated that 20% of healthy individuals are poor sulfur oxidizers. Abnormal sulfur oxidation has also been documented in a variety of health conditions and is genetic in most cases. Challenge with S-carboxymethyl-L-cysteine demonstrates nearly a 100-fold difference between individuals with respect to the amount of sulfoxide metabolites detected in the urine in the eight hours after oral administration.[17]

Impaired sulfur oxidation has been observed in people with, and in some cases implicated in the etiology of, primary biliary cirrhosis (PBC),[18] food sensitivities,[19] myasthenia gravis,[20] rheumatoid arthritis,[21,22] osteoarthritis (OA),[23] lupus,[24] and other conditions. It is interesting to note that, with the exception of PBC, all of these conditions have

successfully responded to treatment with MSM. Future studies are needed to determine whether MSM supplementation affects the sulfur oxidation pathway.

Sulfur appears to play a role in the mediation of inflammatory pathways. In sites of inflammation, as in rheumatoid disease, chemokines regulate the recruitment and migration of leukocytes and induce chemotaxis. Several different highly sulfated molecules—including glycosaminoglycans, heparin, heparan sulfate, chondroitin sulfate, and dermatan sulfate— have inhibited chemokine binding to extracellular matrix and mast cells *in situ*.[25] As discussed in Chapter 6, DMSO has well-documented anti-inflammatory properties. We have extensive clinical experience with its primary metabolite, MSM, in the treatment of numerous inflammatory conditions, including the arthritides that have responded to other sulfur-containing molecules (e.g., chondroitin sulfate, glucosamine sulfate). It is noteworthy, in this context, to mention that virtually every successful trial of glucosamine for osteoarthritis has utilized the sulfur-containing form, glucosamine sulfate. Trials of glucosamine hydrochloride for OA have, to date, produced negligible clinical results.

THERAPEUTIC APPLICATIONS OF SULFUR

Sulfur has long been a valued medicine in dermatology. Applied topically at low concentrations, sulfur is a keratoplastic agent, correcting abnormal keratinization. At high concentrations (i.e., above 5%) sulfur is keratolytic. Two official (USP) forms of sulfur are used in topical preparations: precipitated sulfur (milk of sulfur) and sublimed sulfur (abric, flowers of sulfur). Other topical forms of sulfur include sulfurated lime solution (Vleminckx' solution), ground roll sulfur (flour of sulfur), colloidal sulfur, and washed sulfur.[26] Topically applied sulfur has mild antifungal and antibacterial activity.

Balneotherapy (sulfur baths) is a another historically significant application of sulfur as a therapeutic agent. In the city of Tbilisi in post-Soviet Georgia can be found 500-year-old buildings with Persian-style architecture housing sprawling bathhouses and sulfur baths that have

attracted tourists and locals in droves for centuries. About 865 miles to the southwest lies the Dead Sea, the lowest point on the Earth's surface at 400 kilometers below sea level. Leaching of minerals, including sulfur, from the geological strata contributes to the Dead Sea brine and to the many thermomineral springs along its shores. Alluvial deposits form the much-valued Dead Sea mineral mud, also known as Dead Sea therapeutic black mud. The Dead Sea region has been the major spa area in Israel for patients with various types of arthritis. Controlled clinical trials over the past 15 years have demonstrated that treatments at the Dead Sea, consisting mainly of mud packs and bathing in sulfur baths, have a positive effect on patients with arthritis, such as rheumatoid arthritis and psoriatic arthritis.[27]

HOW IMPORTANT IS THE SULFUR COMPONENT OF MSM?

In the early days of our interest in researching MSM, Bob Herschler was concerned that the FDA might block clinical research on MSM if it were perceived as a novel drug, rather than as a mineral. Herschler therefore concentrated his research efforts on MSM as a source of sulfur, even though not all of its therapeutic properties necessarily derive from the sulfur component. We believe that the reason MSM works is not so much because of sulfur *per se*, but because of the fact that it shares some pharmacological properties with DMSO.

The pharmacology of DMSO is fairly well documented, whereas knowledge of the pharmacology of MSM is limited. DMSO has several pharmacologic properties that are likely to be significant for MSM as well: 1) Analgesia and nerve blockade, 2) increase of blood supply, 3) anti-inflammatory action, 4) effects on collagen—it tends to soften collagen, lessen scar tissue,— and 5) reduction of muscle spasm. The efficacy of MSM for a particular condition may not have much to do with achieving increased sulfur levels in a given tissue. We have little evidence we can increase sulfur levels in diseased tissue by giving MSM.

Practitioners of natural medicine and members of the dietary supplement industry have always explained the therapeutic effects of MSM as a

function of its sulfur content. Sulfur is very important, but it is not likely to be the whole story. For example, a cursory glance at the MSM molecule (see Chapter 4, Figure 1) reveals that two methyl groups flank the sulfur atom. As important as sulfur and sulfation are in human biochemistry, methyl groups and methylation are perhaps equally important in human health. The potential of MSM to donate its methyl groups—an almost entirely unexplored avenue of research—has wide-reaching implications for its therapeutic modes of action. Both sulfation and methylation are key processes in metabolism of xenobiotics. Aberrant DNA methylation is thought by some to be an underlying mechanism in the pathogenesis of cancer. Donation of methyl groups supports the transformation of homocysteine to methionine, a process that has implications for cardiovascular disease, Alzheimer's disease, rheumatoid arthritis, and many other conditions. We anticipate that future MSM research will probe the effects of the methyl groups as well as the sulfur component of MSM to more fully account for the molecule's unique and wide-ranging therapeutic properties.

4

MSM Chemistry

Methylsulfonylmethane (MSM) may be designated by several chemical names. The most technically accurate is dimethyl sulfone ($DMSO_2$). It is also known as methyl sulfone and sulfonylbismethane; it is sometimes incorrectly referred to as methanol sulfone or methanol sulfonylbis. British spellings replace the "f" with a "ph," yielding dimethyl sulphone, and so on. The first published record of the isolation of MSM was in 1940, from the research labs of Parke-Davis.[28] In its purified chemical form, dimethyl sulfone is tasteless to slightly bitter. It is a white, water-soluble powder.

Apart from its therapeutic uses in humans, $DMSO_2$ has industrial applications as well. It is ideally suited for use as a high-temperature reaction solvent. At temperatures above its melting point, many chemicals are soluble in $DMSO_2$. These include acids, anhydrides, alcohols and glycols, phenols, ethers, esters, amines, hydrocarbons, halogenated hydrocarbons, ketones, salts, resins, polymers, and other compounds.[31] $DMSO_2$ is itself soluble in water and in several organic solvents, particularly DMSO, formaldehyde, and dimethyl formanide.

Table
Dimethyl Sulfone Physical and Chemical Properties[29, 30]

Chemical formula:	$C_2H_6O_2S$
Molecular Weight:	94.13
Carbon:	25.52%
Hydrogen:	6.42%
Oxygen:	33.99%
Sulfur:	34.06%
Melting point:	109°C (228°F)
bp_{760}	238°C
Sublimes at:	13 mm and 90° to 100°C
Infrared absorption (solid):	7600–8700 nm
Dipole moment:	4.44 (vapor); 4.25 (Debye)
Specific gravity (26°):	1.450–1.455

BUT IS IT NATURAL?

The many industrial uses of MSM make some people wonder whether it is a natural substance. It is. Decaying biomass, particularly phytoplankton in oceans, gives off the highly odiferous compound dimethyl sulfide (DMS). DMS is much more volatile than water and thus enters the atmosphere readily. Sunlight and oxygen act on DMS to make a series of oxidation products, including DMSO, MSM, and sulfates. Atmospheric research has demonstrated that microscopic particles of sulfate are required for the formation of clouds from water vapor. Since DMSO and

The dimethyl sulfone molecule consists of two methyl groups bonded to a sulfur atom, and two oxygen atoms bonded to the same sulfur atom: $(CH_3)_2SO_2$.

$$CH_3 - \overset{\displaystyle O}{\underset{\displaystyle O}{\overset{\displaystyle \|}{\underset{\displaystyle \|}{S}}}} - CH_3$$

Figure 1: Dimethyl sulfone (DMSO$_2$, MSM) molecule

MSM are soluble in water, they are picked up by the water droplets in clouds and returned to the earth in rainfall.

MSM, DMSO, and other sulfur-containing compounds are dietary sources of sulfur for plants and animals, which require the element for many complex biochemical processes. When it was first discovered that MSM supplementation could have health benefits in humans, it was also apparent that the minute quantities present in plant and animal material (on the order of a few parts per million) would be insufficient as a source for commercial extraction. The only viable process for manufacturing MSM supplements requires the use of chemical technology.

The purest commercial MSM is manufactured by reacting hydrogen peroxide with DMSO and then purifying the product through distillation. The resulting MSM molecule is chemically indistinguishable from that found in nature. MSM is a very simple molecule, containing just eleven atoms, which bond in only one configuration. There are no isomers of MSM. If by "natural," one means that the substance cannot involve chemical technology in its production, then there is no "natural" MSM available as a supplement anywhere.[32] By such a restrictive definition, however, there would also be virtually no "natural" vitamins or "natural" herbal extracts available. As with other dietary supplements, large-scale manufacture of MSM is made possible by chemical technology. It remains true that MSM is a naturally occurring molecule.

5

Metabolism
of MSM

Much of our research on the metabolic fate of MSM stems from our work with DMSO. MSM is the major metabolite of DMSO, and its correct chemical name is dimethyl sulfone, or $DMSO_2$. When dimethyl sulfone began to gain use in humans, Bob Herschler was concerned that, as people began hearing about it, they might try to buy it in a chemical store. The similarity of its name to several highly toxic compounds led Herschler to employ a different name as a public health measure; he popularized the name methylsulfonylmethane, or MSM, in 1977. Herschler reasoned that lay people would be unlikely to confuse MSM with dimethyl sulfate, dimethyl sulfite, dimethyl sulfide, or other similar sounding, but toxic, chemicals. Herschler went on to trademark the name MSM, but the trademark is no longer valid and the name remains in wide use today.

Human plasma naturally contains both DMSO and MSM in small but significant concentrations. Although it is assumed that the presence of these agents in human plasma is the result of absorption from foodstuffs, some authors have proposed a model of DMSO (and hence, MSM) syn-

thesis within the human organism.[33] These same authors examined blood samples from 100 volunteers and determined the naturally occurring levels of DMSO in human plasma to be between 20 and 40 ng/mL (which is equivalent to 20 to 40 parts per billion). The concentrations of MSM found in human plasma were far greater, between 700 and 1,100 ng/mL (0.7 to 1.1 ppm).

ABSORPTION OF MSM

In March 2001, a study was completed by the Equine Research Center in Guelph, Ontario, Canada. The researchers found that a substantial amount of MSM is absorbed through the intestinal tract and retained.[34]

Six horses were used in the study after adapting to a diet of hay and grain fed twice daily for two weeks. Horses remained on this diet throughout the trial. They had free access to water, and their temperature, and heart and respiratory rates were monitored daily. Feces and urine were collected twice daily throughout the trial. On days 0, 5, and 9, blood and synovial fluids were also obtained. However, the researchers were not able to obtain sufficient amounts of synovial fluid from some of the horses, and this prevented statistical analysis of the synovial fluid results. On days 1 to 5, four of the horses were given 18,500 kBq of radiolabeled MSM (OptiMSM™, Cardinal Nutrition, Vancouver, WA) each. The required volume (0.83 ml) was measured and applied to a piece of bread. Molasses was then added to increase palatability, and the mixture was fed to each horse. The control horses received only bread and molasses. On days 6 to 9, 20 grams of "cold" MSM was given to the four treatment horses.

Radiolabeled sulfur was detected in both urine and feces by day 1, with peak excretion around day 5. By day 9, there were decreased levels of radioactivity in both the urine and feces. Additional samples from the four treatment horses revealed no presence of radiolabeled sulfur (S-35) in the feces or urine approximately one month after completion of the trial. This trial, and an initial trial using one catheterized mare found that 55% of the S-35 was absorbed by the horse. Although statistical

analysis of the synovial fluid samples could not be performed, the authors stated that their data suggested some S-35 was present in the synovial fluid. There was no effect of radiolabeled MSM on any variable in the hematology reports.

The results indicated that the radiolabeled sulfur from radiolabeled MSM was absorbed by the intestines and was found in the blood of the four treatment horses. The researchers did not determine whether or not the sulfur was still associated with MSM when it was detected. The results also indicated that a substantial amount of the sulfur from MSM was retained in the body.

METABOLISM OF DMSO AND MSM

With funding from the DMSO Research Institute, we studied the metabolic fate of DMSO in Rhesus monkeys and published our results in 1985 in the journal *Life Sciences*.[35] Three Rhesus monkeys (*Macaca mulatta*), weighing approximately 5 kg each, were given daily oral doses of DMSO (RIMSO-50, Research Industries, Salt Lake City, UT) at a dose of 3 grams per kilogram body weight as a 50% solution in water for 14 days. Each monkey received a total of 210 grams of DMSO. Four ml of blood were drawn from the femoral vein by venipuncture at 1, 2, 4, 8, and 24 hours and then daily thereafter prior to DMSO administration. Urine volume was measured daily, and 5 ml was kept for analysis. Feces were collected every third day and stored at 4°C for analysis. DMSO and MSM levels were measured in serum, urine, and feces at least in duplicate by gas-liquid chromatographic method of Garretson and Aitchison.[36]

An average peak serum concentration of 2.3 mg/ml was observed after about four hours, which declined to about 0.95 mg/ml after 24 hours. The decline in serum DMSO was linear on semilogorithmic coordinates (i.e., a constant fraction was eliminated in each interval time). Its half-life of 16 hours was found by calculating the time required for a given serum concentration to decline by one-half. Its elimination rate constant was $K_e 0.693/16$, or about 4% per hour. With continued daily oral administra-

tion, serum DMSO rose slightly from 0.95 to 1.1 mg/ml on Day 2 and then reached a steady state concentration of about 0.9 mg/ml after four days. After oral DMSO was stopped, serum DMSO declined rapidly and was not detected after 72 hours.

Urinary excretion of DMSO increased rapidly upon oral administration, reaching a steady state level of approximately 9 grams per day after two days. DMSO disappeared rapidly from the urine and only trace amounts were detected after 72 hours. Approximately 60% of the ingested dose of DMSO was excreted in the urine unchanged. Urinary excretion of MSM increased slowly after oral administration and reached a maximum of about 3 grams per day after five days of DMSO administration. Excretion remained between 2 and 3 grams per day during the remainder of oral administration. Once DMSO treatment was stopped, urinary excretion of MSM declined slowly over the next five days. Approximately 16% of the ingested DMSO was excreted in the urine as MSM.

Although fecal samples seemed to have an odor of DMSO on collection, analysis two weeks later detected no DMSO or MSM in these samples. We believe intestinal bacteria may have degraded the compounds during storage. Our estimates suggest that gut bacteria may be responsible for degrading 450 to 500 mg of DMSO per day, approximately 3% of the total DMSO ingested.

The aforementioned results indicate that absorption of DMSO in Rhesus monkeys is similar to absorption of DMSO in humans. As with our findings, peak blood levels have been previously described as occurring in humans at about four hours after a single dose.[37] However, monkeys excreted DMSO and MSM more rapidly than did humans.

After giving oral DMSO, $DMSO_2$ (MSM) appeared in the blood within two hours and reached a steady state concentration after four days of treatment. MSM was cleared from the blood about 120 hours after DMSO administration was stopped. Thus, MSM's persistence in bodily tissues is greater than that of its parent compound. MSM's half-life in blood was calculated to be 38 hours. Urinary excretion of unmetabolized MSM in primates accounted for about 16% of the total ingested dose of DMSO.

In humans, the conversion rates are slightly different, with approximately 15% of the total DMSO dosage being converted to MSM *in vivo*. Whereas MSM was completely cleared from the urine of monkeys after 120 hours, it persisted for over 400 hours in humans. While we are not sure of the reasons for this, we believe it might mean that renal clearance of MSM is either more rapid in monkeys or else MSM binds more extensively to tissues in humans than in monkeys. Differences in diet may also mean that humans have a greater dietary need for sulfur and, hence, MSM.

Following oral ingestion, MSM is reportedly found in the saliva, perspiration, breath, and urine of humans.[38] Although MSM is excreted primarily in the urine, a surprise finding was the measured excretion in expired air. Since MSM is odorless, we had not thought to measure this in prior studies. Herschler's laboratory research showed that both DMSO and MSM are readily detected in perspiration of humans, and that the elimination of these compounds via the skin may be significant. Fecal excretion is low.

INCORPORATION OF MSM INTO SERUM PROTEINS

In their studies of the distribution and excretion of S-35-labeled MSM in rats, Drs. R.L. Reed and D.R. Buhler of Oregon State University provide evidence that orally administered MSM is incorporated into bodily tissues.[39] Radioactively tagged sulfur, assayed at 24 hours, was found in the liver, kidney, and blood (plasma and cells). Subcellular fractions of the liver and kidney—nuclear, mitochondrial, lysosomal, microsomal, and soluble—each were found to contain substantial amounts of radioactively labeled MSM. The tagged agent was also found incorporated into the amino acid methionine.

In 1986, Virginia L. Richmond of the Pacific Northwest Research Foundation in Seattle, Washington, studied the incorporation of radiolabeled sulfur from MSM into guinea pig serum amino acids methionine and cysteine.[40] Methionine and cysteine are the major sulfur-containing amino acids in the human body.

Richmond sought to determine whether sulfur from MSM is incorporated into sulfur-bearing amino acids and whether the donated sulfur of MSM may be found in organosulfur biomolecules required for normal cellular metabolism. She fed ^{35}S-MSM to guinea pigs and analyzed MSM absorption and excretion, as well as its incorporation into peptidyl methionine and cysteine of serum proteins. Both methionine and cysteine, isolated from these proteins, were found to contain small amounts of radiolabeled sulfur derived from the MSM. The specific activity of ^{35}S-methionine was 30% greater than for ^{35}S-cysteine, suggesting a precursor-product relationship, since methionine is converted to cysteine *in vivo*. Total specific activity of serum proteins was increased by only 30%, with a 100% increase of administered ^{35}S-MSM, suggesting a limiting step in synthesis.

In a personal communication, Richmond noted she has also determined that labeled sulfur from MSM is found in other important biomolecules. Herschler concurs, having demonstrated MSM uptake into serum albumin, keratin, and GI mucosa in a rabbit model.[41]

The Richmond study in guinea pigs found that sulfur was incorporated into sulfur amino acids. The equine study cited above, however, did not corroborate these results. We hypothesize that, if larger doses had been used in the equine study, incorporation into serum proteins might have been detected. Alternatively, the process of incorporating sulfur from MSM into amino acids and proteoglycans may be self-limiting. If the horses' diets had been deficient in cysteine and methionine, the sulfur from the MSM moiety may have been incorporated to a greater extent. Another possible explanation for the lack of incorporation is that the dosing regimen may have been too short in the equine study. The concentration of MSM in the horses may never have reached an optimal, steady state. Higher concentrations may be required to drive a water-soluble compound like MSM to partition into cells.

INCORPORATION OF MSM INTO NEURAL TISSUE

Intact MSM appears to be incorporated into human brain tissue. At the Centre for Magnetic Resonance at the University of Queensland in Brisbane, Australia, Dr. Stephen E. Rose and colleagues reported the detection of MSM in the brain of a healthy 62-year-old male using *in vivo* proton magnetic resonance spectroscopy.[42] MSM (MSM Complex, Health Kaire, Auckland, New Zealand) was administered in capsules. A loading dose of 2 g per 11 kg of body weight was administered for seven days, followed by 2 g daily as a maintenance dosage. To characterize the washout of MSM from the brain, spectra were acquired at 2, 7, and 10 days after the subject stopped taking the dietary supplement. The concentration of MSM in the brain was measured to be 2.4 mmol, with a washout half-life of approximately 7.5 days. The concentration of other major brain metabolites, (i.e., N-acetylaspartate, total creatine and choline, and myo-inositol), were within normal limits.

In September 2001, research was published that further documents MSM uptake into brain tissue. Alexander Lin and colleagues at the M R Spectroscopy Unit of the Huntington Medical Research Institutes in Pasadena, California, used multinuclear magnetic resonance spectroscopy and detected 0.42–3.40 nmole MSM per kilogram brain weight in four patients with memory loss and three healthy volunteers who had been supplementing with MSM (1 to 3 g per day).[43] MSM was not detected in the brains of 25 volunteers who did not take MSM supplements.

The authors state that there was no correlation between cerebral MSM concentrations and the concentrations of intrinsic cerebral metabolites, and concluded, "MSM does not appear to have any adverse neurochemical effect in man." Of the four patients studied, one had a history of stroke. The MSM concentrations in the brain of this patient exceeded those of the other patients. This finding suggests that breakdown of the blood-brain barrier (BBB) may allow MSM to enter the brain in higher concentrations, or may interfere with its export from brain tissue. However, there is no evidence to contraindicate MSM supplementation in stroke patients. MSM may, in fact, prove beneficial for

stroke. A substantial amount of evidence suggests that DMSO, the immediate metabolic precursor of MSM, may protect against cerebral ischemia and infarction.[44-52]

We are left to speculate whether it is intact MSM, its sulfur component, or both that are responsible for MSM's biological effects. But where experimental work has left unanswered questions, experience shows that whether provided to bodily tissues in its intact form or as simply as a sulfur donor, MSM plays an important role in human health—including many of the health challenges most commonly faced by our patients.

6

Biological Effects of DMSO and MSM

Experimental and clinical evidence suggests that MSM is effective in the treatment of many health conditions. What are its mechanisms of action? Unlike DMSO, the major *in vivo* effects of MSM remain largely unknown. Most of our experience with MSM has been clinical rather than experimental. As research on MSM continues, its major biological properties will become clearer.

Thanks to intense interest from the pharmaceutical industry, we do know a great deal about the major biological effects of DMSO. It would be incorrect to make a blanket assumption that MSM possesses the same *in vivo* properties as DMSO. However, 15% of ingested DMSO is rapidly oxidized to $DMSO_2$ (MSM) *in vivo* by hepatic microsomes in the presence of $NADPH_2$ and molecular oxygen.[53] Our clinical experience with MSM and DMSO strongly suggests that the first metabolite of DMSO will share some of its biological properties. There are areas where DMSO and MSM probably share similar *in vivo* effects. The following review of DMSO's *in vivo* effects suggests important avenues of future research on MSM.

Effects on Connective Tissue

In 1965, John H. Mayer and colleagues at the Department of Surgery at the University of Missouri School of Medicine compared the effects of DMSO, DMSO with cortisone acetate, cortisone acetate alone, and saline solutions on the incidence of intestinal adhesions following serosal abrasions of the distal ileum in Wistar rats.[54] Several series of animals received postoperative daily intraperitoneal injections of either DMSO (1 gm/kg body weight per day), and an equal volume of normal saline, cortisone acetate (2.5 mg per day), or a combination of DMSO and cortisone acetate. Postoperative treatment was administered for 35 days. Of those animals receiving either saline or cortisone acetate alone, 100% had evidence of adhesions; of those receiving cortisone acetate plus DMSO, 80% developed adhesions; and of those receiving DMSO alone, only 20% showed evidence of adhesions and these were minimal.

In serial biopsy specimens taken from the skin of systemic sclerosis patients treated with topical DMSO, dissolution of collagen was observed, while normal elastic fibers remained intact.[55,56] Urinary hydroxyproline levels were also increased in scleroderma patients treated with topical DMSO. Keloids biopsied in humans before and after DMSO therapy have shown histological improvement toward normalcy.[57] MSM may exert similar effects, as we have observed reduced incidence of scarring and overall improvement in scleroderma patients who used MSM topically. As sulfur donors, both DMSO and MSM could contribute to normal cross linking of proteoglycans, a key component of connective tissue. As mentioned in Chapter 3, topical sulfur applications are keratoplastic or keratolytic, depending on concentration.

Anti-inflammation

David Berliner and Ann Ruhmann found that DMSO inhibited fibroblastic proliferation in vitro.[58] Ashley and colleagues reported that DMSO was ineffective following thermal burns of the limbs of rabbits.[59] Formanek and Kovak showed that topically applied DMSO inhibited traumatic edema induced by dermal injection of autologous blood in the leg of a rat.[60] DMSO showed no antiinflammatory effect in the eye or ear in experimental animal models of inflammation.[61] However, other

researchers have recorded potent anti-inflammatory properties of DMSO applied topically. For example, Gorog and Kovacs used 70% DMSO to treat experimental inflammation in a rat model. Contact dermatitis, allergic eczema, and calcification of the skin were significantly inhibited by application of DMSO.[62,63]

A study by Gerald Weissmann and colleagues[64] elucidated the anti-inflammatory effects of DMSO. Lysosomes can be stabilized against a variety of injurious agents by cortisone. The concentration of cortisone necessary to stabilize lysosomes is reduced 10-fold to 1000-fold by DMSO. We suggest that DMSO might render steroids more available to their targets within tissues (i.e., membranes of cells or their organelles). We have observational data from our clinic that suggests the same may be true for MSM. Many of our patients on corticosteroids have been able to reduce the dosage required to manage inflammation when they took MSM concurrently.

MSM appears to have anti-inflammatory effects when administered orally, intravenously or topically. We first noticed MSM's anti-inflammatory action around 1979. At that time, we were using topical MSM to treat major inflammatory reactions to injuries. We observed consistent reductions in pain, swelling, redness and heat. In other words, we saw a beneficial impact of topical MSM on the cardinal signs of inflammation.

Nevertheless, the anti-inflammatory mechanisms of action of MSM remain largely unknown, despite recent research efforts. Some acute anti-inflammatory actions of MSM were observed in an experimental study released in March 2001 from White Eagle Toxicology Laboratories in Doylestown, Pennsylvania.[65] The study revealed that MSM (OptiMSM, Cardinal Nutrition, Vancouver, WA) produced some anti-inflammatory activity in laboratory rats.

In this report, the anti-inflammatory activity of MSM was compared with that of indomethacin (the gold standard for inflammation testing) in a rat carrageenan air pouch model. The objective of the study was to determine whether MSM inhibited leukocyte influx and edema (indices of inflammation) in an acute inflammation model. MSM was administered orally (300 or 1,000 mg/kg body weight for three days) to male CD Charles River rats, in which inflammation was produced with injections of carrageenan.

Oral MSM at 1,000 mg/kg, administered from two days prior up to two hours prior to carrageenan injections inhibited the total number of leukocytes migrating into the pouch at four hours by 26%. The 300 mg/kg dose inhibited leukocyte infiltration by 18%. These results did not reach statistical significance, possibly due to the small number of animals studied, or because the anti-inflammatory effects of MSM are more likely to be demonstrated in a chronic inflammation model. We know from our clinical experience that MSM can be a "slow worker," so dramatic acute anti-inflammatory effects were not anticipated.

Additional analyses were subsequently conducted for the inflammatory mediators prostaglandin E_2 (PGE_2) levels, for tumor necrosis factor alpha (TNF-α), and for white blood cell infiltration.[66] Predictably, indomethacin completely eliminated detectable amounts of PGE_2 and inhibited white blood cell infiltration more effectively than did MSM. Trends for reductions in PGE_2 and TNF-α were observed after MSM administration, but they did not reach statistical significance. Again, based on our clinical experience with MSM, we would expect amplification of these trends in a chronic inflammation model. It is our hope that such research will be carried out in the future.

An open-label study was performed to evaluate the efficacy of MSM (OptiMSM, Cardinal Nutrition, Vancouver, Washington) in the reduction of symptoms associated with seasonal allergic rhinitis.[67] Details of the study are discussed in Chapter 16: Allergies and the Respiratory System. Researchers sought to elucidate the mechanism by which MSM alleviated inflammation and allergic rhinitis symptoms. One theory was that MSM supplementation might decrease levels of C-reactive protein (CRP). CRP is a marker, not only for inflammation, but also for increased risk of several disorders, including heart disease, stroke, and gingivitis. In the trial, data on CRP was collected in 47 patients taking oral MSM. Thirty-two (68.1%) of the participants had decreases in CRP following MSM supplementation; three (6.4%) had no change in CRP; and 11 (23.4%) had increases in CRP. These data are, therefore, inconclusive regarding an effect of MSM on CRP.

Nerve Blockade (Analgesia)

Immersion of isolated frog sciatic nerves in 6% DMSO decreased nerve conduction velocity by 40%.[68] This effect was totally reversed by washing the nerve in a buffer for one hour. Dr. C. Norman Shealy studied peripheral small fibers after discharge in cats.[69] Concentrations of 5 to 10% DMSO eliminated the activity of C fibers within one minute. Activity of the fibers returned after the DMSO was washed away. A 10% solution of DMSO subcutaneously administered to cats produced a total loss of the central pain response. In addition, 2 ml of 50% DMSO injected into the cerebrospinal fluid led to total anesthesia of the animals for 30 minutes. Complete recovery of the animals occurred without apparent ill effects.[70]

Henry J. Haigler concluded that DMSO produces analgesia by acting both locally and systemically.[71] The analgesia appeared to be comparable in magnitude to that produced by morphine. DMSO had a longer duration of action than did morphine: six hours versus two hours, respectively. Our clinical experience with MSM as an analgesic suggests that it, too, may inhibit pain impulses. Patients with musculoskeletal and other types of pain are often able to reduce their doses of analgesic medications while taking MSM. Further research is needed to determine whether MSM's mechanism of analgesia is similar to that of DMSO.

Antimicrobial activity

DMSO exerts a marked inhibitory effect on a wide range of bacteria, fungi, and at least one parasite *in vitro*.[72] Species that were especially sensitive to DMSO included *Corynebacterium* sp., *Haemophilus influenza*, *Pasteurella multocida*, *Herellea* sp., *M. tuberculosis*, and *Microsporum audouini*. DMSO at 80% concentration inactivated a wide range of viruses tested by J.C. Chan and H.H. Gadenbusch.[73] These included four RNA viruses, influenza A virus, influenza A-2 virus, Newcastle disease virus, Semliki Forest virus, and two DNA viruses, vaccinia, and *Escherichia coli* phage (T2). In 1967, Florence B. Seibert and colleagues studied highly pleomorphic bacteria regularly isolated from human tumors and leukemic blood.[74] Out of 29 cultures tested, nine were completely (100%) inhibited by 12% DMSO, and eight more were

almost completely (75 to 90%) inhibited. Another 17 cultures, including six of those previously mentioned, were treated with 25% DMSO and all were completely inhibited, except two, which showed only a trace of growth (90% inhibition or more).

Sadayoshi Kamiya and co-investigators found that 5% DMSO, although not bactericidal, restored and increased the sensitivity of resistant strains of bacteria to antibiotics.[75] In particular, the sensitivity of all four strains of pseudomonas to colistin was restored when the culture medium contained 5% DMSO. The authors recorded that antibiotics not effective against certain bacteria—such as penicillin to *E. coli*—showed much more powerful growth inhibitory effects when the medium contained DMSO. In light of recent threats of bioterrorism with agents manufactured to maximize antibiotic resistance, we believe that research into the sensitizing effects of DMSO and possibly MSM to antibiotics is especially relevent.

In 1968, Bahram M. Ghajar and Shirley A. Harmon of the Department of Biology at Bowling Green State University reported on the influence of DMSO on the permeability of *Staphylococcus aureus*.[76] They demonstrated that DMSO increased the oxygen uptake but reduced the rate of glycine transport in two strains of the organism, with an overall bacteriostatic effect. W.C. Gillchriest and P.L. Nelson suggest that bacteriostasis from DMSO may occur due to a loss of RNA conformational structure required for protein synthesis.[77]

Our experience with MSM suggests that it, too, possesses antimicrobial or bacteriostatic properties, although probably to a lesser extent than DMSO, as it lacks some of DMSO's penetrant properties. However, we can only speculate as to whether MSM's actions *in vitro* and *in vivo* bear any similarity to those of DMSO. Research is lacking.

Medicine provides several examples of sulfur solutions applied to the skin for antibacterial activity. One is Vleminckx's solution, an orange-colored solution containing sulfides of calcium made by boiling a mixture of hydrated lime and sublimed sulfur in water, which is applied externally as a topical antiseptic and scabicide. The topically applied polysulfides in the solution have been shown to be effective against acne vulgaris.[78] This is

probably due to antibacterial action, as topical sulfur appears to have no direct effect on simple comedones.[79]

Cholinesterase Inhibition

W.M. Sams and co-investigators studied the effects of DMSO on skeletal, smooth, and cardiac muscle *in vitro*, employing concentrations of 0.6 to 6%.[80] DMSO strikingly depressed the response of the diaphragm to both direct (muscle) and indirect (nerve) electrical stimulation, and caused spontaneous skeletal muscle fasciculation. DMSO increased the response of the smooth muscle of the stomach to both muscle and nerve stimulation. The vagal threshold was lowered 50% by a 6% DMSO solution. Mild cholinesterase inhibition could explain fasciculation of skeletal muscle, increased tone of smooth muscle, and the lower vagal threshold observed in these experiments. *In vitro* assays show that 0.8 to 8% DMSO inhibits bovine erythrocyte cholinesterase 16 to 18%. We postulate that MSM may possess similar properties. One common, beneficial "side effect" of MSM is improvement of sluggish elimination. In fact, MSM may be used as therapy for constipation; it produces a produces a "bowel tolerance" phenomenon similar to that of vitamin C.

Nonspecific Enhancement of Resistance

In a study of antigen-antibody reactions, Dr. H. Raettig showed that oral administration of DMSO to mice for ten days prior to an oral infection with murine typhus produced leukocytosis and enhanced resistance to the bacterial infection.[81] Further research is required to determine if MSM enhances nonspecific resistance.

Vasodilatation

Jerome E. Adamson and his colleagues at the Plastic Reconstructive Surgery Service of the Norfolk General and DePaul Hospitals in Norfolk, Virginia, applied DMSO to pedicle flaps (3:1 length-to-width ratio) raised on the backs of rats.[82] Their experiments demonstrated that DMSO is effective in enhancing the circulatory activity of the experimental pedicle flap, reducing anticipated slough by 70%. The authors suggested that the

primary action of DMSO on pedicle flap circulation was to provoke a his-tamine-like response. The same authors previously reported similarly dra-matic effects in a 28-year-old human male, quadriplegic subject.[83] Soon after, Carol A. Roth evaluated the effects of DMSO on pedicle flap blood flow and survival, concluding that DMSO does indeed increase pedicle flap survival, but she postulated that this increase takes place by some mechanism other than augmentation of perfusion.[84] A.M. Kligman had previously demonstrated that DMSO possesses potent histamine-liberating properties.[85,86] Arthur S. Leon found that DMSO reduced experimental myocardial necrosis.[87] DMSO therapy brought about a distinct modification with less myocardial fiber necrosis and reduced residual myocardial fibrosis. The author reported that neither myocardial rupture nor aneurysm occurred in the group treated with DMSO.

Our clinical experience has clearly shown that MSM also enhances blood flow and vasodilatation. I have treated a large number of patients with DMSO soaks who had diminished blood supply to their feet, with accompanying leg ulcers. When I switched from DMSO to MSM—topi-cally, orally, and with soaks—we saw similar results. Improvement was generally rapid and long lasting. Sometimes, I could actually feel patients' limbs become warmer.

Muscle Relaxation

DMSO applied topically to the skin of patients produces electromyo-graphic evidence of muscle relaxation one hour after application.[88] Our clinical experience with MSM suggests a similar muscle-relaxing effect.

Antagonism of Platelet Aggregation

E. Deutsch presented experimental data showing that 5% DMSO lessens the adhesiveness of blood platelets *in vitro*.[89] P. Gorog has shown that DMSO strongly inhibits platelet aggregation, as well as thrombus formation *in vivo*.[90] Our experience and about a dozen anecdotal reports suggest to us that MSM has a slight anti-aggregatory effect, though it is not as pronounced as that of DMSO. Nevertheless, we recommend that individuals on blood-thinning drugs (e.g., aspirin, dicumerol) be moni-

tored for any signs of bleeding. It is also advisable for people taking MSM to discontinue use a few days prior to surgery and to resume use two to three weeks later.

Antioxidation

Although many studies have demonstrated antioxidant properties of DMSO, most research to date indicates that MSM does not share these properties. However, preliminary evidence has demonstrated limited anti-oxidant activity of MSM. In 1987, Mark A. Beilke and colleagues at the Medical College of Wisconsin published the results of *in vitro* experiments testing the ability of DMSO and MSM to interfere with the production of oxidants by stimulated human neutrophils.[91] Both DMSO and MSM significantly suppressed the production of superoxide, hydrogen peroxide, and hypochlorous acid by human neutrophils stimulated with either phorbol myristate or opsonized zymosan. Neither DMSO nor MSM reduced the viability of the stimulated neutrophils. The authors suggest that this inhibition of the oxidative function of human neutrophils could provide an explanation for these compounds' enhancement of the microbiocidal activity of neutrophils, and for their observed anti-inflammatory effects.

Growth factor regulation

Another way in which MSM may enhance the body's healing response, particularly with regard to inflammation, is via regulation of various growth factors. During inflammation, many cells (e.g., fibroblasts) interact and proliferate to repair damaged tissues. As we age, however, expression of regulating proteins may become impaired. For example, abnormal expression of transforming growth factor-beta (TGF-beta) and other growth factors may occur. These altered growth factors stimulate overproduction of fibroblasts, resulting in formation of adhesions, atheromas, and perhaps even malignancies. We know that both DMSO and MSM cause a dose-dependent suppression of growth and proliferation of cultured aortic smooth muscle and endothelial cells.[92] These biologic effects are particularly encouraging for possible cardiovascular applications of MSM, such as the prevention of athero-

sclerosis. Further support of this potential application is provided by research showing that both DMSO and MSM reduce the binding, uptake, and degradation of low-density lipoproteins by cultured fibro-blasts,[93] a critical step in the pathogenesis of atherosclerosis. MSM may also contribute to cardiovascular health by donating methyl groups to homocysteine, thereby up-regulating its conversion to methionine.

The conversion of DMSO to MSM *in vivo* is rapid and predictable. The typical serum level of MSM is between 700 and 1,100 ng/ml, much greater than that of DMSO.[94] This has led some researchers to suggest that MSM may in fact be responsible for many of DMSO's therapeutic effects. We believe that some of the pharmacological properties of DMSO are also possessed by MSM, and that the application of the above data on DMSO to its primary oxidation metabolite, MSM, is valid. Obviously, additional research is required to confirm this hypothesis.

PART II

Clinical Applications of MSM

7

Osteoarthritis

Osteoarthritis (OA) is a nearly universal consequence of aging among vertebrates. Unlike some autoimmune diseases and cancer, OA is not a disease of modernity, although certain factors of the modern environment may contribute to its pathogenesis. OA has been documented among prehistoric animals and is found in both reptiles and birds. The disease does not occur in bats or sloths, animals that spend a significant amount of time hanging upside down, suggesting that gravity and the steady mechanical forces upon the joint tissues are primary contributing factors. Nevertheless, joint articulations are quite resilient and virtually without friction, thus mitigating the effects of gravity and mechanical wear and tear. If gravity and wear and tear were the only factors contributing to joint deterioration, it would be difficult to explain arthritic conditions such as chondromalacia patella, which affects younger people in a non-weight-bearing part of the knee joint.

Over 40 million Americans have some form of degenerative joint disease, including 80% of people over 50 years old. The physical evidence of OA first appears in the second and third decades of life, although the

disease is usually asymptomatic until much later, typically the fifth or sixth decade. By the seventh decade, OA is nearly universal, producing the highest rate of morbidity of any disease.

Joints affected by OA suffer from uneven loading, which leads to altered lines of weight bearing. Dysfunction and focal death of chondrocytes lead to reactive chondrocyte proliferation. Increased amounts of intra-articular enzymes (e.g., collagenase and protease), possibly triggered by the chondrocyte proliferation, may be responsible for proteoglycan degradation seen in the disease. Consequent roughening and deformities in the joint surface, paired with proliferation of new joint tissue, lead to remodeling of subchondral bone and proliferation of osteoarticular tissue at the joint margins. These changes prove irritative, triggering a nonspecific synovitis, and a cycle of degeneration is set into motion, exacerbated by weight-bearing, oxidative stressors that further damage tissue, and by pro-inflammatory foods in the diet.

Conventional wisdom is that there is no satisfactory way of preventing or reversing OA. Treatment is therefore aimed at the mitigation of symptoms. In determining treatment, we must first look at the natural history of the disease. In one study of the natural history of OA, (i.e., no treatment was given) nearly half of the patients had confirmed recovery of joint spaces without any therapy.[95] These results raise the question: Does medical intervention in some way promote OA progression? Cellular and tissue responses to OA are purposeful and aimed at repair of the joint structure. The major goal of therapy should be to enhance repair processes by connective tissue cells while reducing the damaging aspects of the tissue response.[96]

Aspirin and other nonsteroidal anti-inflammatory drugs (NSAIDs), the standard first line treatment for OA, are often effective at relieving symptomatic pain. Unfortunately, as with many drugs, NSAIDs have adverse effects and may actually accelerate the long-term progression of OA. A retrospective investigation, reported in *The Lancet* in 1985, explored the relation between use of NSAIDs and acetabular destruction in primary osteoarthritis of the hip.[97] In this study, 70 hips were examined in 64 patients, and the authors found a highly significant association between

NSAID use and acetabular destruction. While effective at suppressing the symptoms, chronic NSAID use may accelerate joint damage in OA by enhancing the production of pro-inflammatory cytokines and inhibiting cartilage proteoglycan synthesis.[98] While not all NSAIDs necessarily inhibit cartilage metabolism,[99] experimental evidence has confirmed deleterious effects on articular cartilage from indomethacin, diclofenac, and other popular NSAIDs.[100] Aspirin and sodium salicylates have been found to inhibit incorporation of sulfur into proteoglycans *in vitro*.[101] Moreover, acetaminophen and other drugs metabolized by sulfation have been shown to deplete the body's sulfate reserves.[102,103] Any therapy that potentially impairs the ability of chondrocytes to repair damaged extracellular matrix, as NSAIDs potentially do, could be viewed as antithetical to the therapeutic goals of the physician and patient. These data also suggest that NSAIDs may interfere with the therapeutic efficacy of MSM as a sulfur donor in OA.

CLINICAL DATA

In terms of numbers of patients we have treated with MSM, OA is the most significant clinical entity. Although we have obtained more dramatic results in other conditions (e.g., scleroderma), the clinical significance of MSM as a therapeutic agent is probably much greater for OA, since the disease is so widespread. Scleroderma affects half a million people in the United States; OA affects tens of millions, almost everyone by the age of 70. Most people who use MSM as a dietary supplement have some OA and are using MSM to support joint health. Moreover, OA appears to be the clinical entity of greatest interest to clinical researchers studying MSM. In the next few years, we anticipate the publication of several clinical trials of MSM, most of which will examine the effects of MSM on the symptoms of OA.

To understand how MSM could influence the pathogenesis and progression of OA, we should first consider how MSM and its component sulfur are involved in normal structure and function of the joint. Joints are lined with cartilage, which is composed of several types of connec-

tive tissue. Glycosaminoglycans (GAGs) are the fundamental building blocks of joint cartilage, and GAG molecules are linked together in chains by disulfide bonds. As the name implies, these bonds are between two sulfur molecules. The disulfide bridges reduce conformational flexibility of GAG chains, making cartilage firm and resilient. Cartilage integrity is thus a sulfur-dependent state.

The degradation of proteoglycans in osteoarthritic joints is well established. The increased turnover and eventual loss of proteoglycans from osteoarthritic tissue is the consequence of a change in chondrocyte metabolism. A recent theory of how proteoglycans are degraded involves the lysing of proteoglycans from the hyaluronic acid chain. In osteoarthritic cartilage, smaller proteoglycans are lost, suggesting enzymatic cleavage of these molecules with their subsequent diffusion out of the tissue into the synovial space. Gel electrophoresis of cartilage samples provide evidence of such enzymatic degradation.[104,105]

The result of the structural and metabolic changes is that the cartilage becomes softer and loses its compressive stiffness and tensile strength. The normal smooth surface of the cartilage begins to crack and fibrillate and eventually splits. The cartilage becomes thinner, causing joint space narrowing and bone exposure (eburnation).

There are data to show that cartilage in an osteoarthritic joint has lower sulfur content than cartilage in a nonosteoarthritic joint. Experimental evidence from an equine arthritis model suggests that sulfur concentration in arthritic cartilage is reduced to about one-third of that in normal, nonarthritic tissue.[106] The reduction in joint sulfur content may be linked with the phenomenon of proteoglycan degradation.

We lack direct evidence that the sulfur from orally supplemented MSM is taken up into arthritic joint tissue. However, indirect evidence suggests that this may occur. The sulfur from MSM is known to be both bioavailable and taken up by the sulfur amino acids cysteine and methionine in serum proteins.[107] These amino acids are components of proteoglycans that make up cartilage. Future studies will hopefully explore the question of whether MSM supplementation increases sulfur levels in osteoarthritic cartilage. Radiolabeling studies would be required to

demonstrate whether the sulfur in MSM is directly taken up by cartilage.

Although it is widely assumed to be the case, we cannot say for certain that sulfur is the active principle in MSM, or that it has any direct effect on OA. We would be surprised to find no effect of sulfur on OA, were it to be studied under controlled conditions. Sulfur has a long historical use as an anti-arthritic agent. One interesting thread of evidence supporting a role for sulfur as a treatment for arthritis comes from the Dead Sea. Several studies have been conducted using mudpacks and sulfur baths derived from the Dead Sea as treatment for osteoarthritis,[108] rheumatoid arthritis,[109] psoriatic arthritis,[110] and fibromyalgia.[111,112]

MSM appears to exhibit many properties of potential benefit for people with OA, which may be partially attributable to its sulfur content. These include:

- Analgesic effects
- Anti-inflammatory effects
- Reduced muscle spasm around joints
- Decreased formation of scar tissue
- Improved blood flow
- Sulfur donation for GAG synthesis

The evidentiary basis for MSM as a treatment for OA primarily resides in case studies.* Listed below are 11 case evaluations performed at our OHSU clinic. The patients' initials are used to protect their identity.

In the case descriptions below, and throughout the book, certain shorthand terms are used. Some (like BID for "twice daily") are standard. Others are my own personal shorthand to evaluate patient progress. The following table will clarify my use of the terms "excellent," "very good," "good," "fair," and "poor" with regard to efficacy of MSM for symptom relief.

* Further research needs to be done in this area, particularly controlled clinical trials. Several such trials were in the early stages of planning at the time this book was written.

Term	Degree of Improvement	% Improvement	"Academic" Grade
Excellent	Complete	95–100	A
Very good	Nearly complete	90–95	A-, B+
Good	Substantial	80–90	B
Fair	Noticeable	50–80	C+, C, C-
Poor	Minor	< 50	D
None	None	N/A	F

CLINICAL CASES

JM, 69-year-old male

JM presented to our clinic with an eight-year history of symptomatic OA of the hands, feet, and spine. We treated him with oral MSM liquid (15% concentration; $1^1/_2$ tsp twice daily)* and topical MSM gel applied as needed. After one month of treatment, JM was completely asymptomatic. He continued on MSM for three years and experienced no further symptoms.

PM, 58-year-old female

PM came to our clinic after suffering OA symptoms for 14 years. Her left knee was the most significantly affected joint. We started her on our typical regimen for OA: oral MSM liquid ($1^1/_2$ tsp twice daily) and topical MSM gel applied as needed. We also administered seven subcutaneous MSM injections in the first 10 days of treatment.† The patient reported "doing much better" after the series of injections, with a decrease in pain and an increase in mobility of the knee. Improvement was steady over her one year of treatment with oral and topical MSM.

* One tsp of 15% liquid MSM provides 739 mg of MSM.
† See Protocol section, Chapter 20, page 175 for composition.

JC, 60-year-old female

JC had a chief complaint of OA of the left knee. The pain was a significantly limiting factor in her daily activities for approximately 10 months prior to her first visit to our clinic. We started her on IV MSM (15 grams of 15% MSM with an equal amount of 5% dextrose in water, yielding a 7.5% MSM solution) administered three times over a one-week period. She was then maintained on oral (1 1/2 tsp twice daily) and topical (twice daily) MSM for one year. After approximately four weeks, JC reported improvements in her pain level. Eight months after initiating therapy, she reported "doing well," with pain reduction lasting beyond one year of treatment.

TC, 46-year-old male

TC reported having OA-type pain in his hands bilaterally since he was in his early twenties. He had difficulty achieving success with medication, natural or otherwise, as he was very sensitive and could not tolerate them. This turned out to be true of MSM as well. We have rarely seen a patient who does not tolerate oral MSM, but it has occurred on a few occasions. Fortunately, other routes of administration are viable. In TC's case, we provided MSM gel for topical application, approximately 120 cc every six weeks. He continued treatment for three years, reporting good relief of symptoms.

LD, 58-year-old male

LD had generalized OA, severe headaches and fatigue, and bronchial asthma. He came for treatment of his OA but found that, after two months of treatment (1 1/2 tsp of oral MSM liquid twice daily), his OA and asthma symptoms were both approximately 50% improved. He also noted significant improvements in his energy level, reporting less fatigue and more ability to concentrate in his daily activities. LD continued to report improvements over the next year of treatment.

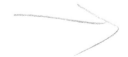

BD, 65-year-old female

BD had a three-year history of bilateral knee OA that interfered with her ability to walk and climb stairs. She also had a secondary complaint (not revealed until a future visit) of allergic asthma. We began treatment with our usual regimen of $1^1/2$ tsp BID of MSM liquid and twice-daily applications of MSM gel. On her first return visit, four months later, she reported "good pain relief" and increased joint mobility. After doing well on this regimen for a little more than a year, she began to lapse in her application of the topical MSM gel. She soon found that her knees were becoming stiff again. After resuming the gel applications, BD's mobility and pain levels were again improved.

NK, 85-year-old male

NK presented to our clinic with generalized OA symptoms that had given him discomfort for more than two years. NK achieved "good" pain relief for about a year using a regimen of 1 tsp per day of oral MSM liquid. After one year of treatment, NK was satisfied and reported "feeling well," but he wanted to see if he could improve his response to MSM by adding topical gel to his program. We also recommended at that time that he double his oral dose. He noticed the benefits of these changes to his regimen within just a few days. He did "very well" on this program for the two years we saw him. We believe his results might have been even better had he used more topical gel.

EK, 66-year-old male

EK presented to our clinic with OA of the neck and right shoulder of more than two years' duration. We supplied him with oral MSM liquid and recommended the typical dose of $1^1/2$ tsp twice daily. We did not hear from him again until one year later. He related that his response to MSM had been very quick and that his symptoms were much improved. EK continued to do very well for nearly two years. Shortly after running out of his supply, he experienced an exacerbation, which was quickly alleviated by resuming oral MSM.

MK, 71-year-old female

MK had severe OA of her left knee, with bone-on-bone crepitus and occasional incapacitating pain. She had to keep the knee immobilized with an elastic brace most hours of the day. Physical examination of the knee revealed significant swelling, stiffness, and tenderness. Her orthopedist recommended knee replacement surgery. We gave her oral MSM liquid (1 1/2 tsp BID) and topical MSM gel (to apply as needed) and observed a dramatic response. Within two days, her knee pain was so much improved that she no longer required the elastic brace. MK continued to improve over the following weeks and, to date, has given us no indication of plans for surgery.

RL, 68-year-old male

RL came to us with OA of the neck and hands that had given him trouble for the preceding year. We started him on the usual regimen of oral and topical MSM. After three weeks of therapy, he reported feeling "A-plus." RL responded very well to oral MSM liquid, but did not find the topical gel to be of benefit. He discontinued the topical MSM and maintained good results with the oral preparation.

ML, 83-year-old female

ML had degenerative OA of the right knee, which had caused her significant pain for more than three years. She was able to partially control her pain with sulindac, a nonsteroidal anti-inflammatory drug, but she wanted to discontinue the sulindac because of concerns regarding adverse effects and potential drug interactions. Her rheumatologist identified her as a candidate for knee replacement surgery. ML began therapy with a combination of oral, liquid MSM (1 1/2 tsp BID) and topical MSM (applied as needed). After two months of taking MSM regularly, ML reported doing well, with "very little pain." At the six-month mark, her knee pain was under moderately good control. She was able to maintain good pain relief and avoid surgery for as long as we followed her.

DOSAGE NOTES

We have found that OA patients tend to do best with 6–8 grams of MSM per day. Patients may begin with 2 grams per day. Stiffness may not respond to this dose, but improvement may still be achieved increased by increasing the dose gradually (i.e., 1–2 additional grams each week until a clinical benefit is achieved). Treatment needs to be engaged over the long-term. With extensive involvement of the larger joints, we have observed graded, dose-dependent improvements with amounts up to 16–20 grams MSM per day.

COMBINING MSM WITH GLUCOSAMINE OR CHONDROITIN SULFATES

We have recommended the combination of MSM and glucosamine sulfate (GS) to approximately two dozen patients. In general, reports from these patients were positive (i.e., less pain, more mobility). In my experience, MSM is more effective than either GS or chondroitin sulfate (CS) alone for severe cases of OA. Many supplement manufacturers add MSM to joint formulas containing glucosamine and/or chondroitin sulfates on the assumption that there are synergistic relationships among the supplements. We are aware that the research supporting GS and CS is extensive, and that there have been no controlled trials comparing MSM with either of these agents, or evaluating whether combinations work better than any of the supplements alone. We have not observed any synergy from combining MSM with chondroitin sulfate.

A PRELIMINARY DOUBLE-BLIND TRIAL: PUBLISHED DATA

At the time of this writing, only one double-blind trial of MSM for OA has been reported. In 1998, correspondence from Ronald M. Lawrence, Ph.D., M.D. appeared in the first and only issue of the *International Journal of Anti-Aging Medicine*.[113] In this abstract, Lawrence presented data on a "preliminary study" in which patients suffering from degenerative arthritis were treated with either 2,250 mg per day of MSM (Adaptin, no manufacturer

specified) or placebo for an unspecified length of time. Sixteen patients were reportedly enrolled in the study. Eight received MSM and six received placebo. The author does not indicate what treatment, if any, was administered to the two remaining patients. Lawrence reported "a better than 80 percent control of pain within six weeks of beginning the study." The title of the abstract indicates that a double-blind protocol was followed.

A PRELIMINARY DOUBLE-BLIND TRIAL: UNPUBLISHED DATA

One manufacturer of MSM has claimed responsibility for sponsoring the abovementioned study and has made more detailed information about the study available to the public on its website. This report,[114] which goes by a slightly different name and has minor differences in the abstract (i.e., word inversions, change of product name) is clearly intended to represent and expand upon the data presented in the published abstract; these additional data have not been published in any journal nor have they been subject to peer review. The expanded iteration of the Lawrence abstract adds important, if unverified, data about materials, methods, criteria for selection and analysis of results used in the trial. The material is identified as crystalline MSM (Lignisul™, Carolwood Corporation, Greenwood, PA), not "Adaptin" as in the published abstract, and the placebo is listed as a sucrose/quinine combination. The length of treatment was four months. The material was encapsulated in 750 mg gelatin capsules. In this iteration, ten patients reportedly received MSM, in contrast to the published abstract which reported that number as eight. A discrepancy in reported sample size raises obvious concerns regarding the soundness of the data.

The dose was 2,250 mg of MSM or placebo per day, two capsules taken on arising in the morning and one capsule taken before lunch. Randomization was by lot. The patients and attending physicians were blinded to treatment allocation until the conclusion of the study. No allocation concealment procedures were described.

The participants were between 55 and 78 years of age. All reportedly had x-ray evidence of degenerative joint disease and symptoms of pain lasting for at least four weeks prior to the beginning of the study. No

further diagnostic criteria were provided. Most patients had reportedly tried NSAIDs but none had a history of corticosteroid use. No case histories or further patient data were provided. There was a three-day washout period for NSAIDs, analgesics, and anti-inflammatory drugs prior to the beginning of the regimen.

Assessment of treatment effect was performed at the four-week and six-week visits. Pain was measured on a visual analog scale (VAS), which consisted of a 10 cm line labeled "no pain" at one end and "pain as bad as it could possibly be" at the other. Patients were instructed to mark a place on the line indicating the intensity of their pain. Position of the line was quantified on a 0–100 scale.

At the four-week and six-week visits, patients taking MSM reportedly showed a 60% and 82% improvement on VAS scores, respectively. VAS scores of patients taking placebo reportedly improved an average of 20% at week 4 and 18% at week 6. No description of statistical methods was provided. No evaluations were reported after the sixth week of this 24-week (four-month) study.

There has been, to our knowledge, no follow-up or formal publication in the years since the preliminary report appeared. Well-designed double-blind trials are necessary to confirm these preliminary observations.

8

Rheumatoid Arthritis

Rheumatoid arthritis (RA) is a multi-system, chronic, relapsing inflammatory syndrome, with a particular and damaging affinity for the synovial membranes of the joints. RA is essentially a severe form of chronic synovitis, characterized by symmetrical inflammation and sometimes resulting in progressive destruction and ankylosis of articular and peri-articular structures. The disease affects approximately 1 to 3% of the U.S. population; women are affected about three times as often as men. RA may occur at any age, but it is more commonly diagnosed in people between the ages of 20 and 50.

The most widely held view is that RA is an autoimmune disease. What triggers the autoimmune response is largely unknown. Speculation has centered on genetic susceptibility, abnormal intestinal permeability, lifestyle and nutritional factors, food allergies, and microorganisms. The histocompatibility antigen HLA-DRw4 is found in about 70% of patients with RA. This may have important ramifications on immune function in RA patients. Severe RA is four times more likely in first-degree relatives of patients with seropositive disease. These genetic associations are not

absolute, and development of the disease, even in genetically predisposed individuals, may be triggered by environmental factors.

Individuals with RA often have increased intestinal permeability to dietary and bacterial antigens. Food allergies, NSAID use and numerous other factors may cause a pathologic increase in intestinal permeability. Increased permeability to gut-derived antigens may increase the levels of circulating endotoxins and immune complexes seen in RA patients. Protein components of pathologically absorbed antigens may resemble protein components in joint tissues, thus stimulating immune cross-reactivity and autoimmune damage to joints. New research in press at the time of this writing suggests that an autoimmune reaction against the carbohydrate portion of glycosaminoglycans may be involved in causing RA.

About 70 to 80% of RA patients have a positive test for rheumatoid factor (RF). This circulating autoantibody forms immune complexes, usually with IgG. The presence of such immune complexes in the joint spaces activates complement, with subsequent formation of powerful chemotactic factors. An accumulation of neutrophils follows, with colonization by lymphocytes and plasma cells. Cell-mediated immunity is also activated in RA. The interface between the cartilage and the proliferating synovial membrane (i.e., pannus, with its many inflammatory cells) is the site of the most active joint destruction. The pannus may erode cartilage, subchondral bone, articular capsule, and ligaments. Subcutaneous rheumatoid nodules are seen in 30 to 40% of patients, but this is a late sign.

To be diagnosed with RA, a patient needs to have four or more of the following symptoms, and the first four symptoms must have been present for six weeks or more: Morning stiffness lasting at least 30 minutes; arthritis in three or more joints; arthritis of hand joints (wrist, MCP or PIP); symmetric arthritis; rheumatoid nodules; positive RF; and radiographic changes.[115]

Onset of RA may be abrupt or insidious, with progressive joint involvement. Tenderness is seen in nearly all "active" (inflamed) joints. The most active joints eventually develop synovial thickening, with a concomitant loss in range of motion. Symmetric involvement is typical, particularly of small hand joints (i.e., proximal interphalangeal and metacarpophalangeal joints), foot joints (metatarsophalangeal joints), wrists, elbows, and ankles.

A helpful rule of thumb in differentiating RA from osteoarthritis is that RA spares the distal interphalangeal joints. Morning stiffness usually lasts more than an hour or may commonly occur after prolonged inactivity. Early afternoon fatigue and malaise are also common.

Flexion contractures may develop rapidly in RA patients. As the disease progresses, the joints become deformed: The fingers deviate in an ulnar direction with slippage of the extensor tendons from the MCP joints. Wrist synovitis can cause a secondary carpal tunnel syndrome. Extra-articular manifestations of RA include visceral nodules, vasculitis, pleural or pericardial effusions, lymphadenopathy, Sjögren's syndrome, and episcleritis. Low-grade fever may also be present. About 5% of RA patients are under 16 years of age and have the juvenile form of the disease. Juvenile RA (JRA) differs from adult RA in several respects: It is more often preceded by a fever; fewer joints are typically involved (about one third of JRA patients have only one or two joints involved, usually the knees or ankles); generalized lymphadenopathy and hepatosplenomegaly are more prominent; and RF is not usually positive.

Laboratory studies can support a diagnosis of RA, but they are not definitive. Usually there is a mild anemia and an elevated erythrocyte sedimentation rate (ESR). RF seropositivity occurs in about 80% of patients. However, a significant number of RA patients lack a positive RF; moreover, RF is positive in about 5% of normal individuals. Synovial fluid analysis can support but not establish a diagnosis; the fluid is characteristically cloudy and sterile, with reduced viscosity and leukocytosis.

Many drugs are commonly used to reduce pain and slow the progression of RA. These include NSAIDs (e.g., indomethacin, nabumetone, naproxen sodium, oxaprozin), disease-modifying anti-rheumatic drugs (e.g., methotrexate, hydroxychloroquine, sulfasalazine, oral corticosteroids), chelating agents (e.g., penicillamine), and cytotoxic agents (e.g., azathioprine, cyclophosphamide, cyclosporine).[116] The adverse effect of cytotoxic agents is well known. As discussed in Chapter 7, chronic NSAID use may suppress repair of cartilage. Of additional concern for RA patients is the finding that chronic NSAID use may cause or contribute to gastroduodenal inflammation and increased intestinal permeability, thus increasing the long-term risks of disease relapse and exacerbation.

MSM FOR RA: EXPERIMENTAL EVIDENCE

In 1985, Jane I. Morton and Richard D. Moore of Oregon Health & Sciences University (OHSU) studied the role of MSM and DMSO in experimental rheumatoid arthritis.[117] The MRL/1pr strain of mice had been identified as a model for the spontaneous development of rheumatoid arthritis-like joint lesions. These mice live only about five months. In the study, which began when the mice were two months of age, 18 were given water to drink *ad libitum*, and 14 received water with 3% MSM *ad libitum*. The mice received this protocol until they were 4 to 5 months old. Knee joint examination revealed proliferation of synovial lining cells in all control animals and in only 71% of the MSM-treated mice. However, the degree of proliferation was less marked in the experimental group.

More impressive was the effect of MSM on inflammation. Ninety-five percent of the control animals had an inflammatory reaction of the synovial tissues, compared with only 50% of the MSM-treated animals. The degree of inflammation was also judged to be less severe in the MSM-treated group. Pannus formation was present in 50% of controls but only in 14% of MSM-treated mice. Pannus was usually minimal in the animals receiving treatment. DMSO performed similarly, but its effects were less pronounced than those of MSM in this study. The decreases in inflammatory joint disease observed with MSM treatment in this study are consistent with previously reported decreases in autoantibody titers and abnormal T cell proliferation in similar animals; moreover, they are consistent with the clinical effects of MSM we have seen in RA patients at OHSU.

MSM FOR RA: CLINICAL EVIDENCE

I have used MSM for both the adult and juvenile forms of rheumatoid arthritis with good, sometimes dramatic results. Common results from combined intravenous, oral, and topical application of MSM include generalized reduction of pain and inflammation, ability to reduce analgesic and anti-inflammatory medications, normalization of ESR in about 20% of patients, reversion of rheumatoid factor (RF) test from positive to negative

in about half of patients, reduction of ulnar deviation and flexion contractures of the fingers, reduction in the size of rheumatoid nodules, and less joint stiffness and disability. If a patient begins MSM treatment in the early stages of RA, I believe some joint deterioration can be prevented.

The oral doses of MSM needed to effectively manage RA are often high (some patients take as much as 240 ml per day of 15% MSM solution—equivalent to 34 grams of MSM per day). However, such high doses seldom need to be maintained for more than a month or two. Patients are usually able to titrate down to one quarter this amount while managing symptoms. However, even the large doses are well tolerated. We have had occasional reports of mild gastrointestinal upset with high amounts of oral MSM alone or oral MSM combined with IV MSM.

In addition to IV and oral MSM, I have found topical MSM to be efficacious in the treatment of RA. The best results are obtained when the patient combines topical MSM with heat for at least 30 minutes per application. In my experience, topical MSM with heat can reduce the size and tenderness of rheumatoid nodules.

SE, 47-year-old male

This was the first case of RA that I treated with MSM. SE, an attorney from Mississippi, had severe RA that required six joint replacement surgeries (hips, knees, and shoulders bilaterally). He required large doses of prednisone to control pain and inflammation. The patient demonstrated corticosteroid toxicity, cortisone facies, and early stages of diabetes. His illness was progressive.

SE came to our clinic for two weeks of IV MSM therapy (five treatments per week; protocol described at the end of the chapter). He then returned to Mississippi and worked his way up to an intensive oral regimen of 8 ounces MSM liquid per day in four divided doses. After 14 years, the patient maintains a normal sedimentation rate, his RF has returned to normal, and he is off prednisone. SE has been taking oral MSM for 14 years and has not required prednisone again. I have never seen an RA patient this ill, and yet not demonstrating typical RA changes in his hands. This is an unusual outcome with RA of this severity.

His disease is not in complete remission, but he remains active, seeing an average of 14 clients per day.

LN, 2-year-old female

The patient was first treated in 1996. The girl's mother provided the medical history. LN had recently fallen, landing hard on her left knee. The joint immediately became erythematous, hot, and swollen. The inflammation persisted for three days. The patient was taken to the family physician, who prescribed an anti-inflammatory analgesic. The drug did not effectively control the pain or inflammation, and her mother reported that LN was crying more and more. The girl reportedly stopped walking and began to crawl again. She refused to eat.

LN's pediatrician ordered tests of the ESR and RF. The ESR was five to six times higher than normal, and the RF was positive, establishing her diagnosis of JRA. The mother took her to a rheumatologist, who prescribed naproxen and ibuprofen.

JRA affects girls more frequently than boys and increases the risk of chronic bilateral iridocyclitis. This form of uveitis is usually painless but can damage vision. The patient visited an ophthalmologist every two months, who documented some progressive loss of peripheral vision.

Prednisone offered some relief, but adverse effects (i.e., bloating, knee and ankle swelling, weight gain) were found to be unacceptable. The rheumatologist recommended gold shots or methotrexate as a next step. Her parents declined. They were advised that their daughter's case was so severe that she would likely become disabled and live life confined to a wheelchair. They then tried several alternative therapies—hyperbaric oxygen, homeopathy, acupuncture, and several others—with no apparent benefit.

LN presented to our clinic with the RA symptoms described above, impaired growth (secondary to corticosteroid therapy), osteoporosis (also from the corticosteroids), and loss of peripheral vision. We started her on oral MSM (up to 4 ounces of a 15% solution per day, mixed in additional water) and topical MSM gel applied several times daily.

LN's response to MSM therapy was dramatic. Over a period of six months, her RA symptoms subsided. She was able to discontinue pred-

nisone. She gradually regained her peripheral vision and normal stature. She is now in a complete remission.

I believe that MSM (combined oral and topical) is the optimal treatment for JRA. I have had about 20 such patients, and the effects of MSM are, in my opinion, superior to any other therapy I have seen. MSM also has the advantage of being essentially free of serious side effects, which cannot be said of the conventional treatments for rheumatoid arthritis (corticos-teroids, methotrexate, gold shots, etc.). In some patients we used 4 oz. of 15% MSM liquid per day (i.e., 17 grams of MSM per day). That is a large dose for a 2- or 3-year-old child, but the effects were excellent. Parents give liquid MSM to children in milk, juice or additional water.

TE, 36-year-old female

This patient came to our clinic from California; she had been diag-nosed with the juvenile form of RA at the age of 18. TE had had 28 oper-ative procedures, including joint replacements and finger corrections. Her hips and left knee were the areas of primary concern to her. Walking was painful (she had to use a crutch) and she complained of intense general-ized pain and rheumatoid nodules. Her laboratory work indicated that she was RF-positive and her ESR was very high. She was taking ibuprofen (600 mg BID) for pain.

We initiated therapy with a series of five intravenous MSM treat-ments, according to our protocol (see below). In addition, TE began taking high doses of oral MSM (240 ml of 15% solution per day, or 34 g of MSM) and applying topical gel as needed. Within two days of beginning treatment, she was able to walk "without discomfort." She returned home after one week and continued to take the oral and topical MSM as before. Within two months, she had reduced her MSM dose to 60 ml (providing 8.5 g of MSM) per day. At the three-month mark, she was tested again for RF and ESR; the ESR had returned to normal, and she was now RF-negative.

Around this time, TE wrote two separate letters to our clinic, each describing her success in treating rheumatoid nodules with topical MSM and heat. The first letter, written two months after initiating treatment,

described a nodule on her right forearm as "huge." After one week's application of MSM gel with heat, the patient reported that it "reduced quite dramatically in size! The heat…makes a big difference." A month later, she reported that another nodule near her right elbow, this one the size of a golf ball, was gone after using topical MSM with heat for a week. Seven months after beginning treatment, TE reported that she was in "relative remission." She continues to take MSM and has been in long-term remission for three years at the time of this writing.

MSM rheumatoid arthritis protocol

Intravenous administration of MSM is the preferred route of administration for rheumatoid arthritis. For acute inflammatory conditions or a patient in extreme pain, we administer 7.5% MSM intravenously (250 mg/kg body weight in 5% dextrose solution infused over 15 minutes). The usual regimen is five treatments per week, plus oral MSM (15% solution; $1^{1}/_{2}$ tsp twice daily, providing approximately 2 g MSM daily) and topical MSM gel (15% MSM) applied several times per day.

9

Chronic Pain
Syndromes

Pain relief may be the most important application for MSM. Reduction of inflammation and inhibition of pain impulses are the likely mechanisms of action. MSM has a wide variety of applications, particularly for various forms of arthralgia (i.e., rheumatoid arthritis and osteoarthritis), low-back pain, soft-tissue damage, occupational and sports injuries, fibromyalgia, and dental discomfort. Some of these clinical entities are discussed elsewhere in the book. We have observed that MSM ameliorates muscle cramps, particularly in geriatric patients who experience such cramps at night after long periods of inactivity, and leg cramps in premier athletes during participation in their sport.

We have found that MSM supplementation can reduce or obviate the need for over-the-counter and prescription painkillers, including the widely dispensed NSAIDs. Reducing the use of these drugs can yield important health dividends by lessening the risk of intestinal permeability defects, inhibition of cartilage synthesis, and kidney and liver disease.

Alternative medicine—especially use of dietary supplements such as MSM—is an area of intense interest for patients in their quest to overcome chronic pain. Health professionals need to be knowledgeable about alternative modalities to relieve pain. In 1998, a Stanford University study found that approximately 40% of Americans used an alternative health treatment in the previous year.[118] Pain was the most oft-cited condition for which health consumers sought alternative remedies.

Most of the information I have compiled on the use of MSM for pain relief is based on my work with thousands of patients at the DMSO-MSM clinic at OHSU. To date, I have not completed controlled studies, so my clinical reports are anecdotal in nature. However, observation is the beginning of all scientific inquiry. Compelling reasons can be found to utilize MSM for pain relief, especially when the relative safety of the natural compound is compared and contrasted with the more commonly used drugs.

HOW MSM BENEFITS PAIN PATIENTS

What is the mechanism for pain reduction by MSM? MSM has not undergone the kind of rigorously controlled scientific trials needed to validate the clinical effects we have observed. However, some of my earlier work on DMSO sheds light on the mechanisms by which MSM possibly acts.

Based on a review of the scientific literature and experience with both compounds, I believe that the following similarities between DMSO and MSM may account for MSM's ability to ameliorate pain:

- **Inhibition of pain impulse transmission.** In a 1993 report in *Neuroscience Letters*, researchers found that even very low amounts of DMSO are able to block or slow the transmission of pain impulses.[119] DMSO reduced C fiber nerve conduction velocity and increased the period of response latency, an effect that was reversed when DMSO was withdrawn. The mechanism of the conduction block induced by DMSO is unclear, but may involve a potassium channel blockade. Mayer and Avi-Dor have suggested that DMSO can change the state

of hydration of the potassium ion, which might alter its ability to penetrate ion channels.[120] The body's C fibers seem to be a primary route for the conduction of pain impulses. DMSO may act both locally and systemically. Blockade of C-fibers has not been studied using an MSM model.

- **Anti-inflammatory action.** Inflammation is a source of chronic pain in many diseases, including rheumatoid arthritis, post-surgical trauma, and sports injuries. Several studies have demonstrated anti-inflammatory actions of DMSO.[121] Similar actions of MSM may be a key to its ability to relieve chronic pain.

- **Dilation of blood vessels and enhanced blood supply.** DMSO improves blood flow to bodily tissues. This may also be a key to its long-term benefits. DMSO appears to facilitate oxygenation of tissues and nutrient supply to sites of injury, scarring, and inflammation. We have observed similar vasodilation in patients applying topical MSM.

- **Reduced muscle spasm.** Pain is closely interwoven with muscle spasm. DMSO applied topically to the skin of patients produces electromyographic evidence of muscle relaxation one hour after application.[122] The ability of MSM to reduce such spasms is another key to its pain-relieving properties.

In a study of 37 patients with intractable pain problems,[123] Drs. William M. Rosenbaum, Edward E. Rosenbaum, and I found that periods of pain relief following application of DMSO became progressively longer and the dosage of DMSO required to maintain pain relief gradually diminished. In our surgical department at the University of Oregon Medical School (now OHSU), we studied the effects of DMSO in the treatment of intractable pain arising from several clinical entities, including phantom limb pain in post-amputation patients (n=11), tic douloureux (n=11), posttraumatic pain (n=10), and postoperative pain (n=5). Intractable pain was defined in the study as persistent pain despite one year or more of conventional therapy. One significant feature of DMSO treatment was that patients were frequently able to discontinue drugs they had taken for years and to sleep soundly without being repeatedly awakened by pain.

CLINICAL REPORT: ANALGESIC PROPERTIES OF MSM

In an unpublished study performed at our clinic at OHSU, eight patients suffering from intractable pain were given MSM orally in the amounts and for the period of time set forth in the table below.

Overall, the patients reported their use of MSM alleviated much of their pain. This study included patients with osteoarthritis, rheumatoid arthritis, low-back pain, tendinitis, bursitis, and pain from multiple sclerosis.

Methylsulfonylmethane Pain Results: A Clinical Study					
Patient	Age	Sex	Diagnosis	Administration	Results
PA	61	F	OA	1 g QID 19 months	Pain relief*
BA	63	F	OA	0.25 g QID duration of use not known	Pain relief
CA	62	M	Bursitis	0.25 g BID 3 months	50% pain relief
MA	55	F	RA	0.25 g BID 9 months	Pain relief
AB	69	F	OA	0.5 g BID 18 months	Pain relief
NB	62	M	Tendinitis	0.25 g QID	Reduced pain
DB	35	M	Low back pain	0.5 g QID 9 months	Pain relief
IB	62	F	Multiple sclerosis	0.5 g BID 18 months	Muscle pain reduction

* "Pain relief" here means complete or nearly complete pain relief.
OA = Osteoarthritis RA = Rheumatoid Arthritis

JH, 47-year-old male

Codeine is one of the most common pain-relieving agents doctors prescribe for their patients. At my OHSU clinic, we compared MSM with codeine for the control of pain in a male subject who awakened one morn-

ing with excruciating pain in the mid-thoracic region, so intense it was difficult to pinpoint the specific location. The patient had a history of urinary calculi. Aspirin was ineffective but codeine provided acceptable relief during and after X-ray evaluations. Analgesic requirements were 30 mg of aspirin with codeine every two hours. Throughout day 2, the patient complained of mental confusion and codeine was withdrawn. The intense pain returned. We administered 1.5 g of MSM dissolved in a half-filled glass of warm water. About 30 minutes after taking the MSM, the pain had essentially disappeared. We continued MSM (1.5 grams QD) until the afternoon of the third day, when X-rays confirmed that urinary calculi were obstructing the ureter. The patient was switched again to codeine (60 mg every four hours) with aspirin (30 mg every two hours). He reported less pain relief than was provided by MSM. Thereafter, MSM was again administered (1.5 grams every four hours). On the fifth day, several calculi passed. Recovery was uneventful, and required no codeine, MSM, or urinary tract antimicrobial agent.

MR, 26-year-old female

In a second patient, codeine and MSM were compared for the relief of pain in a 26-year old female who had sharp spasms of pain in the left lower quadrant of the abdomen. The patient's appendix had been previously removed. Her pain began after suffering an accidental traumatic blow to the abdomen during a volleyball game. A pyelogram revealed no ureteral obstruction. The pain pattern suggested ureteral spasm. Codeine (60 mg) and 15 mg of aspirin were given every four hours. These provided some relief. The codeine-aspirin regimen was discontinued; instead, 1 gram of MSM powder mixed in warm water was administered. Thirty minutes later, discomfort had ceased. A second gram of MSM in water was given four hours later, after which the subject continued pain free. No further treatment was required.

Low back pain

With back pain, the patient may experience intense muscle spasm, inflammation, connective tissue adhesions, diminished blood supply, and

radiating pain. Our experience shows that each of these low back pain symptoms responds well to MSM. It may be worthwhile to have patients try MSM before recommending back surgery. Even though I am a general surgeon, I rarely recommend surgery for low back pain.

While approximately 500,000 back surgeries are performed each year in the United States, some experts estimate that 95 to 98% of people with back pain do not require surgery. Patients who undergo multiple surgeries are frequently worse off than when they began. I have seen patients who have had multiple laminectomies and spinal fusion, who often have more pain than when they began seeking medical help. For these patients, I provide a combination of oral and topical MSM. After a few months, they frequently feel better than they have felt in years. I have observed a 60 to 70% efficacy rate in treating low back pain with MSM.

In some cases, we have seen MSM eliminate the need for surgery, such as knee or hip replacement, or surgery for low back pain. Even when MSM cannot eliminate the need for surgery, a high percentage of patients can delay the need for surgical correction for a few years. Occasionally, we find patients with chronic pain experience relief within just a few days.

The use of MSM doesn't usually produce instant pain relief; I advise patients that pain relief with MSM can take weeks or months. In some cases, the pain may have subsided without therapy. However, many of my patients suffered intense pain for months or years, with no relief from a variety of other therapeutants. Thus, I believe that the pain reductions I have observed were not due to chance or to the placebo effect.

In my experience, MSM therapy produces relief for most types of chronic pain in about 70% of cases. Whether relief is fast or slow, MSM has the potential to make a significant and positive impact on the quality of life for many people in pain.

Many health professionals and patients have asked whether MSM supplementation needs to be continued to maintain effective relief of pain. No single answer is appropriate for all patients. Some of my patients obtained lasting pain relief and were able to discontinue MSM. More often, however, the use of MSM must be continued for longer periods, sometimes indefinitely. Patients frequently report that effective pain relief from MSM

requires daily supplementation; when they stop using it the pain returns, and remits again when they recommence MSM therapy.

Initial pain relief may be achieved with a relatively small intake of MSM, approximately 5 grams per day. For consistent and more complete pain relief, the dosage required may be much greater. However, while taking 30 grams daily poses no risk for serious side effects, patients do need to work up to this amount to avoid gastrointestinal upset. When patients are taking this much MSM, they should increase their dose gradually and take the MSM in at least three divided doses throughout the day, with meals.

Although 30 grams daily may seem like a large dosage of MSM (particularly in tablets or capsules), this dosage may be easily achieved using MSM powder. I would rather see a patient employ a large dose of MSM than experience a lifetime of dependency on OTC or prescription analgesics.

After many years of using both MSM and DMSO, it is clear that DMSO is a more powerful analgesic than MSM, but MSM is more acceptable to patients since it produces neither skin irritation when applied topically, nor the fish-like or garlicky odor that results when DMSO is taken orally.

10

Repetitive Stress Injuries and Inflammation

Repetitive stress injuries, particularly carpal tunnel syndrome, are the fastest growing type of occupational injury. According to the Bureau of Labor Statistics, over 5 million workers are injured on the job each year. Disorders associated with repeated trauma are by far the most significant cause of nonfatal occupational illness in industry. Moreover, these figures only represent reported cases from tracked businesses; the number of unreported cases is likely to be quite high.

CARPAL TUNNEL SYNDROME

Carpal tunnel syndrome (CTS) is caused by compression of the median nerve as it passes through the carpal tunnel in the wrist. It is very common and usually occurs in women aged 30 to 50 years. Causes include tenosynovitis, rheumatoid arthritis, diabetes, hypothyroidism, and pregnancy (which produces edema in the carpal tunnel). More commonly, however, activities or jobs that require repetitive flexion and extension of the wrist (e.g., computer keyboard use) are the causes of CTS. Many

occupations involve repetitive movements that increase the risk of developing CTS: farm work, office work, carpentry, construction, millwork, stonework, metalworking, assembly line work, light industry, and work with fabrics and textiles. Musicians and some athletes are particularly prone to developing CTS. In many cases, however, an underlying cause remains elusive.

Symptoms of CTS include pain in the hand and wrist associated with tingling and numbness distributed along the median nerve (the palmar side of the thumb, the index, and the radial half of the middle finger). Typically, the patient awakens at night with burning or aching pain and with numbness and tingling in the affected fingers. The patient may need to shake the hand to obtain relief and restore sensation. Thenar atrophy and weakness on thumb elevation may become evident later in the illness. Electrodiagnostic testing of median nerve conduction velocity is definitive, but usually unnecessary to establish a diagnosis. The symptoms of CTS are reproducible in the clinical setting using Phalen's* and percussion† tests.

Conventional treatment of CTS includes wrist splints, especially at night, and analgesics (e.g., acetaminophen, NSAIDs). Oral diuretic medications are sometimes recommended to reduce swelling. Some people find relief by changing the position of computer keyboards and making other ergonomic corrections. If these therapies fail to control symptoms, a corticosteroid may be locally injected into the carpal tunnel. Progressive hand weakness and thenar wasting are considered indications for surgical decompression of the carpal tunnel, although symptoms may recur even after these procedures. A few studies have found pyridoxine deficiency to be common in CTS patients. Pyridoxine supplementation has relieved CTS symptoms in some, but not all, clinical trials.[126-134]

* The patient rests the elbows on a flat surface, holds the forearms vertically, and actively places the wrists in complete and forced flexion for at least one minute. This maneuver moderately increases the pressure in the carpal tunnel and has the effect of pinching the median nerve between the proximal edge of the transverse carpal ligament and the anterior border of the distal end of the radius.

† Direct, light percussion of the volar carpal ligament of the involved wrist will elicit Tinel's sign, a tingling or shock-like sensation in the fingers supplied by the median nerve.

I have treated several hundred CTS patients with MSM and estimate that approximately 70% have been helped enough to avoid surgery. Once they have had surgery, MSM appears to be less effective than if they had been treated nonsurgically. As a general surgeon, I have performed many surgical release procedures on the carpal tunnel. It is my conclusion that surgery should usually not be considered until conservative options have been exhausted. Follow-up from hundreds of carpal tunnel surgeries has made it clear to me that surgery predisposes to formation of excess scar tissue in a significant minority of patients, which may account for the high rate of postsurgical relapses. Some orthopedic surgeons want patients to think that cutting the carpal ligament is a minimally invasive procedure. My experience has shown that postsurgical scar tissue can produce more pain than the original CTS condition. In my opinion, surgery for CTS should be reserved as a last treatment option. MSM helps CTS by reducing inflammation, pain, and scarring.

PF, 45-year-old male

PF, a public relations employee, was in his early 40s when he began to experience symptoms of CTS. He could not work for more than 15 minutes on his computer because his wrist pain would become too intense. We administered oral MSM (6 grams per day) and topical MSM, which significantly reduced his pain within eight weeks. He continues on oral and topical MSM after one year of therapy.

RM, female, age withheld

RM, a businesswomen, had a chief complaint of numbness in her hands, with a great deal of nighttime pain and aching forearms. I started her on one-half a level kitchen teaspoon (2.5 grams) of MSM powder twice a day in juice. The first effect RM noticed after beginning MSM was an increase in her energy level. Within approximately two months, she began to notice that the pain and numbness in her hands and soreness in her forearms had lessened, until the symptoms ultimately disappeared after six months of therapy.

TENDINITIS

The synovial-lined tendon sheath is usually the main site of inflammation, but the enclosed tendon may also be inflamed (e.g., as a result of a calcium deposit). The cause of tendinitis is often unknown. It usually occurs in middle-aged or older patients as the vascular supply to tendons lessens. Repetitive stress and overuse may cause microtrauma to the tendons and thus contribute to injury and inflammation. Strain and unaccustomed excessive exercise are the most frequent causes. Tendinitis is sometimes related to systemic diseases, such as rheumatoid arthritis, systemic sclerosis, gout, Reiter's syndrome, and diabetes.

The sites most commonly affected by tendinitis and tenosynovitis are the shoulder capsule and associated tendons (rotator cuff), wrist and finger flexors, hip capsule and associated tendons, hamstrings, and Achilles tendons. In de Quervain's disease, the abductor pollicis longus and extensor pollicis brevis, which share a common fibrous sheath, are affected. The involved tendons are usually painful on motion and palpation. Tendon sheaths may become edematous. Calcium deposits in the tendon and its sheath are occasionally seen on X-ray.[135]

TG, 25-year-old female

TG, a teacher, suffered an ankle injury four years prior to visiting our clinic. She had had two surgeries on her right Achilles tendon and developed chronic, right-sided Achilles tendinitis, with concomitant build-up of scar tissue. I prescribed $1^1/2$ teaspoons liquid oral MSM (15%) and topical MSM as needed. We also administered IV MSM on the first day of her treatment. She had another IV treatment five months later, by which time she had increased her oral MSM dose to 3 teaspoons BID (or 4.5 g MSM per day). TG's results were not satisfactory until she had been treated for seven months, at which time she finally began to experience improvement. After one year of treatment, she reported "doing well." We have found that complications from surgery can take a long time to heal, but they generally heal better with MSM treatment than without it.

TENNIS ELBOW (*LATERAL EPICONDYLITIS*)

Doctors first identified lateral epicondylitis more than 100 years ago. Today nearly half of all tennis players will suffer from this disorder at some point, but these athletes account for less than 5% of all cases, making the common name of this condition something of a misnomer. Lateral epicondylitis is an overuse syndrome caused by continued stress on the grasping muscles (extensor carpi radialis brevis and longus) and supination muscles (supinator longus and brevis) of the forearm, which originate on the lateral epicondyle of the elbow.

Pain typically first occurs in the extensor tendons when the wrist is extended against resistance (e.g., as in manual screw driving). Movements such as gripping, lifting, and carrying tend to cause pain. With continued stress, the muscles and tendons may even cause pain at rest. Progressive disease is marked by subperiosteal hemorrhage, periostitis, calcification, and spur formation on the lateral epicondyle. To reproduce the pain in a diagnostic examination, the fingers may be extended against resistance when the elbow is held straight. Pain occurs along the common extensor tendon.

Conventional treatment of lateral epicondylitis typically includes rest, ice, stretching, and strengthening exercises. Any activity that causes pain on extension or pronation of the wrist should be avoided. As healing progresses, exercises to strengthen the wrist extensors can be initiated.[136]

LC, Female, age withheld

LC, a gardener with chronic lateral epicondylitis, had received a series of physical therapy treatments without benefit. Oral and injected corticosteroids had also failed to provide any relief. We prescribed 2 teaspoons of oral MSM liquid (15%) twice daily (i.e., 3 g MSM per day) and topical MSM as needed. Within one month, LC had good pain relief, increased pain-free range of motion, and she was able to perform more physical activities associated with her work and leisure time. Overall, her result was very good; although the condition was not cured, she did obtain significant pain relief.

BURSITIS

Bursitis is an inflammation of the saclike cavities or potential cavities (bursae) that contain synovial fluid and which are located at sites where friction occurs, such as where tendons or muscles pass over bony prominences. Bursae minimize friction between moving parts and thus make normal, smooth movement of joints possible.

Bursitis most often occurs in the shoulder (subacromial or subdeltoid bursitis). There are many other, less common, forms of bursitis: miner's elbow is bursitis of the olecranon; housemaid's knee is inflammation of the prepatellar bursa; Achilles bursitis affects the retrocalcaneal bursa; and tailor's bottom or weaver's bottom is a form of ischial bursitis.

Bursitis may be caused by trauma, chronic overuse, inflammatory arthritis (e.g., gout, rheumatoid arthritis), or acute or chronic infection. Acute bursitis causes pain, localized tenderness, and limited range of motion. Swelling and erythema are common if the bursa is superficial. Crystal-induced bursitis and bursitis caused by bacterial inflammation are especially painful and inflamed. Chronic bursitis may ensue from repeated trauma or recurrent acute bouts of bursitis. As with tendinitis, acute symptoms often follow unaccustomed exercise or strain.

Histologic changes associated with bursitis include thickening and proliferation of the synovial lining. Chronically inflamed bursae may eventually develop adhesions, villi, and calcified deposits. Pain, swelling, and tenderness may lead to muscle atrophy and limited range of motion. Subacromial bursitis (also known as subdeltoid bursitis) presents with localized pain and tenderness of the shoulder, particularly on abduction of the arm.[137]

TB, 60-year-old female

TB was a nurse being treated for left-sided subacromial bursitis. She was given oral MSM (10 grams TID) and topical MSM (15% gel applied hourly). One hour after taking 10 grams orally, the patient reported reduced pain and increased range of motion of the left shoulder. She continued on the regimen for three days, at which time she was essentially

pain-free; TB had regained a full range of shoulder motion, and tenderness to palpation had disappeared. She was able to discontinue her MSM after three days of treatment.

ACUTE BURSITIS PROTOCOL

Some patients require 10 grams per day of MSM at the outset. This may cause some mild gastrointestinal upset due to a possible mild cholinesterase-inhibiting action of MSM. Acute bursitis requires a larger dose of oral MSM than do chronic conditions. In the acute phase of the condition, the dose should be increased to 10 grams of oral MSM BID to TID for three days.

Topical MSM gel (containing 15% MSM) can be applied to the affected area as often as every hour. This will be rapidly absorbed but will leave a slight white residue, which can be washed off with a warm wet cloth.

BJ, 40-year-old female

BJ had a two-year history of subdeltoid bursitis of the right shoulder. The patient presented with pain, localized tenderness, and limitation of motion of the right shoulder. She was treated with 15% MSM gel, applied four times daily; $2^1/2$ grams of oral MSM, taken twice daily in liquid; and once-weekly intravenous infusions of 100 ml of 15% MSM admixed with 100 ml of 5% dextrose in sterile water to make a 7.5% solution of MSM. After three months of therapy, BJ had regained an almost complete range of motion of her shoulder without pain. She experienced no tenderness to palpation and was able to stop taking MSM.

CHRONIC BURSITIS PROTOCOL

MSM gel (15%), applied four times daily; $2^1/2$ grams of oral MSM, taken twice daily in liquid; and once-weekly intravenous infusions of 100 ml of 7.5% MSM are recommended for chronic bursitis.

11

Scleroderma

Systemic sclerosis is a multisystem disease characterized by diffuse fibrosis, degenerative changes, and vascular abnormalities in the skin (scleroderma), articular structures, and internal organs (especially the esophagus, the rest of the GI tract, lung, heart, and kidney).[138] Systemic sclerosis is often called scleroderma, because the skin manifestations are the most common elements of the disease. But the complications in the internal organs are the most devastating. In systemic sclerosis, the skin of the trunk is involved.

Scleroderma has only recently gained significant medical attention. Perhaps this is because it develops slowly and the onset is not usually dramatic, or because life-threatening complications were formerly thought to be uncommon. Scleroderma is also difficult to diagnose. Many cases in the past were not fully recognized, and physicians tended to treat only isolated symptoms. Finally, it may be because scleroderma is relatively rare—it affects about 500,000 people in the United States—and little research is being done. Fortunately, scleroderma has recently attracted major medical interest both among basic researchers and clinicians.

Perhaps it will also attract attention by researchers who are attuned to natural remedies.

I have been the medical director of the Scleroderma International Foundation (SIF) since 1970 and try to stay abreast of all treatments for this disease. The SIF was the first of the international scleroderma organizations, with 4,000 members from every state and six foreign countries. With almost 40 years of experience in treating scleroderma and over 800 patients who have come to my clinic at OHSU, I believe I have seen as many patients with various types of scleroderma as any other physician.

I started employing DMSO, because in 1963 we weren't using MSM, except insofar as the body converted DMSO into MSM. Penicillamine, methotrexate, cyclophosphamide, cortisone, and the like are, in my opinion, of no benefit. Apart from DMSO and MSM, I don't believe any other treatment among those currently available for scleroderma has any significant value. I have found nothing that helps in the treatment of internal organs—heart, lungs, kidneys, and esophagus—afflicted by this disease, except DMSO and MSM. Intravenous MSM is the most effective and best-tolerated therapy for scleroderma I have encountered.

Patients seeking this treatment usually came from outside the state. It is difficult for people to live in a hotel or other temporary residence and come in for IV treatment five days a week for six weeks. That's why I decided to try oral MSM with my patients. IV MSM is still my preferred route of administration, but I have seen efficacy with oral and topical MSM without IV infusions. The optimal treatment involves a combination of all three (see Scleroderma Protocol at the end of this chapter).

With IV MSM, I have seen some degree of improvement in about 80% of my patients with scleroderma. With oral and topical MSM, approximately 50% of them improve. While the results of oral and topical MSM in scleroderma patients can take several months or longer to appear, this treatment usually leads to 30% improvement in most patients. I especially see continued skin softening, improved mobility of the fingers, and lessening of body hair loss. The best results are achieved when patients first use IV MSM and then employ oral MSM to continue improvement.

Patients also report greatly increased energy, a "side effect" I have seen with MSM therapy for most of the conditions I have treated.

Patients with CREST syndrome have shown improvement on MSM therapy. CREST syndrome is a chronic variation of scleroderma characterized by calcium deposits, usually in the fingers; Raynaud's phenomenon (frequent spasms of the small arteries induced by cold and emotion, accompanied by color changes in the fingers and sometimes in the toes); loss of muscular control of the esophagus, which can cause difficulty in swallowing (dysphagia); sclerodactyly, a tapering deformity of the bones of the fingers; and telangiectasia (small red spots on the skin of the fingers, face, or inside of the mouth).

CLINICAL CASES

CM, 48-year-old female

CM was the first patient treated for scleroderma with MSM. The year was 1978. Our patients had already enjoyed excellent results with DMSO. Other physicians, including the late Arthur L. Scherbel, Chairman of the Departments of Rheumatic Diseases at the Cleveland Clinic Foundation, had extensively documented the benefits of DMSO. Dr. Scherbel had a female patient with severe systemic sclerosis. He had been treating her successfully with DMSO, but she stopped responding. He asked me what I would recommend.

I knew that the high dosages of DMSO required to improve CM's condition would involve significant drawbacks—namely, nausea and odor problems. We knew that about 15% of DMSO is converted endogenously to MSM. I suspected MSM might be useful in CM's case. She came to Oregon for treatment.

We administered IV MSM* for six weeks and then she returned to the Cleveland Clinic. Dr. Scherbel said he had never seen a scleroderma patient

* 15 g/d, five days per week. The solution was 100 cc of 15% MSM with deionized water, mixed into 100 cc of either saline or 5% dextrose in water, given over 15 minutes as a drip.

show such dramatic improvement in such a short time. CM's recovery so impressed him that he predicted MSM would prove to be the most important treatment for scleroderma ever known. I believe he was correct.

For CM, the degree of involvement of her internal organs had led to virtually complete closure of her esophagus. In order to eat, CM required monthly intervention with a metallic dilator to enlarge her esophagus, so that food could pass through to her stomach.

Cachexia is one of the profound consequences of advanced scleroderma with esophageal or gastrointestinal complications. Swallowing solid food is extremely difficult or impossible, and food that is ingested is poorly absorbed in the small intestine due to sclerotic changes in the intestinal mucosa.

I have observed a dose-response relationship with MSM in the treatment of systemic sclerosis and CREST syndrome: Patients obtain better results as you raise the dosage and lengthen the duration of treatment. We gave CM five IV infusions weekly for six consecutive weeks. Her esophagus started to open and she could once again eat some solid foods. Her other symptoms began to lessen. That was 24 years ago and she has not required any esophageal dilation since that time. She has been maintained on 10 grams per day of oral MSM.

JP, female, age withheld

JP, a hair stylist who lives in Virginia, came to our clinic severely ill. Her husband was in the military and she had access to some of the best hospitals in America. But no matter where she went—Walter Reed, Johns Hopkins, and Harvard—everyone said there was nothing to be done for her. She read about our work at OHSU and came to Portland, Oregon.

When JP visited the clinic, she could hardly move her hands; she could no longer work. Her skin was hardened, and I judged her prognosis to be poor. Her other doctors concurred. Due to the advanced nature of her sclerosis, JP could not swallow solid food. Like many scleroderma patients with advanced disease, her weight had dropped significantly (JP weighed only 70 pounds when I first began treating her.) I started her on DMSO

because it was the therapy we were employing at that time (this was prior to our work with CM). She also improved, and her improvement continued after she later switched from DMSO to MSM. We are happy to report she has been our patient now for more than 30 years.

Today, JP uses a combination of IV, oral, and topical MSM. She has raised a family, has a full schedule of activities, and she supervises 20 women at her salon. When she needs help, she has a personal nurse in Virginia who has been trained to administer MSM intravenously. JP maintains her quality of life and continues to take 20 grams of oral MSM per day.

DC, 42-year-old female

DC was diagnosed with scleroderma in 1996. She had previous diagnoses of fibromyalgia and Raynaud's phenomenon. She visited our clinic in late March 1998 complaining of dysphagia and weight loss, facial and neck tightness, an ulcer on her right elbow, and skin induration on both arms, across her abdomen and chest, and on her lateral thighs. She was unable to make a fist. Unlike most of my scleroderma patients, she did not complain of fatigue. However, she was no longer able to walk the four to six miles per day she normally walked for exercise. She was taking methotrexate, penicillamine, and nifedipine.

DC traveled to our clinic from her home in Arkansas. We gave her IV infusions of MSM for several days, along with 2 grams per day oral MSM in solution and a topical MSM gel to be applied as needed. She returned home to Arkansas and continued to take MSM orally and to receive IV MSM infusions twice weekly. She first began to report improvement in early May, just five weeks after initiating treatment. The main improvement was less tightness of the skin. After eight weeks of treatment, DC reported significantly less pain and was back to walking six miles per day. She remained on her other medications.

As of January 1999, her improvement had continued. Her skin became softer; she felt "well" and maintained good pain relief. At this point she was receiving one IV treatment per week, plus 2 grams oral MSM per day. By June, she had discontinued the penicillamine and reduced her dose of methotrexate (from 20 mg per day to 15 mg per day). Her pulmonary symptoms did not improve significantly, and her Raynaud's was still "act-

ing up." In my experience, MSM does not usually help the pulmonary manifestations of scleroderma, although some of patients note relief from their Raynaud's symptoms. After two years of treatment, the patient continued to report skin improvement, as well as regrowth of hair on her skin.

KN, 45-year-old female

I have seen a disproportionate number of scleroderma, systemic sclerosis, and CREST syndrome patients who were from northwestern Montana (KN is from Kalispell). I do not have an explanation for it, but every time my telephone's caller ID indicates that an incoming call is from the "406" area code, I say to myself, "That is another scleroderma patient or her doctor calling." I am often correct. There may be some environmental factor in Kalispell, Montana, or the surrounding region contributing to the pathogenesis of these cases. I am unaware of any population studies that have examined this regional phenomenon, but it is my opinion that such studies could provide valuable insight into these extremely disabling conditions.

KN was first seen in my clinic in 1992, having been diagnosed eight years earlier with CREST syndrome. She had been through all the conventional therapies for the syndrome (penicillamine, methotrexate, cyclophosphamide, cortisone) with no success. In my experience, these therapies are of no value for these patients. In this case, I believe KN was misdiagnosed. She had decreased pulmonary function, a sign of systemic sclerosis, not of CREST. She also suffered from pedal swelling, finger stiffness and numbness, Raynaud's phenomenon, dysphagia, and generalized musculoskeletal pain and stiffness.

We commenced with IV MSM treatments for five weeks (five treatments per week). After three weeks, KN reported improvement in her musculoskeletal pain. After five weeks of treatment, she returned to Montana, but received no more MSM. Her condition quickly deteriorated, so she returned the following week to our clinic for an IV treatment and assistance in securing access to IV treatment in Montana. She returned to Montana and followed our clinic's protocol (five IV MSM treatments per week, 1 tsp oral solution of 15% MSM twice daily, and topical gel).

Since being diagnosed with systemic sclerosis, KN had lost 16 pounds. Within ten weeks of treatment with MSM, she was able to swallow solid foods again, and had gained back 3 pounds. She also reported improved ability to breathe and less dyspnea. Although pulmonary symptoms do not usually improve with MSM therapy, in KN's case they did.

Eventually, KN moved with her husband to Portland to have closer access to our clinic. She did not want to stop the IV MSM so we had her continue long term on two IVs per week, plus oral and topical MSM. She has remained on this regimen until the present. KN is now almost free of musculoskeletal pain. She is able to eat a normal diet, and her skin is softer and the color is normal. Hair growth has returned, her energy has increased, and she is engaged in all the usual activities of daily living. MSM is not a cure for scleroderma, but KN's case reminds us of how much can be achieved with this safe, natural therapy.

From KN's testimonial:

"I have seen supposedly the best doctors in the U.S. I've been to the Mayo Clinic in Minneapolis, Sister Kennedy's, Seattle University, and also to Spokane's Deaconess Hospital. I had exhausted all of the doctors and clinics in the state of Montana, where we lived at the time.

"My heart and lungs were calcified, my esophagus had to be reopened three times, and I was having trouble with my stomach, bowels, and intestines. My hands and legs were so tight they didn't bend anymore. Hands so crippled up I couldn't bend my fingers well enough to button my clothes or fix a dinner; just holding a cup of coffee became a challenge. I slept maybe an hour or two out of twenty-four, and I soon learned all I had taken for granted was quickly being taken away. My kidneys and bowels were shutting down, and the doctors had given me three months to live, if I was lucky. [My doctors told me], "this is a terminal illness and you will die from it, there is nothing we can do for scleroderma, so accept it."

After beginning MSM treatment

"It was incredible! Daily I noticed very small changes, but progress. The pain wasn't so severe, and gradually my hands and back and legs

seemed to be a little more limber. When I got off the plane two weeks later, my husband and kids didn't recognize me. I could walk like a normal person again!! And excited beyond words. [Dr. Jacob] had given me hope, something that I had not had for a very long time. Dr. Jacob gave me back my life! After that I couldn't find a doctor in Montana to give me IVs...

"Yes, you're right, we sold everything we had and moved to Oregon, leaving my husband's job of 13 years and all of our family and friends. It took about a year, a very slow progression, but an uphill climb. Three IVs a week, plus the oral and topical. But, for the last two years, I am happy to say I've been put into remission! Not only has it helped the pain, (I still have about 20% left, reminding me that I still have this disease), but my hands now look normal and my face and skin looks healthy once again...

The calcification in my hands, heart, esophagus, and lungs are gone. All of the [CT] scans, and heart and lung tests are normal. The heart specialist told me if he hadn't read my chart, he wouldn't have believed I ever had scleroderma..."

SCLERODERMA (INTERSTITIAL LUNG DISEASE)

As I have said previously, in my experience, the pulmonary manifestations of scleroderma do not typically respond to MSM therapy. I did have one scleroderma patient, however, who achieved a 40% improvement on pulmonary function tests after MSM therapy. My colleagues have also reported cases in which MSM appeared to help the pulmonary manifestations of scleroderma. Elizabeth Hawruk, M.D., and Randy Krakauer, M.D., of St. Michael's Medical Center in Newark, New Jersey, reported on two patients with advanced progressive systemic sclerosis and significant interstitial lung disease.[139] They administered a total of three courses of IV MSM. Both patients had significant cutaneous ulceration, bony deformities in the hands and feet, periarticular calcifications, Raynaud's phenomenon, sclerodactyly, significant esophageal hypomobility, telangiectasia, and bowel hypomobility. In

addition, both were nonsmokers with significant restrictive lung disease, with FEF 25-75 of 2.71 and 0.68 respectively.

Patient #1 was a 44-year-old white female on penicillamine (750 mg daily for three months). Patient #2 was a 26-year-old white male on penicillamine therapy (100 mg per day) for eight months. Neither was taking steroids or other medications judged to have a possible effect on interstitial lung disease.

Both patients were given three courses of IV MSM at months 1, 3, and 5 (100 cc daily for 20 days). Vital signs, blood counts, chemistries, pulmonary function studies, T and B cell counts, T-4/T-8 cell count, and Helper cell functions were studied at bimonthly intervals. No significant changes were noted in blood counts or chemistries. Changes in immunologic phenomena were transient and not considered to be significant.

Both patients reported considerable improvement in subjective sense of well-being. This is thought not likely due to psychological factors, as it persisted for several months and had not been previously reported on other courses of medications. In addition, both showed improvement in FEF 25-75, with patient #1 going from 2.71 to 3.46 and patient #2 from 0.68 to 1.20. Both also showed improvement in diffusion of pulmonary gases, patient #1 from 9.0 to 11.5, and patient #2 from 4.8 to 5.1. The authors concluded that IV MSM might be beneficial in chronic fibrotic illnesses, including interstitial lung disease associated with scleroderma.

SCLERODERMA—MSM PROTOCOL

Our experience at OHSU leads us to conclude that intravenous, oral, and topical MSM help scleroderma—often better than the so-called drug of choice, D-penicillamine.

However, most of my colleagues are unfamiliar with the use of MSM for scleroderma. Less than 1% of scleroderma patients in the United States (there are approximately 500,000) are using MSM—in spite of its clinical efficacy and lack of harmful side effects (the most notable side effect of MSM is more frequent bowel movements). There has been little interest thus far in studying MSM as investigational new drug so that clin-

ical trials can begin. Nevertheless, I believe that as word about MSM reaches more physicians who see for themselves the beneficial results in their patients, its use will become more widespread and the knowledge level among doctors will increase.

Patients can begin treatment by using oral MSM (2–8 grams per day) and topical MSM (15% MSM gel BID to affected skin). Most patients increase the oral dosage to about 10 grams daily. MSM liquid may be given to some patients; it is useful for higher dosages. Have your patients increase gradually to higher dosages, keeping in mind that more frequent bowel movements may occur at higher dosages.

Dr. Scherbel did the first thorough study of DMSO for scleroderma.[140] We started working with scleroderma and DMSO in 1962. Dr. Scherbel was also president of the American Society of Clinical Investigators. We conducted a study using DMSO with 42 scleroderma patients who had already exhausted all other therapies without relief. Dr. Scherbel and his coworkers concluded 26 of the 42 showed good or excellent improvements. Histologic improvement was observed together with healing of ischemic ulcers on fingertips, relief from pain and stiffness, and an increase in strength. The investigators wrote, "[T]he results seen in treating patients with scleroderma with DMSO have never been observed with any other method of therapy." Researchers in other studies have since come to similar conclusions.[141]

I think MSM is more effective than DMSO for scleroderma. In my experience, there are three conditions for which MSM is clinically superior to DMSO: scleroderma, interstitial cystitis and relief from pollen allergy. With six weeks of IV MSM, many scleroderma patients can resume eating some solid foods.

We have treated almost every scleroderma patient with an initial six-week course of IV MSM (15 grams MSM per day, five days per week),* then maintained on oral and topical MSM thereafter. Continue with one to two IV treatments per week if possible.

* 100 cc of 15% MSM with deionized water mixed with 100 cc of either saline or 5% dextrose in water (to make a 7.5% concentration of MSM) given over 15 minutes in a drip.

With scleroderma, we have had excellent results using MSM. Most scleroderma patients will benefit to some extent. If a practitioner has no access to IV therapy, we recommend prescribing as much oral MSM as can be tolerated (liquid may be easier to dose in large quantities) . We also suggest topical MSM up to once every hour. It dries in two minutes, leaving a white residue that can be washed off with warm water. This residue does not harm clothing as does DMSO.

In my experience, about one in five scleroderma patients go into partial remission with MSM. Almost all scleroderma patients come in with major weight loss because they are unable to eat solid foods. They gain weight, and as you palpate the skin, it is softer. The color returns to normal, and hair growth returns. If these people have major involvement of the fingers, DMSO will not clear it. But many scleroderma patients reach the point with MSM treatment where they can have successful corrective surgery they hadn't been able to undergo before their therapy with MSM.

We have observed a 50% response rate of associated Raynaud's phenomenon using MSM therapy. The same rate of improvement is seen in Raynaud's Disease. Almost all our scleroderma patients have improvement in the skin and GI tract, particularly when using IV MSM.

Other organ systems involved in scleroderma include the heart, lungs, GI tract, and kidneys. We had one patient who was on renal dialysis and improved sufficiently on MSM therapy to discontinue dialysis. I had one scleroderma patient who had echocardiographic evidence of improved heart function after IV MSM therapy.

12

Systemic Lupus Erythermatosus

Systemic lupus erythematosus (SLE; lupus) most often strikes young women between the ages of 20 and 40. The condition is characterized by severe fatigue and butterfly rash across the face. Debilitating pain and swelling often occur in the hands, wrists, elbows, knees, ankles, or feet. There may also be morning stiffness in the joints. Other signs and symptoms of lupus include a worsening of the butterfly rash across the face following sun exposure; a pale or blue tinge to the fingers when exposed to cold; and possibly hair loss.

Lupus is a serious condition because its pathology also affects internal organs, including the heart, brain, lungs, and kidneys. Lupus patients are prone to bleeding disorders, anemia, and chronic infections. It is not unusual for lupus patients to require dialysis and kidney transplants. With proper treatment, however, symptoms of lupus can be controlled.

Diagnosing lupus is not always easy. While some 95% of patients with lupus will have a positive test for antinuclear antibodies (+ANA), this test is not diagnostic; approximately 5 to 10% of older patients will have +ANA in the absence of lupus. What is needed to make the diagnosis is a

finding of the "rimmed pattern" of the ANA, and a positive anti-double-stranded DNA test. If renal disease is present, physicians may order a kidney biopsy to confirm the diagnosis.

Although it involves arthralgia, SLE is usually not a primary cartilage-destroying disease. However, patients with lupus become physically deconditioned and typically take high doses of cortisone for long periods of time. Their joints soon deteriorate. Therefore, nutritional supplements, antioxidant therapy, and specific joint-sparing activities should be part of the treatment program.

EXPERIMENTAL EVIDENCE

In a study conducted by Jane I. Morton and Richard D. Moore at OHSU in 1986, lupus-prone B/W hybrid mice were fed 3% solutions of either DMSO or MSM, or water (control group), from the age of one month.[142] After 6 to 8 months, strong plasma antinuclear antibody responses were observed in 46% of those drinking water, 6% of those drinking the DMSO solution, and 14% of those drinking the MSM solution.

At 7 months of age, 30% of the control and none of the DMSO- or MSM-fed females had died. Anemia, as determined by hematocrit, was less severe in the DMSO and MSM groups, compared with the control group. In the control mice, 25 to 36% of the glomeruli showed severe damage, with extensive deposition of extracellular material; distortion of tuft, with compression and distention of basement membranes; obliteration of capillary lumens; and decreased cellularity. Only 3 to 5% of DMSO glomeruli, and 7 to 17% of MSM glomeruli showed this degree of change.

Other B/W females were started on DMSO or MSM treatment at 7 months of age, when disease was well developed. After three months, only 14% of the controls were alive, compared with 78% of those treated with DMSO and 62% of those treated with MSM. The mechanisms of these protective effects are not known, but the authors of the study speculated that diminished disease may have resulted from decreased ANA formation, or diminished deposition or enhanced clearance of immune complexes.

CLINICAL CASES

MSM is not a cure for lupus, any more than is cortisone. However, treating dozens of lupus patients with MSM has demonstrated to me that MSM can play an important role in improving the patient in about 75% of cases. I have observed that MSM relieves inflammation, pain, stiffness, and fatigue in lupus patients, allowing them to function in a more normal fashion. MSM may also permit lupus patients to reduce or discontinue prednisone use. Consistent with the mouse study cited above, we have found improved kidney function (i.e., BUN, creatinine) in lupus patients treated with MSM. There may be other physiologic benefits to MSM therapy in lupus patients. For example, oral MSM was associated with an improved platelet count of one of my lupus patients from 84,000 (following prednisone therapy) to 200,000 over a two-year period. This patient took 500 mg TID.

MM, 30-year-old female

MM, a certified public accountant, presented to our clinic with multiple joint pains. She was taking prednisone and was suffering from its side effects. We treated her with intravenous MSM daily, five days a week for two months. She then switched to oral MSM (about 8 to 10 grams daily in liquid form). MM is now in a long-term remission (seven years at this writing) and continues her daily oral MSM regimen.

AK, 22-year-old female

AK came to our clinic with a chief complaint of multiple arthralgias. She characterized her pain as severe. She had been struggling with lupus for half her life, and she also had fibromyalgia and Sjögren's syndrome. AK had tried prednisone, DHEA, and thyroid tablets without relief. At the time of her first visit, AK's pain was not controlled, despite taking gabapentin, rofecoxib, hydrocodone/acetaminophen, temazepam, and celecoxib. She reported that she had "exhausted all options."

We gave AK intravenous MSM treatments daily for five days, and sent her home with six more IV kits for her doctor to administer. In addition, she was prescribed oral MSM liquid (3 tsp BID) and topical MSM gel (to

apply as needed) to start after her IV treatments. She reported no change in her condition after two weeks. In our last communication with the patient's mother, at a three-month follow-up consultation, she reported that the "topical MSM gel helped her more than anything she has tried."

BL, 16-year-old female

BL was diagnosed with lupus at the age of 8. Her brother died of kidney complications of lupus after a failed transplant. BL also had renal involvement, but so far had not required dialysis. She came to our office with a chief complaint of chronic fatigue. Her ANA was positive, and her ESR was elevated, as were her creatinine and BUN. BL also experienced hypertension and ascites with her severe flare-ups, which occurred approximately once per year.

We treated BL with IV and oral MSM ($1^1/2$ tsp of MSM liquid twice daily). We began intravenous therapy with five treatments per week and eventually reduced the number to two per week. It took about three weeks of therapy for BL's energy level to improve. This trend continued throughout the first year of treatment. A decrease in creatinine was also evident within three weeks. After two months, BL reported "doing well." At three months, she was stable, and at four months, her ESR was decreased, as was her lupus titer.

Over a six-year period, BL received a total of 544 IV MSM treatments. During that time, her kidney function nearly normalized, with BUN and creatinine values barely elevated. Her symptoms improved overall and, although she required one month of dialysis two years after commencing treatment, she has not needed it in the five years since. Apart from one slight flare-up 16 months after initiating MSM therapy, and the month that she required dialysis, BL did well using the IV and oral MSM treatment regimen. Her father reports that she is now in complete remission and no longer requires MSM.

LS, 44-year-old female

LS, a physician, believed that her condition, which was severe, dated to her exposure to the environmental pollutants benzene, toluene, and mer-

captan. She was disabled by lupus. She had ataxia and could not maintain her balance. She was unable to drive or work. She suffered from profound fatigue, severe vascular headaches with nausea and vomiting, left-sided weakness, and dyspnea on exertion. LS required a cane to walk. Her pulmonary function tests were abnormal, consistent with severe COPD. She had symptoms of dysautonomia (severe symptomatic tachycardia and occasional hypotension), as well as arthralgia, myalgia, visual changes (blurred vision, eye pain), episodes of severe tinnitus with vertigo, depression, and an inability to handle even small stresses. Her ANA was positive, she had leukopenia, and her cerebrospinal fluid was abnormal, with an oligoclonal band. A single photon emission computerized tomography (SPECT) scan of her brain revealed decreased perfusion to her frontal and parietal lobes, changes consistent with lupus. Her diagnoses included lupus-like vasculitis, dysautonomia, moderately severe COPD, and left-sided weakness with ataxia. Her medications included pulse steroids, DHEA, propranolol, hydrocodone/acetaminophen, trimethobenzamide, and triamcinolone acetomide inhaler.

Our initial regimen for LS included five IV treatments per week: three of them were IV MSM and two were IV MSM with 10 cc of a gamma-aminobutyric acid (GABA) and gamma-amino beta-hydroxybutyric acid (GABOB) combination. We also put her on oral MSM liquid ($1^{1}/_{2}$ tsp BID). After two days, she reported feeling more alert and her vision was somewhat improved. Although objective improvement took several months to occur, the patient presently reports that she is asymptomatic and back to work practicing anesthesiology two days per week. She remains on 8 grams of oral MSM per day in four divided doses.

13

Interstitial Cystitis

Many of us have suffered at one time or another from common cystitis. Such bladder problems are usually caused by a bacterial infection. They can be successfully treated with a combination of antibiotics and/or natural remedies. When urinary tract problems become chronic and inflammation in the bladder mucosa becomes severe, the problem is no longer simple.

Interstitial cystitis (IC) is a chronic and disabling condition of the bladder the etiology of which remains unknown. Some or all of these symptoms may be present in the IC patient:

Frequency. Day and/or night frequency of urination (up to 60 times a day in severe cases). In early or very mild cases, frequency is sometimes the only symptom.

Urgency. The sensation of having to urinate immediately, which may also be accompanied by pain, pressure, or spasms.

Pain can be in the lower abdominal, urethral, or vaginal area. Dysuria occurs, but pain is not limited to pain on urination. It is also frequently associated with sexual intercourse. Men with IC may experience testicular, scrotal, and/or perineal pain, and painful ejaculation.

IC was first recognized in 1907[143] and later described by G.L. Hunner, who believed it was a bladder infection.[144] However, IC was only recognized as a discrete disorder in the 1950s, and today most experts believe IC is not primarily caused by bacterial infection. It usually does not respond to antibiotic therapy. The correct and timely diagnosis of IC continues to elude many physicians, including some urologists. Sometimes the diagnosis is not determined until after the patient has experienced years of discomfort and frustrations with ineffective treatments. People with IC often undergo multiple rounds of antibiotic therapy with no relief. After other causes of cystitis are ruled out, the IC diagnosis may be established by cystoscopy with hydrodistention under general anesthesia.

Routine office cystoscopy may not reveal the characteristic abnormalities of IC and can be quite painful for the patient. Hydrodistention of the bladder under general or regional anesthesia is necessary in order to visualize the characteristic pinpoint hemorrhages on the bladder wall. A biopsy of the bladder wall may also be useful to rule out bladder cancer and to assist in the definitive diagnosis of IC. However, we have observed many flare-ups of IC symptoms following biopsy. IC is not known to increase the risk of bladder cancer.

While IC affects both women and men, and people of any age or race, it is most commonly seen in women. Recent epidemiological data suggest that there may be greater than 700,000 cases of IC in the United States.[145]

CONVENTIONAL THERAPIES

The five most commonly used therapies for IC symptoms are cystoscopy with hydrodistention, amitriptyline, phenazopyridine, special diet, and intravesicular heparin.[146] Pentosan polysulfate sodium—a semi-synthetic, heparin-like, sulfated macromolecular compound that structurally resembles glycosaminoglycans—is an increasingly popular conventional treatment for IC. Pentosan polysulfate sodium received FDA approval in 1996. It is the only oral medication currently approved by the FDA specifically for use in IC. It is believed to work by repairing a thin or damaged bladder

lining. We have treated many patients in our clinic who took this drug for extended periods without apparent relief.

Several other treatments are available for IC, with little evidence of efficacy. These include anti-inflammatory agents, antispasmodics, bladder analgesic/antispasmodic combination drugs and antihistamines. Bladder distention, part of the diagnostic workup for IC, is sometimes used to improve urinary capacity and to decrease frequency and urgency. However, the beneficial effects of this procedure are usually short-lived. All of the treatments mentioned thus far, with the possible exception of pentosan polysulfate sodium, are palliative and probably do not address the underlying pathophysiology of the disease, which remains obscure.

Intravesicular instillations of Bacillus Calmette-Guerin (BCG) and of hyaluronic acid are in clinical trials and are not yet approved by the FDA for use in IC. Like pentosan polysulfate sodium, these therapies are interesting because they may actually be directed at healing the IC lesions, either immunologically (BCG) or structurally (hyaluronic acid). Efficacy of these agents is not known at this time.

Having treated hundreds of IC patients, I believe the most common mistake both doctors and patients make is to classify IC as simply a urinary bladder problem. In point of fact, IC is a systemic disorder, and almost everyone with IC has other systemic symptoms— musculoskeletal pain, fibromyalgia, gastrointestinal problems (e.g., irritable bowel syndrome), migraines, and allergic reactions—in addition to urinary disability and emotional disturbance (which may be due to the condition itself).

To my knowledge no one has conducted a thorough epidemiologic evaluation of IC; observations noted in this chapter are based on seeing many IC patients over the years. People with IC are more likely to have other problems associated with immune system dysfunction, including nasal or GI tract inflammation or inflammations of other mucous membranes. Some IC patients, however, have only bladder symptoms. IC is not a psychosomatic disorder, nor is it caused by stress, though stress may be an aggravating factor.

Almost invariably, the IC patients we have seen in our clinic have been treated at some point with antidepressants. Limited data and anecdotal

experience suggest that amitriptyline may help relieve pain in some IC cases.[147,148] However, urinary retention is one of the many adverse reactions documented with amitriptyline therapy,[149] making its use in IC potentially problematic. Although antidepressants are ostensibly used in IC for their analgesic properties and not as treatments for depression, nearly all of the IC patients we have seen in our clinic were struggling with depression.

IC, in our experience, almost never presents as an isolated clinical entity. Rather, it appears to be an element of a larger syndrome involving the genitourinary, gastrointestinal, musculoskeletal, and psychological systems. IC patients frequently present with concomitant changes in bowel habits—such as diarrhea or constipation—gastroesophageal reflux, fibromyalgia, lupus, and mental/emotional issues such as depression, anxiety, eating disorders, and insomnia. To overlook these other clinical entities, in our opinion, leads to incomplete understanding (and often incomplete treatment) of IC.

DMSO FOR INTERSTITIAL CYSTITIS

Throughout the years, I have spoken to many IC groups on enhancing the healing response through the use of complementary medicine. I started using DMSO with IC patients in 1962 at my clinic at OHSU. I was the first to promote the use of DMSO as a treatment for IC and was closely involved in its FDA approval in 1978 for that condition.

Dr. Bruce H. Stewart and colleagues at the Cleveland Clinic popularized the use of DMSO intravesically for IC in the late 1960s and early 1970s, and reported a success rate of 65%.[150,151]

In April 1978, the FDA approved a 50% dilution of DMSO for instillation into the bladder to treat IC. Research Industries, Inc. of Salt Lake City marketed it under the brand name RIMSO-50. This prescription drug was the only FDA-approved treatment of IC at the time. DMSO reduces the inflammation of IC quite well, but in some cases there is a great deal of discomfort associated with its use.

Perez-Marrero and colleagues reported the first placebo-controlled trial of DMSO for IC in the *Journal of Urology* in 1988.[152] Thirty-three

patients (30 women and 3 men) participated in a controlled crossover trial. Patients were randomly allocated to receive 50 cc of 50% DMSO or 50 cc of placebo (saline) intravesically at two-week intervals for two sessions of four treatments each. No significant side effects of DMSO instillation were observed. Fifty-three percent of the patients treated reported marked improvement of symptoms, compared with 18% given placebo. In the DMSO group, 93% exhibited objective signs of improvement (i.e., in cystometric urge, maximum cystometric capacity, and pain at maximum cystometric capacity) compared with 35% in the placebo group. Blinding in DMSO trials has always been hampered by the agent's potent and recognizable side effect of producing a characteristic halitosis and body odor. As a result, 70% of the patients treated with DMSO were able to correctly identify at what point in the crossover study they received the active treatment. Nevertheless, DMSO instillations were effective and well tolerated.

Preliminary findings in 213 patients suggest that intravesicular DMSO is effective for other inflammatory conditions involving the lower urinary tract, including intractable IC, radiation cystitis, chronic prostatitis, and chronic female trigonitis.[153] This study documented 100 cases of classic chronic IC treated with intravesicular DMSO. All of the patients had progressively severe symptoms of suprapubic pain, frequency, and nocturia despite intermittent hyperdistention under anesthesia, intravesicular electrodesiccation or chemofulguration, instillation with various medications, or various types of analgesic and antispasmodic medication. Length of treatment varied from one year to over 11 years in 79 patients, with the majority receiving 10 to 20 treatments over one- to three-year periods. In these patients, 54% reported good or excellent results (equal numbers in each category), 35% reported fair or poor results, and 11% had initial benefits followed by relapses. The authors concluded that patients with a clear-cut diagnosis of chronic IC or radiation cystitis respond favorably and predictably to intravesicular DMSO instillations; over half experienced long-term satisfactory symptomatic relief with endoscopic evidence of improvement and accompanying increases in bladder capacity.

MSM FOR INTERSTITIAL CYSTITIS

Around the time DMSO gained government approval for its use with IC patients, I began using MSM with my IC patients. The almost universal occurrence of odor-related side effects of DMSO therapy, and the burning that many patients experienced upon instillation of DMSO, led me to explore whether its primary metabolite, dimethyl sulfone ($DMSO_2$, MSM) could also be effective intravesically.

To our gratification, we have observed that MSM appears to be better tolerated than DMSO for the treatment of IC. Although we sometimes use solely intravesicular MSM, we have more often combined intravesicular MSM with oral, topical, and IV administration. IC is one of the three clinical entities in which we have observed a clinical response to MSM superior to that of DMSO. Improvement may take several months with MSM. While benefit from DMSO is faster, patients do not tolerate it as well. In general, we estimate that approximately 80% of IC patients show improvement using our protocol, although MSM treatment of IC has not been subjected to controlled clinical trials.

Therapy with MSM does not produce the odor associated with DMSO therapy. Patients may be taught how to self-instill either DMSO or MSM intravesically, without diminishing clinical efficacy. In a small clinical trial, 9 out of 10 patients with IC had positive responses to self-catheterization and instillation of DMSO, reported no difficulty with the technique, and felt comfortable with their ability to control symptomatic recurrences.[154]

We know so much about DMSO and so much less about MSM. We have observed that MSM promotes healthy blood flow to areas in need of repair, hastening the healing process, reducing inflammation, and helping to eliminate pain. While MSM won't necessarily work as fast as prescription analgesics for pain, we believe it works more completely and systemically.

CLINICAL CASES

In an unpublished trial, Dr. K. Whitmore of the University of Pennsylvania School of Medicine, Department of Urology, enrolled 22

patients with documented IC, instilling 50 cc of MSM intravesically at weekly intervals.[155] Because the investigator had exhausted her supply of the compound, patients received varying doses, depending upon when they began therapy. At the end of six months, 16 of the 22 patients (72%) continued to improve and required no further therapy. After one year, however, only four of the original 22 patients were completely free of symptoms without continuing therapy. None of the patients experienced any serious side effects of the therapy.

Stacy J. Childs, M.D., then of the University of Alabama-Tuscaloosa and now practicing in Cheyenne, Wyoming, conducted a small study of MSM use among IC patients who had not been helped by standard medical treatments. This is the first published clinical trial of MSM to appear in a peer-reviewed medical journal. The following six case studies were published in the *Urology Clinics of North America* in 1994.[156]

A 38-year-old female with biopsy-proven IC and a several-year history of urinary frequency, urgency, and nocturia, did not have success with either DMSO or MSM instillations.

A 40-year-old female with a more than one-year history of urinary frequency and cystoscopic evidence of IC, failed to improve after DMSO instillations and imipramine therapy. She did improve somewhat after seven months of pentosan polysulfate sodium therapy. A four-week course of intravesicular MSM instillations produced dramatic improvements after only seven treatments. Her day-to-night urination decreased from 30:3 to 10:1, and she had no pain. Seven months later, the patient remained symptom-free and required no further treatment.

A 41-year-old female with cystoscopically proven severe IC and typical symptoms, showed a negligible response to a DMSO "cocktail." She then received a single intravesicular administration of MSM, from which she obtained a moderate response and was lost to follow-up.

A 33-year-old female previously treated for trigonitis with trigone cauterization and hydrodistention, had a questionable diagnosis of IC. Nevertheless, twice weekly intravesicular administrations of MSM for four weeks resulted in her becoming asymptomatic with only rare nocturia, no frequency, and no pain. She required no further treatment.

A 40-year-old female with biopsy and cystoscopy-proven IC had been treated with DMSO, amitriptyline, hydrodistention, pentosan polysulfate sodium, and other symptomatic therapies, with some benefit. After being off therapy for six months, her symptoms returned. She was placed on intravesicular MSM instillations every other week for two months, after which time she became asymptomatic. Her symptoms returned seven months after not using MSM.

A 45-year-old female who had been previously treated for IC with DMSO, urethral dilation, and hydrodistention, had a day-to-night urination ratio of 12-15:11. After slight improvement on amitriptyline, her symptoms worsened, and she eventually experienced urinary retention, presumably as an adverse effect of the amitriptyline therapy. She was given MSM intravesically on a weekly basis for one month, and then switched to monthly instillations. Her day-to-night frequency ratio decreased to 6:1. After six months of MSM therapy, she was totally asymptomatic and was removed from the protocol. Her symptoms recurred eight months following cessation of treatment with MSM.

Although funding has not been forthcoming to conduct controlled clinical trials of MSM for IC, I believe that MSM will someday be shown to be one of the most effective treatments for this condition. It is a more desirable treatment for IC than DMSO, since there is neither odor nor irritation with intravesicular administration.

Aspects of Dr. Childs' experience with intravesicular MSM have been corroborated in our clinic. I have found MSM to be very effective for IC, but I always inform my patients that the effects sometimes take weeks or months to manifest, and that symptoms may return within months if therapy is withdrawn. This emphasizes the importance of an approach to the whole patient, not just to their urinary bladder. In all, we have treated over 200 IC patients with MSM at our clinic. If a patient obtains a good clinical result with MSM and can maintain it for three years, we have found that approximately one-third can be withdrawn from MSM therapy and will not require further treatment. Here we will report on seven of our most recent cases. These cases are not selected based on outcome, but rather to present a balanced account of the type of improvements generally seen.

JF, 52-year-old female

JF was the first patient I treated with MSM for IC. She suffered urgency, frequency, bladder pain, fibromyalgia, and bowel disturbances. While she had been using DMSO and had noted some benefits, she objected to the odor and burning sensation with intravesicular administration. We gave her a combination of oral, IV, intravesicular, and topical MSM: three intravenous infusions on the first three days of therapy with 100 cc of 15% MSM and 100 cc of 5% dextrose and water (to make a 7.5% MSM solution), 8 grams of oral MSM per day, and topical MSM gel applied to the perineum and suprapubic region TID. JF followed this regimen five times a week for one month. The next month she was treated four times a week, then three times a week, and, finally, two times a week in the fourth month. JF did as well or better with MSM than she had with DMSO, and without the nuisance side effects. From that point on, I used MSM with more patients, using a combination of IV, topical, oral, and intravesicular administration. I continued to achieve very good results, comparable to those of DMSO, although the treatment time to improvement was usually longer.

JB, female, age withheld

JB, a salesperson, presented to our clinic with a medical history of "spastic colon" by her own report. Her IC had been diagnosed about three months prior to visiting our clinic. JB's day-to-night urinary frequency ratio of 4:3 was unremarkable for IC. Her chief complaints were dysuria, urinary urgency, and nocturia. She also complained of left lower quadrant pain and pressure, fatigue, headache, low back pain, intermittent constipation and diarrhea, and a sense of pressure in the vaginal and rectal area suggestive of prolapse. Her symptoms kept her from exercising and from having sex. We treated her with intravesicular MSM according to the protocol described previously.

Urinalysis was normal, but her peak urinary capacity had recently declined from 350 cc to 240 cc. Her treatment goals were to be infection-free (she had frequent urinary tract infections) and to be able to sleep through the night without needing to urinate. She was taking

hyoscyamine sulfate (an anticholinergic/antispasmodic) and a stool softener.

After six weeks of treatment, her daytime voiding pattern was unchanged, but her nocturia was decreased to one to two times per night. At two months, her back pain was diminished and her daytime urination was down to three times per day. She also reported that her sense of urinary urgency was much improved. At this stage, the only bladder pain she experienced was about twice monthly at her urethral meatus. Eight months after starting MSM, JB reported she had no daytime urgency, although she still had not resumed sexual intercourse. Her urologist evaluated her at this time and reported that MSM therapy had improved her condition. After 11 months of therapy, JB continued intravesicular instillation of MSM once every two weeks and reported that she was significantly improved, with only episodic urinary frequency or nocturia. Eventually, she was able to resume exercising (running vigorously one to two miles per day), and she maintains her good health to the present.

WC, 36-year-old female

WC, a medical assistant, first came to our clinic with chief complaints of urinary frequency, urgency, and nocturia. Her day-to-night frequency ratio was 20:4. She also suffered from depression, fibromyalgia, asthma, and constipation. Her medications at the time of her initial visit included pentosan polysulfate sodium, sertraline, oxazepam, ibuprofen, and an asthma inhaler. We treated her with a combination of intravesicular, IV, oral, and topical MSM: daily intravesicular instillations, three intravenous infusions on the first three days of therapy (with 100 cc of 15% MSM and 100 cc of 5% dextrose and water to make a 7.5% MSM solution), 8 grams of oral MSM per day in four divided doses, and topical MSM gel applied to the perineum and urethral meatus TID.

After her second IV MSM administration (on the second day of treatment), the patient no longer required use of her inhaler. WC had five intravesicular instillations per week for one month, and continued at four instillations per week until her last visit, six weeks after beginning MSM therapy. She reported slight improvement in her IC symptoms after one

week. Three weeks into her treatment, she experienced less dysuria. Her pain improvement continued through her last visit to the clinic.

SC, 57-year-old female

SC presented to our clinic with a classic case of IC, as well as fibromyalgia, depression, Sjögren's syndrome, TMJ syndrome, gastroesophageal reflux, and acne rosacea. Her medical history included back pain and rheumatoid arthritis. Her IC was triggered two years prior to her first visit, following a motor vehicle accident. Physical trauma of this type is a frequent trigger of IC (as well as fibromyalgia and TMJ syndrome) in our experience.

SC was taking hydrochloroquine sulfate, lamotrigine, omeprazole, clonazepam, phenazopyridine HCl, modafinil, and rofecoxib. Such disturbing examples of polypharmacy are common among IC patients.

We treated SC with a combination of intravesicular, IV, oral, and topical MSM. Two days after initiating treatment, SC reported feeling "well." Her overall improvement was slight in the first three weeks of therapy, but continued at the two-month mark, after which she was referred to another doctor for continuation of MSM therapy and was lost to our follow-up.

JC, 26-year-old male

IC occurs less frequently in men than in women, but we have treated about ten men in our clinic, all of who experienced major improvement in their symptoms of IC.

JC presented with a medical history of IC throughout most of his life. He had tried, without success, hydrodistention, various diets, pentosan polysulfate sodium, and a host of other medications. We prescribed three IV MSM treatments on successive days, as well as intravesicular, oral, and topical (suprapubic) MSM. After three days of therapy, JC complained of cramps and diarrhea, so we temporarily discontinued the oral MSM. This is a known, though uncommon, side effect of MSM therapy. Five days later, JC was feeling better and resumed oral liquid MSM at $1/2$ tsp per day (about one-sixth the typical dose). After two weeks of therapy, JC was in less pain, and his improvement continued slowly over sev-

eral months. After ten months of therapy, his IC was 50% improved. His improvement continued through his last visit to our clinic.

RF, 67-year-old male

RF had more than a year-long history of dysuria. He had received multiple treatments, including ciprofloxacin, levofloxacin, finasteride, amitriptyline, diazepam, tamsulosin HCl, alpha-blockers, cefotetan disodium, cephalexin, and various blood pressure-lowering medications. Each treatment was unsuccessful. Two months prior to visiting our clinic, RF was seen by an urologist for his urinary symptoms. Cystoscopy and biopsy revealed partially denuded urinary mucosa with moderate chronic cystitis and mild acute cystitis. Three days after the biopsy, RF was admitted to the hospital with gross hematuria, a complication of the biopsy. He was eventually diagnosed as having IC.

We treated RF with a combination of intravesicular, IV, oral, and topical MSM per our usual protocol. After only one day of treatment, RF reported decreased urinary urgency. Improvements continued after a month of therapy, and the patient was referred to another practitioner to continue MSM therapy.

SL, 58-year-old female

SL, a social worker, came to our clinic with chief complaints of stress incontinence, dysuria, frequency, urgency, and nocturia. She had initially been treated for IC five years earlier with DMSO and responded well. However, she found the side effect of breath and body odor unacceptable and discontinued therapy. She found it difficult to exercise (jogging exacerbated her symptoms). She was taking terfenadine, amitriptyline, and melatonin.

We treated SL with intravesicular MSM instillations once per day for six days, then decreased to one to two times per week thereafter. After five weeks of therapy, SL responded well. Within another three months, her IC was under control. She soon added topical MSM gel to her regimen, which she applied suprapubically. SL has continued to do well for five years while remaining on oral and topical MSM, with only "occasional twinges" of IC symptoms.

Testimonial from JS, 25-year-old male

"I am writing this letter to let you know that the $DMSO_2$ solution has helped tremendously with my interstitial cystitis. My IC started in July of 1998. The pain my pelvic region was so bad I had to quit college at the age of 21, and become practically homebound. My pain symptoms were so high that in the year 2000 I finally went to a pain management doctor. I was put on high doses of pain medicine to deal with my pain level. In January 2001 my mother and I flew out to see you and that is when I began my $DMSO_2$ solution treatment plan. You warned me that it was a 'slow worker' and indeed it was, but I never gave up. I gave myself the instillations often and, in September of 2001, I began to drink the oral $DMSO_2$ solution as well. That was the turning point in my improvement. In January of 2002, I was healthy enough to start back to college classes. [In] February I stopped all pain medicine and feel great. $DMSO_2$ …gave me my life back. I will be forever grateful to you so that I can once again live my dreams and have a full, productive life."

JL, 37-year-old female

JL was diagnosed with IC five years prior to her first visit to our clinic. She may have had the disease for nine years prior to her diagnosis, judging from her 14-year history of chronic pelvic pain. Her medical history included a tailbone injury and a full hysterectomy for her chronic pelvic pain a year before seeing us. The hysterectomy did not address the cause of her pelvic pain, which was bladder-related. Her mother also had IC and a cystectomy.

JL presented to our clinic with frequency, burning, aches, sharp pain, and a "sand paper" sensation. She was hypersensitive to being jarred and experienced cutting suprapubic and pelvic pain if bumped. We treated her with a combination of intravesicular, IV, oral, and topical MSM. The treatments were well tolerated, but improvement was slow in coming; at least four months elapsed, and SL experienced no improvement in her symptoms. At the six-month mark, she reported moderate improvement, which continued slowly over the next year. The

improvement she experienced was primary in her symptom of urinary frequency. Her pain was still a problem. A year after beginning treatment, JL came in for another series of IV treatments (one per week for eight weeks). Her improvement remained minimal over the next six months, although she did report less burning.

These results are included because they illustrate the difficulty in treating IC, even with MSM, which we believe is one of the most effective therapies available. IC is a multifactorial illness. While MSM therapy alone will generally help, we also recommend other supportive therapies that address the mental-emotional, gastrointestinal, and musculoskeletal aspects of the disease.

To date, I have treated approximately 200 IC patients with MSM, and I have not observed serious side effects. Most of the IC patients I see are severely ill. Although I have found that some IC patients can eventually go off DMSO or MSM and remain off for many years, I currently advise IC patients to continue their use of MSM even when symptoms have subsided. MSM is without significant side effects and we have no evidence of problems with prolonged use.

MSM PROTOCOL FOR INTERSTITIAL CYSTITIS

Our intravesicular MSM formula consists of 15% MSM in deionized sterile water. We teach the patients to perform self-instillation, because clinical results are superior when this method is followed. Patients can control the pace of administration and can adapt their technique instantaneously in response to the level of pain or sensitivity to urethral introduction of the catheter.

We instruct our patients to instill the MSM and retain the solution as long as is comfortable. Some patients feel the need to void after just 30 minutes. Others are able to do the instillations before bed and retain the solution all night. Retention should not be carried out to the point of increasing pain or discomfort. Patients are instructed in proper catheter technique, with a new sterile catheter and syringe used for each instillation.

The first clinical trials of MSM to be published in a peer-reviewed medical journal were of intravesicular MSM for IC. I believe our results have been superior to those of the published clinical trials of MSM because we treat more aggressively. Our usual recommendation is for five instillations per week for the first month, four per week for the second month, three per week for the third month, two per week for the fourth month, and then to either remain at two instillations per week or decrease to one instillation per week thereafter.

In addition to intravesicular administration of MSM, we often treat our IC patients with IV MSM (typically just three infusions on the first three days of therapy with 100 cc of 15% MSM and 100 cc of 5% dextrose and water, making a 7.5% MSM solution), oral MSM ($1^1/2$ tsp BID for a week, then 3 tsp BID as tolerated), and topical MSM gel (applied to the suprapubic region in males and to the perineum and suprapubic region in females, BID).

I have achieved good, although less spectacular, results with use of oral and topical MSM only. Although I prefer to administer MSM both intravenously and intravesically as a bladder wash, catheterization cannot always be performed, especially in patients with intense bladder inflammation.

Some patients improve using only oral and topical MSM. I start patients on one gram per day of oral MSM. They can gradually increase the dosage to 18 grams or more under a doctor's supervision. Topical application in the area of the bladder and perineal region is important, since we believe MSM is also absorbed through the skin. If patients have other organ systems involved such as lungs, the need of inhalers may be reduced by MSM therapy. We have also regularly observed higher energy levels and improved sense of well-being with MSM therapy.

14

Fibromyalgia

Fibromyalgia is also known as fibromyositis, myofascial pain syndrome, and fibrositis. It is a common musculoskeletal disorder characterized by aching pain and tenderness at characteristic trigger points. Other common features of the disorder include stiffness of muscles, tendon insertions, and adjacent soft tissues; nonrestorative sleep; paresthesia; and easy fatigability. It is not considered a disease of the joints, nor is it characterized by cellular inflammation, which explains the shift away from the names fibrositis and fibromyositis.

Fibromyalgia syndrome is an increasingly recognized clinical entity. Although its precise etiology remains unknown, it is closely linked to affective disorders. In 1990, a large multicenter study was published by the American College of Rheumatology to identify the criteria most predictive of the syndrome.[157] Epidemiologic studies have subsequently estimated the prevalence of fibromyalgia in the United States at approximately 2% of the adult population.[158,159] Fibromyalgia is thus at least twice as common as rheumatoid arthritis. Although studies show that fibromyalgia is very common, the symptoms of the syndrome represent

more of a continuum than a discrete disease.[160,161]

The etiology and pathophysiology of fibromyalgia continue to elude researchers. Many mechanisms are potentially involved in the development of the disease, including abnormalities in muscle metabolism, neurologic and hormonal function, and psychological state.[162] However, studies of muscle metabolism using magnetic resonance spectroscopy and other advanced analytical techniques have, for the most part, failed to find abnormalities. Current research suggests decompensation of the hypothalamic-pituitary-adrenal (HPA) axis in fibromyalgia patients.[163] However, it is not known whether such abnormalities are a cause or an effect of fibromyalgia.

The psychological component of fibromyalgia is beyond dispute. Nearly all fibromyalgia patients seen in our clinic are also battling depression. This observation is clearly supported in the medical literature.[164,165,166] Fibromyalgia syndrome may best be considered part of the "affective spectrum" that includes panic disorder, irritable bowel syndrome, migraine, major depression, and chronic fatigue syndrome.[167]

Fibromyalgia is most commonly seen in young and middle-aged women. In fact, every single one of our more than 100 fibromyalgia patients has been female. The disorder is found in most ethnic groups and in most countries around the world, regardless of climate. Mental stress, poor sleep, trauma, or exposure to damp cold can trigger or exacerbate the syndrome. Fibromyalgia may occur in tandem with, or be aggravated by, rheumatoid arthritis, lupus, or polymyalgia rheumatica.

A diagnosis is usually made only when there is longstanding (greater than six months) multi-regional muscle pain, above and below the diaphragm and bilaterally, and when more than 11 out of 18 trigger points are found to be positive by direct palpation. Patients with fibromyalgia may also experience global joint soreness. This soreness, however, is more likely to arise from nonarticular tissues, such as tendon insertions that occur near the joints.

More than 75% of our fibromyalgia patients also present with one or more associated symptoms, including headaches, irritable bowel syndrome, and sleep dysfunction; these symptoms also require treatment. We

have observed that the precipitating event for many fibromyalgia cases is physical trauma, commonly attributed to an auto accident. Chronic trigger-point pain, muscle deconditioning, and generalized pain sensitization of soft tissues and joints follow the trauma. The medical literature also describes a higher likelihood of a history of physical and/or sexual abuse among fibromyalgia patients.[168]

Antidepressants have emerged as the mainstay in the pharmacologic treatment of patients with fibromyalgia.[169] Low doses of tricyclic agents and combination therapy with low-dose tricyclic agents[170] and selective serotonin reuptake inhibitors (SSRIs)[171] are commonly employed. Patients treated with the combination should be cautioned about the possibility of side effects, including increased anxiety and insomnia. Benzodiazepines, corticosteroids, and NSAIDs have been shown to be ineffective and should generally be avoided. Long-term narcotic use is also discouraged.

Several placebo-controlled trials have demonstrated that many available therapies are effective in the short term, including aerobic exercise[172] and electroacupuncture.[173] There remain, however, few long-term trials and few trials of comparative therapies in the treatment of fibromyalgia.[174]

In treating fibromyalgia patients, I have found MSM to be helpful when administered orally, topically, intravenously, or subcutaneously. I caution my fibromyalgia patients that MSM is a "slow worker" in this condition. While MSM administration does not cure fibromyalgia, it does offer gradual pain relief. I have been able to control the pain of fibromyalgia in the majority of cases I have treated, without the side effects associated with prescription or over-the-counter analgesics. Oral and topical MSM may be required indefinitely.

I have treated more than 100 fibromyalgia patients with an efficacy rate of about 70%. Patients experience less pain and stress, and sleep better. Typically, they become able to go through their days and nights without being incapacitated by unrelenting pain. Their joints feel better, they can walk further with less discomfort, and they can ride in cars without feeling pain.

CLINICAL CASES

CN, female, age withheld

CN visited my clinic to receive help for allergies that had become so severe that she relocated to Hawaii for several months each year simply to be free from pine and grass pollen. About a year before her initial visit, CN had also begun to suffer from fibromyalgia. The pain began in her neck and within a few months spread to the entire upper torso—elbows, wrists, and hips included.

Hydrocodone/acetaminophen provided no relief. I put her on 5 grams of oral MSM (liquid) daily to help with her allergies. CN experienced nearly instant relief from her allergies and, quite unexpectedly, her fibromyalgia. Within 24 hours of taking the MSM, her fibromyalgia pain had been reduced by 50%. Today, CN's allergies are under control and she is mostly pain-free, using a high maintenance dose of 30 grams of MSM daily.

RS, 72-year-old female

RS had been taking cortisone for eight years to control her symptoms of pain and inflammation; while the cortisone gave some benefit, it also produced many adverse effects. I am not enthusiastic about treating a chronic condition like fibromyalgia with the long-term use of corticosteroids. I started her on MSM, and its effects were slow in coming; it took a year for RS to notice a significant improvement. However, by the end of the year, she was able to discontinue cortisone, using a tapering-down regimen. Her swelling, inflammation, and pain were significantly reduced. RS uses a maintenance dose of 10 grams MSM (liquid) daily, which she takes every morning in juice.

BR, female, age withheld

At the time of her diagnosis, BR was raising her young children and depended a great deal on her husband to help her even with simple tasks, such as washing the dishes or bathing the children. Her pain and fatigue were debilitating. She had been prescribed amitriptyline and had also

taken cortisone and gold salts for rheumatoid arthritis. We put her on 5 grams of oral MSM daily; it took about one week for her to notice an improvement. She continues this daily regimen and reports that 90% of the pain has been eliminated since beginning her program with MSM.

PB, 50-year-old female

PB, a pediatric nurse, presented with typical symptoms of fibromyalgia and a characteristic pattern of trigger points. She had experienced chronic myofascial pain for two and a half years prior to coming to our clinic. She was taking morphine sulfate, gabapentin, venlafaxine, and trazodone. She also had a history of taking prednisone, without benefit.

Ten weeks of IV MSM therapy (five treatments per week), plus oral liquid MSM ($1^1/2$ tsp BID, providing 2 g MSM daily) and topical MSM gel enabled her to reduce her dose of morphine by one-third. PB felt "good" pain relief after the first IV treatment, and her improvement continues. She now takes 10 grams per day of MSM (in liquid form) orally in four divided doses.

AH, 53-year-old female

Originally misdiagnosed with lupus, AH, an artist, presented with a 15-year history of fibromyalgia; she had been taking fluoxetine for five years. We treated her for five months, beginning with a week of IVs, plus oral and topical MSM in the usual amounts ($1^1/2$ tsp BID of oral and topical applied BID.) It took six months, but AH reported "very good pain relief" from the treatment regimen.

LM, 42-year-old female

LM was not taking any other medications when she presented to our clinic, complaining of pain in her hand, feet, neck, and shoulders. She was particularly affected by cervical muscle spasms. We treated her with one week of IVs, followed by oral and topical MSM (again, $1^1/2$ tsp BID oral liquid, topical BID or as needed.) Within two days of commencing IV MSM, the patient reported some pain relief and decreased tenderness of trigger points in the posterior cervical and upper thoracic regions. One

month after commencing therapy, the patient was doing well and reported continued pain relief.

MO, female, age withheld

This patient came to our clinic with a 12-year history of fibromyalgia pain and trigger-point tenderness, mainly above the waist. The pain was severe and made it impossible for her to play golf. In my experience, severe pain syndromes frequently require IV treatment. In this case, we began with a week of IV MSM (five treatments), followed by two IV treatments per week for a year. After the first week, the patient reported some pain relief. At the time of this writing, she continues to be seen by a colleague and has achieved 40% pain relief on this regimen.

RS, 68-year-old female

RS had a 20-year history of fibromyalgia so severe in her feet that she was forced to use a wheelchair most of the time. In 1980, she went into a long-standing remission after using DMSO. But after discontinuing treatment, the condition returned. We began treating her with MSM (IV for one week, then oral ($1^1/2$ tsp BID) and topical (PRN). RS reported feeling better after just two days. Eventually, her ability to walk increased, and she continues to do well on the combination of oral and topical MSM.

15

Myasthenia Gravis

Myasthenia gravis is a chronic, autoimmune neuromuscular disease characterized by episodic muscle weakness caused by loss or dysfunction of acetylcholine receptors at the postsynaptic neuromuscular junction. Transmission of nerve impulses is thereby interrupted, leading to the characteristic symptoms. The initiating event leading to antibody production is not known. Myasthenia gravis is more common in women; the onset is usually between the ages of 20 and 40, although the disease may affect either gender at any age.

The hallmark symptom of myasthenia gravis is muscle weakness that increases during periods of activity and improves after periods of rest. Other common symptoms include ptosis and diplopia. Muscles that control eye and eyelid movements, facial expression, chewing, talking, and swallowing are often, but not always, involved. The muscles that control breathing and neck and limb movements may also be affected. Approximately 85% of myasthenia gravis patients will have ocular involvement, and nearly half will experience it as their first symptom. Dysarthria, dysphagia, and proximal limb weakness are also common.

A diagnosis of myasthenia gravis is suggested by the clinical picture and confirmed with a trial of edrophonium, an anticholinesterase drug with a short duration of action. If muscle function improves rapidly and briefly after administration of edrophonium, a diagnosis may be established. This test is potentially hazardous and should only be performed by trained medical personnel in a facility equipped to maintain respiration and to administer atropine, if necessary, to prevent cardiorespiratory depression. Equivocal diagnoses can be confirmed with electromyography and serologic tests, such as anticholinesterase antibodies.[175]

Myasthenia gravis can be challenging to treat. Anticholinesterase agents may relieve symptoms. Thymectomy benefits symptoms in certain patients and may even significantly improve some individuals. Corticosteroids and immunosuppressive drugs may interfere with autoimmune events, but carry long-term risks. Other therapies include plasmapheresis, a procedure in which abnormal antibodies are removed from the blood, and high-dose intravenous immunoglobulin.

With appropriate treatment, the prognosis for most patients with myasthenia gravis is good: They can expect to lead normal or nearly normal lives. Some cases of myasthenia gravis may go into temporary remission, and muscle weakness may be attenuated to the extent that anticholinesterase medications can be discontinued.

MSM is thought to be a mild anticholinesterase agent, and it is this property that may account for the clinical results I observed in the few myasthenia gravis cases I have treated.

CLINICAL CASE

BE, 30-year-old female

BE worked as a nurse at the University of California at Los Angeles (UCLA). She was very active, regularly working 12-hour shifts in the intensive care unit (ICU); many shifts were as long as 16 to 18 hours. With the addition of work at a home healthcare agency, she worked the equivalent of two full-time jobs. In December of 1992, BE began noticing weakness in her legs and was unable to climb stairs by the time of her

diagnosis a month later. She was also unable to step on to a step stool, blow dry her hair, or hold a telephone to her ear. Her neurologist described her condition as "severe."

BE was started on pyridostigmine bromide, an anticholinesterase agent that offered some symptomatic relief, but it was insufficient to allow her to continue working. She was forced to quit her job at UCLA, because she could only function effectively a few hours per day; the remainder of her time was spent in bed or in a chair. Her condition deteriorated and her breathing became labored. Her physicians recommended thymectomy, prednisone, and IV gamma globulin therapy. She feared that prednisone and surgery might compromise her already poor pulmonary function to the extent of confining her to a ventilator.

Around this time, BE became aware of MSM at a feed store and read it might increase muscle strength and decrease inflammation. She began taking it as a supplement and noticed improvement soon thereafter. BE described her improvement as being so dramatic that her physicians ceased to consider surgical options for her, as they believed she was going into remission. After eight weeks of supplementation, BE began to experience increased bruising and menorrhagia. She discontinued MSM and her condition promptly deteriorated. Her doctors agreed, given her dramatic response, that she should travel to Portland and visit our clinic for a trial of MSM. If BE didn't show improvement with MSM therapy, she would initiate therapy with prednisone and gamma globulin and have the thymectomy.

We administered ten intravenous MSM treatments (15 grams of MSM with each infusion) over two weeks. She continued on oral MSM (1 to 4 grams per day) after returning home. After two to three months of oral MSM therapy, BE was able to resume work as a nurse. She wrote to our clinic two years later to say that she was again working in the ICU at UCLA part-time and at her other part-time job as well. She was not in complete remission and reported having ups and downs, but her exacerbations were far less severe and rarely confined her to bed. Stress still weakened her, but BE reports that she maintains 80% of normal function, compared with 5 to 10% of normal function prior to IV MSM therapy. BE wrote to our clinic:

"Upon my return visit—both my doctors were astounded. My neurologist announced to a waiting room full of people and 14 feet away from me, "My God, you're better!" My internist exclaimed the same thing when I saw him… I am very grateful for Dr. Jacob and his work... I am now living again thanks to him. I know I would be dead by now or in a facility for long-term ventilator-dependent people. Now I'm able to do the work I love, spend quality time with my children, and ride my horses. What more could I ask for?"

16

Allergies and the Respiratory System

We have been using DMSO and MSM to treat respiratory conditions for over four decades with good success. Respiratory conditions we have treated with encouraging results include bronchiectasis, allergies, asthma, and emphysema.

BRONCHIECTASIS

The first patient I studied with MSM was one who had bronchiectasis, an irreversible bronchial dilation, usually accompanied by chronic infection. Bronchiectasis may be focal and limited to a single segment or lobe of the lung, or it may be widespread and affect multiple lobes in one or both lungs. The condition is usually acquired rather than congenital, and it is typically caused by either direct destruction of the bronchial wall (e.g., due to infection, inhalation of noxious chemicals, immunologic reactions, or vascular abnormalities) or by mechanical alterations (e.g., atelectasis).[176]

CH, 78-year-old female

In 1978, CH presented to our clinic with chronic cough, dyspnea, and recurrent bouts of fever. We had large wafers made from MSM. I instructed the patient to place a wafer in boiling water and inhale the vapors. She did this approximately four times a day for several months. After about three weeks, CH's bouts of fever had ceased. Her breathing was easier, her energy levels were increased (probably due to improved oxygenation), and she could walk longer distances without shortness of breath. It is difficult to confirm whether the therapeutic effect in this case was due to the steam or to the MSM vapors. However, after about three months, we switched to oral MSM powder (approximately 5 grams TID), and her improvement was maintained. For this reason, we think the MSM was responsible for her benefit.

EMPHYSEMA

I have treated six patients with emphysema using oral MSM. Patients with emphysema tend to become breathless with only minimal exertion, such as walking to the mailbox or up stairs. We treated these patients with oral MSM powder (gradually working up to 5 grams two to three times per day). After a week at the target dose, five out of the six patients reported that breathing became less labored after walking short distances. The sixth patient could not tolerate a therapeutic dose of MSM, which may explain the lack of significant benefit in this case. Patients with emphysema require continued therapy with MSM to maintain relief of dyspnea.

Most interesting were results in the patients with emphysema who also had allergies. Once they began taking MSM, they found that they did not require their antihistaminic medications, even when the pollen count was high.

ALLERGIES

My Personal Experience with MSM & Allergies

Since 1948, when I was age 24, I have suffered from a major grass pollen allergy. Every year, from around April 15 to July 15, my nose would be stuffy and my eyes would burn daily. I had all of the typical symptoms of respiratory distress. At that time, the antihistaminic agents we use today, such as Benadryl®, had just been released. Although I needed them, I didn't like taking them primarily because they made me drowsy.

In 1977, I tried about 4 to 5 grams of MSM on a daily basis. This enabled me to discontinue antihistaminic medications—I had not been able to get off them for almost 30 years. I found MSM to be just as effective as antihistamines. Instead of making me drowsy, MSM seemed to give me more energy.

In fact, as I write this report, pollen season is in full swing. I require a little bit less MSM now than previously to obviate my allergy to grass pollens. I have tried to discontinue using MSM, but the symptoms of allergy returned.

Research in the past decade has revealed the presence of inflammation of the airways in asthma patients and the importance of clinical treatment to reduce chronic inflammation. MSM, as we'll point out later, is effective at relieving chronic inflammation and accompanying muscle spasm.

BRONCHIAL ASTHMA

Asthma is a pulmonary disease characterized by reversible airway obstruction and inflammation of the lungs. There are over ten million people with bronchial asthma in the United States; our major experience has been with children. Asthma is the leading cause of hospitalization for children.

AA, 6-year-old female

AA came to our clinic from the East Coast of the United States. During the year prior to visiting our clinic, AA had been hospitalized for seven months (multiple admissions) for asthma. She experienced frequent attacks, beginning with wheezing, coughing, and shortness of breath; this was followed by respiratory distress. Her therapy had included antihista-

minic agents, theophylline, and corticosteroids. We administered oral MSM, starting with 1/4 tsp of powder (approximately 1 gram) BID. We gradually increased her dosage to 8 grams per day (2 grams QID). She remains on this dosage at the time of this writing and has not required hospitalization for three years. Shortly after returning home, one in-hospital stay was required until AA reached 4 grams of MSM per day. She remains symptom-free but still requires MSM.

BC, 7-year-old female

BC came to our clinic from Hawaii. She had moderately severe bronchial asthma requiring periodic visits to the hospital. Early prodromal symptoms of pruritis over the anterior chest and dry cough preceded her acute attacks. The attacks themselves were characterized by paroxysms of wheezing, coughing, and shortness of breath. In this case, we gave oral MSM (500 mg BID), gradually increasing over a two-month period to 10 grams daily in divided doses. Episodes of acute asthma ceased by the time she had reached 5 grams per day. BC remains on 10 grams oral MSM per day and has not experienced an acute asthmatic episode in three years.

SEASONAL ALLERGIC RHINITIS (HAYFEVER)

An open-label study was recently performed to evaluate the efficacy of MSM in the reduction of symptoms associated with seasonal allergic rhinitis (SAR).[177] This study also examined possible adverse reactions associated with MSM supplementation, and sought to elucidate the method of action by which MSM elicits its effects on allergy symptoms. This is the first full clinical study of *oral* MSM to be published in a peer-reviewed scientific journal.*

Of the 55 subjects recruited, 50 completed the study. Those subjects completing the study consumed 2,600 mg of MSM (OptiMSM, Cardinal Nutrition, Vancouver, WA) orally per day for 30 days. A Seasonal Allergy

* The very first published clinical trial was of intravesicular MSM for interstial cystitis (see Chapter 13).

Symptom Questionnaire (SASQ) was used to evaluate clinical respiratory symptoms and energy levels on days 7, 14, 21, and 30. Immune and inflammatory reactions were measured by plasma Immunoglobulin E (IgE) and C-reactive protein (CRP) at baseline and on day 30. An additional inflammatory biomarker, plasma histamine, was measured in a subset of subjects (n=5).

On day 7, the frequency of upper and total respiratory symptoms was reduced significantly from baseline. By the end of the third week, lower respiratory symptoms were significantly improved from baseline. All respiratory improvements were maintained through the end of the trial. Energy levels increased significantly by the end of the second week (p<0.0001) and persisted through the end of the study. No significant changes were observed in plasma IgE or histamine levels.

The researchers found that MSM supplementation of 2,600 mg per day for 30 days was effective at reducing symptoms associated with SAR. Few side effects were associated with the use of MSM in this study. We concur with the researchers' conclusion that a larger, randomized, double-blind trial is justified to validate these promising preliminary results.

17

Snoring

Snoring is an inspiratory sound that arises during sleep as a result of partially obstructed breathing. Snoring is caused by the narrowing of the nasopharyngeal airway, such that turbulent airflow during relaxed breathing vibrates the soft tissues of the oropharynx (i.e., soft palate, posterior faucial pillars of the tonsils, and the uvula).

Snoring is very common and affects both males and females of all ages. During wakefulness, a person is typically able to consciously maintain a patent nasopharyngeal passage; however, with the onset of sleep, relaxation allows the nasopharyngeal passageway to constrict, and snoring results. It has been estimated that up to 45% of all adults snore occasionally, while about 25% are habitual snorers. Snoring increases with age; about 50% of men and 40% of women are habitual snorers by the age of 60.[178]

A restricted nasopharyngeal passageway may be due to anatomical abnormalities, as in obstruction due to enlarged tonsils or adenoids in children. Obesity may contribute to anatomical obstruction of the nasopharynx; snoring is three times more common in obese people. Anatomical narrowing can simply be a matter of genetics, with some peo-

ple being predisposed toward a smaller nasopharyngeal cross-section. An obstructed nasopharynx may also be caused by a lack of muscle tone. Other anatomical conditions contributing to the narrowing of the nasal pharyngeal passageway include choanal atresia, chronic polyps, nasal septal deviation, nasopharyngeal cysts, macroglossia, retrognathia, and micrognathia, but these are less common.[179]

Alcohol, tranquilizers, hypnotics, and antihistamines may also exacerbate snoring.[180] Snoring and sleep apnea are associated with cerebrovascular diseases. Several other factors may be involved in this association because many established or potential risk factors for stroke are related to snoring and sleep apnea. These include arterial hypertension, coronary heart disease, and smoking.[181]

Heretofore, it has been reported that there is no effective pharmacologic management of snoring.[182] However, numerous management techniques have been described, depending upon the perceived cause of snoring. None of these treatments has proved completely adequate. Where snoring is caused or exacerbated by nasal allergy or an upper respiratory tract infection, these conditions may be treated pharmacologically, but, as noted above, such an approach is palliative and does not constitute comprehensive management of the condition.

One simple treatment involves having the patient sleep in the prone position or on his or her side. Sewing a marble or a similar object into the back of the snorer's clothes may encourage maintaining the new sleep position. When a snoring patient is obese, treatment may be a program of weight loss. Along with these treatments, of course, is the recommendation that the patient avoid use of drugs, cigarettes, or alcohol prior to bedtime to attenuate the loss of oropharyngeal muscle tone.

Snoring can sometimes be managed by the use of an appliance. One example is a custom-made mouthpiece constructed to move the snorer's lower jaw forward, thus opening the airway. Another example is the use of a positive pressure generator and facemask. These machines pump air through a hose and nose/mouth facemask to keep air passages clear. Continuous positive airway pressure (CPAP) therapy is typically reserved for cases of sleep apnea, and its long-term effectiveness is lim-

ited.[183] Use of each of these devices, however, can cause the subject to have less restful sleep.

Surgery is another option for treating snoring. In children whose snoring is caused by enlarged adenoids, adenoidectomy is sometimes recommended. Where tonsils are also enlarged, a tonsillectomy often accompanies surgery to the adenoids. In adults, uvulopalatopharyngoplasty (UPPP) may be recommended for habitual or heavy snorers. Here, the surgeon resects the uvula, the distal portion of the soft pallet, the anterior tonsillar pillars, and the redundant lateral pharyngeal wall mucosa. The purpose of such surgery is to increase the size of the air passageway thereby allowing unobstructed movement of air through the pharynx. Rates of success of the UPPP are uncertain, with improvement reported to be in a range from 15 to 65%.[184] In some instances, surgical repair of a deviated nasal septum has been shown to improve snoring.[185]

HEALTH IMPLICATIONS OF SNORING

Snoring remains a serious problem for a large segment of the population. While it is a nuisance, it may also indicate a more serious condition, sleep apnea. Patients who snore and have decreased pulmonary function have been shown to suffer from severe apnea. Cardiac arrhythmia has been reported during sleep apnea attacks. Not only is the risk of cessation of breathing a danger from snoring, but an obstructed nasopharyngeal passageway may also deprive the body of sufficient oxygen, leading to oxygen desaturation. Lack of oxygen may cause the brain to rouse the sleeper just enough to take a breath without fully waking. Since this may happen hundreds of times a night, the snorer does not get sufficient sleep. Moreover, being aroused from deep REM sleep on a repetitive basis may increase heart rate and blood pressure. Thus, snoring may increase the risk of heart attack and stroke. Further, daytime sleepiness resulting from inadequate sleep can cause a lack of attention during waking hours, thus reducing productivity and increasing the hazards associated with operating machinery or vehicles.

MSM AND SNORING

MSM is an effective, noninvasive, safe method of managing snoring. We usually instill intranasally a solution containing MSM dissolved in a carrier solvent (typically pharmaceutical-grade phosphate-buffered saline and water mixed in a ratio of 1:1 by volume). A sufficient quantity is used to saturate the patient's nasal mucous membrane about one hour before bedtime. We have found that intranasal administration of MSM reduces the incidence of snoring for approximately 8 to 12 hours. The addition of an analgesic compound, such as menthol, may provide even better results.

CLINICAL STUDY #1

We conducted two clinical trials of intranasal MSM for snoring, the first of which was a partial crossover trial with a single-blind design.[186] The initial experiments to determine effectiveness of the instillation of MSM as a snoring reduction agent were carried out at OHSU with a sampling of 15 patients. The data collected for the initial experiment are summarized in Table I.

In each of the above cases, the subject was instructed to instill approximately 0.5 to 1.0 ml (8 to 16 drops) of the MSM solution 10 minutes to one hour prior to retiring for sleep. The observation of the presence or absence of snoring was made by the subject's mate. The observer was blinded to whether or not the subject was employing intranasal MSM. As noted in Table I, 80% of the subject's mates reported the lessening or absence of snoring in their partners, while 20% reported no result from the intranasal administration of the MSM. Results were typically noticed after one or two nights.

CLINICAL STUDY #2

A second sampling of subjects was undertaken wherein the weight percentage of MSM in water was varied from 1 to 10%. Results of this study are summarized in Table II.

Table I

Subject	Sex	Age	% MSM (by weight)	Results
AO	M	56	16	R
US1	M	62	16	R
MD	F	50	16	R
GC1	F	56	15	R
PH	M	61	15	R
DM	M	62	15	R
GC2	M	72	14	NR
EC	M	76	14	R
DR	M	83	14	R
RB	M	56	13	R
MS	F	69	13	R
AD	M	50	13	NR
SJ	M	70	12	R
US2	F	76	12	R
RP	M	60	11	NR

R = Relief NR = No Relief

Table II

Subject	Sex	Age	% MSM (by weight)	Results
SC	F	54	10	R
JB1	M	34	10	R
TC	F	33	9	R
JP	F	55	9	R
WW	M	74	8	NR
CM	F	54	7	R
RB2	M	62	6	R
HP	M	42	6	R
WS	M	65	6	R
JM	F	49	5	R
KS	M	40	4	R
JS	M	60	3	R
SG	M	52	2	R
RH	M	59	1	R
JB2	M	60	1	NR

R = Relief NR = No Relief

While Table II demonstrates that relief of snoring occurred at concentrations of as little as 1% MSM by weight in water, the relief was not reported to be as dramatic as at higher concentrations. By warming the solution of water and MSM to no more than about 37.0°C (98.6°F), a greater concentration of MSM will go into solution. Accordingly, a third sampling of four subjects employed such a warmed solution, and the results are reported in Table III.

Table III				
Subject	Sex	Age	% MSM (by weight)	Results
JB2	M	60	20	R
EL	M	39	20	R
RF	M	40	19	R
LW	M	52	18	R

R = Relief NR = No Relief

Here, it may be noted that subject JB2 responded positively to 20% MSM, whereas the subject had previously failed to respond to 1% MSM.

From the data derived from these experiments, as tabulated in Tables I to III, it can be surmised that concentrations within a range of 1 to 20% MSM by weight in water are effective for snoring. Double-blind trials are recommended to confirm these preliminary observations. Higher concentrations within this range appear to be the most effective. However, due to the solubility properties of MSM in water, the best range for effective treatment that avoids the need of warming the solution is in the range of 10 to 16% MSM by weight.

In order to determine whether the intranasal introduction of simple saline alone might have ameliorated snoring in our subjects, we employed a crossover segment of the trial that included the first five subjects listed in Table I. A saline solution was substituted for the MSM solution after two weeks. Whereas relief had occurred in all five subjects while receiving the MSM solution, these subjects returned to snoring when that solution was replaced with simple saline solution on the first night. This suggests that saturation of the nasal membrane with the MSM solution produced the desired effect. The effects on snoring reduction were improved by instill-

ing the MSM directly before retiring for sleep. Several subjects reported that better results occurred when the solution was re-instilled during the night if they awakened.

A few of the subjects in Table I experienced minor irritation upon introduction of the MSM solution into the nasal passageway. In order to minimize irritation, a mild analgesic compound was included in the solution. In one example, approximately 0.25% by weight menthol was placed in solution. Of the patients who had experienced irritation, about one-third indicated a preference for the menthol solution while two-thirds preferred the solution without the menthol. Alternatively, a majority of the subjects who received a solution made of equal proportions of water and phosphate-buffered saline indicated a preference for that mixture over the simple water solution, except for the inconvenience of refrigeration required to prevent deterioration of the buffered phosphate. Refrigeration also reduces the amount of MSM that remains in the solution.

MSM PROTOCOL FOR SNORING

Preferably, a 10 to 16% solution of MSM is used. The solution is instilled into the nasal passageway as a spray or drop. The solution may contain a mild analgesic, if desired—menthol, procaine, xylocaine, and the like. Regardless of the method by which the solution is instilled, it should be instilled within one hour—preferably no more than 10 minutes—before the patient retires for sleep. An amount of solution should be instilled of sufficient quantity to saturate the patient's nasal mucus membranes, typically on the order of 0.5 ml to 1.0 ml per nostril. Premixed MSM for intranasal instillation is available to health professionals and can be formulated by most compounding pharmacists.

18

Miscellaneous Conditions and Unique Cases

In the course of treating approximately 18,000 patients with MSM, I have had the opportunity to use the compound for conditions less commonly seen in clinical practice, and for conditions for which there is no effective conventional treatment. In some cases, MSM produced dramatic effects, and in others, it was not helpful. The reasons for success or failure of MSM in these cases was not always clear; however, we believe there is value in presenting these cases as it may provide help to other patients suffering from these conditions. It is also our hope that reviewing several unique cases may help practitioners ascertain the types of conditions that could potentially respond to MSM.

BRAIN ATROPHY

JL, 76 year-old male

JL presented with a long history of chronic headache and instability of gait. JL was misdiagnosed with multiple sclerosis in 1981 and given intravenous adrenocorticotropic hormone (ACTH). In March 1994, he

began to develop frontal headaches that became progressively worse and were not alleviated by NSAIDs. The patient eventually saw the chief neurosurgeon at OHSU, who ordered CT and MRI scans. The imaging revealed generalized brain atrophy with enlarged subarachnoid spaces and fluid collection overlying the convexity of the brain, but an absence of focal lesions.

The neurosurgeon advised JL that there was no "correct" way to treat the condition and the only standard treatment available—surgically placing a shunt to drain the fluid accumulating in the subarachnoid space—had an equal chance of helping the problem or of causing significant complications. JL declined the surgery. Around the same time, JL had visited our clinic. His decision to decline the shunt procedure was partially based upon preliminary success he was experiencing with intravenous MSM (15 grams daily over nine weeks at our clinic at OHSU.) His neurosurgeon acknowledged the benefits of the MSM therapy and encouraged JL to pursue it, reserving surgery as a last resort.

JL presented to our clinic with severe headaches, which he described as "burning, sharp, aching" and radiating throughout his head. The pain was aggravated by most activities, particularly standing and straining (i.e., Valsalva maneuver). He was also experiencing nausea, vertigo, and a popping in his ears. His symptoms adversely affected his sleep, sex, and recreational activities. He had tried—without success—relaxation exercises, lying supine, heat therapy, bed rest, traction, and other physical modalities. He required narcotics to keep his pain under control.

We treated JL with a three-week series of IV MSM infusions (three times per week). The dose used was 100 cc of 15% MSM and 100 cc of 5% dextrose in water to make a 7.5% MSM solution. After one week of treatment, the symptoms persisted. After two weeks, the vertigo persisted, but JL reported that the headaches had improved somewhat and that there was a decrease in the popping in his ears. After a few more days, the vertigo resolved and the popping in the ears was "almost gone." After three weeks, headache was the only significant symptom remaining. It was constant, though significantly less severe than when he began MSM treatment. He reported that IV MSM had enabled him to discontinue taking

narcotics. He now described his headaches as "mild" and reported that he could control them with acetaminophen.

Because his response was so impressive, JL elected to continue with the IV MSM for an additional six weeks (three treatments per week). Six weeks after beginning MSM treatment, JL had "no complaints." After completing nine weeks of IV therapy, the patient was asymptomatic. He now takes a maintenance dose of oral MSM liquid (6 tsp per day, or 4.5 g MSM) and has been able to keep his pain under almost complete control, with only occasional episodes of pain. The patient reported being able to resume playing golf (in 100°F weather). He has continued to take oral MSM until the present time (seven years). An MRI scan performed five years after initiating MSM treatment showed no further brain deterioration.

JF, 71-year-old male

This patient, a medical doctor, had a sudden and severe disturbance in his gait (he was unable to walk) that coincided with a 102°F fever, an incessant cough, and an episode of urinary incontinence. He went to the emergency room for treatment and was admitted to the hospital; on physical exam, JF was confused and disoriented to person, place, and time. He exhibited bilateral endpoint dysmetria,* which was worse on the right side.

CT scan revealed mild cerebral atrophy and enlargement of the ventricles, but no evidence of hemorrhage or mass. Electroencephalography was normal and ruled out a seizure disorder. MRI demonstrated atrophy, bilateral chordate, and right semi-ovale lacunar infarcts. The patient was placed on clarithromycin and a guaifenesin-containing cough syrup to manage his fever and cough, respectively. He was discharged after four days, oriented but with the disturbance of gait persisting, with instructions to return the following week for a cisternogram (intrathecal injection of contrast media followed by scintigraphic imaging of the cranium at four intervals). The cisternogram result was abnormal,

*Dysmetria is an aspect of ataxia. It is impairment in the ability to control the distance, power, and speed of movement, usually of cerebellar origin.

showing ventricular penetration with delayed clearance over the cerebral convexities at 48 and 72 hours. However, the pattern was not consistent with normal pressure hydrocephalus, which was the working diagnosis.

Despite the uncertainty, JF was given a presumptive diagnosis of normal pressure hydrocephalus. The etiology of his condition remained unknown. Although the patient had a history of coronary artery disease and cardiac arrhythmia, vascular causes were ruled out, particularly vertebrobasilar insufficiency. No treatment was available for the condition, other than a surgical shunt to drain the hydrocephalus. The patient declined surgery.

JF was referred to our clinic by his family practitioner, whose daughter and son we had treated for lupus. He came to our clinic three months after his initial episode, still suffering from disturbance of gait and memory problems. The patient was given two IV treatments of MSM (100 cc of 15% MSM with 100 cc of 5% dextrose in water to make a 7.5% MSM solution) twice weekly, as well as oral and topical MSM per the usual regimen ($1^1/2$ tsp BID oral MSM liquid (15%), topical twice daily or more as needed).

Two weeks after initiating MSM treatment, JL reported feeling "brighter," and his gait was significantly improved. After ten weeks, his gait was reportedly good, and he showed improved cerebration. At this time, he was able to resume an active medical practice. JF continued MSM treatment for more than three years. Ten months after beginning treatment, he reported feeling "great—100%." Improvement continued after the one-year mark. A CT scan performed more than three years following his initial incident showed symmetrical dilation of the lateral ventricles and mild cerebrocortical atrophy. In short, no deterioration from his previous CT scan was evident. Shortly thereafter, the patient wrote, "In general, I seem to be doing well, enjoying life and still have a small medical practice that I enjoy greatly." He is now past 75 years of age and requires no prescription medications. He continues to take oral MSM (6 tsp daily, or 4.5 g MSM).

GRAFT-VERSUS-HOST DISEASE

JM, 40-year-old male

This patient received a bone-marrow transplant in 1998 following chemotherapy treatment of leukemia. However, he soon exhibited signs of a graft-versus-host reaction to the transplant. By January 2001, he was suffering considerably. JM's dermatologist reported poikilodermatous and sclerotic changes on the patient's arms, back, legs, and face. He described the patient's forearms as "hide-bound," and the degree of sclerosis was significant enough to restrict movement of the wrists and elbows. The dermatologist commented that this sclerosis was the worst he had seen in a case of graft-versus-host disease (GVHD).

We began treatment with oral MSM liquid ($1^{1}/_{2}$ tsp BID, to be doubled after three days) and topical MSM gel as needed. A week later, the patient reported doing "just OK." We administered IV MSM (100 cc of 15% MSM and 100 cc of 5% dextrose in water to make a 7.5% MSM solution), increased the topical applications to one 4-ounce bottle per day, and increased the oral dose to 4 ounces per day (17 grams MSM). Four days later, we recommended a six-week series of IV MSM treatments, but JM could not find a practitioner in his area to administer the treatments, so he continued on only oral and topical MSM. He returned to our clinic two months later for an IV treatment, and reported "feeling better" from the oral and topical MSM. JM received another IV treatment a week later (in addition to continued oral and topical MSM), and reported improved flexibility in his arms. A week after that, we observed that the skin on his arms had continued to soften. That was his last visit to our clinic.

GVHD occurs when immunocompetent lymphocytes or their precursors are grafted into immunologically compromised recipients. When normal bone-marrow cells from allogenic donors enter the recipient's bloodstream, immunocompetent T lymphocytes from the donor marrow may recognize the recipient's tissues as "other" and react against them. Any organ can be affected by GVHD, but the predominant clinical manifestations occur in the skin, liver, and intestinal mucosa. The disease and its complications are often life threatening.

We do not know by what mechanism MSM mitigated the cutaneous manifestations of GVHD in JM's case. It should be noted that the effects were modest, and the dose of MSM used was relatively large. Nevertheless, we have found MSM to be effective for many other immunological conditions, most notably seasonal allergic rhinitis, asthma, and autoimmune conditions such as scleroderma, lupus, and interstitial cystitis.

ACNE ROSACEA/DERMATOMYOSITIS

CB, male, age withheld

CB came to our clinic with an eight-year history of acne rosacea and dermatomyositis. His rheumatologist had prescribed methotrexate, but it was not effective. CB presented with a rash on his forehead and hands; his chief complaint was incapacitating pruritis and inflammation of the scalp. We began treatment with oral MSM ($1^1/2$ teaspoons liquid MSM BID) and topical MSM (twice daily or more as needed).

After two months of treatment, the patient reported "1000%" improvement. The erythema on his forehead was significantly diminished. However, he discovered that he needed to stay on the MSM to maintain these benefits. After running out of his supply of oral MSM, he felt less well and had a flare up of the rosacea. Six months after initiating treatment, CB reported that he had increased his dose to 3 tsp (about 2,250 mg MSM) twice daily plus the topical MSM. The blotchy redness on his knuckles disappeared, and his scalp inflammation decreased.

ECZEMA

Many patients ask whether topical MSM is an effective treatment for eczema. Unfortunately, our experience with MSM and eczema is somewhat limited, and results have not generated the same enthusiasm as they have for other conditions involving the skin (e.g., scleroderma).

SE, 45-year-old female

SE visited our clinic in 1999, complaining of fatigue and severe eczema of the face, breasts, and anterior abdomen. The condition was refractory to previous medical treatment. We treated her with a combination of oral and topical MSM, beginning at $1^1/2$ tsp oral BID and increasing over time to 3 tsp BID per patient tolerance.

Two weeks after initiating treatment, SE reported feeling more energetic. Her skin had improved and was noticeably softer, less lichenified. One month after initiating MSM, she felt she had lost ground, but her improvement resumed after two months; SE's skin showed marked improvement and her skin felt more normal as well.

The following month, her improvement was maintained on oral MSM alone. She increased the dose to 3 tsp TID to see if taking more would eventually allow her to discontinue therapy. A month later, she ran out of MSM for three or four days and her skin broke out in an eczematous rash. On her last visit to our clinic—seven months after beginning treatment—she reported feeling well and observing improvement in her skin.

MYOSITIS OSSIFICANS GENERALIS

Myositis ossificans generalis is a non-neoplastic condition of the musculature that may clinically or radiologically mimic malignant bone tumors. The etiology of this disease is unknown but is probably a genetic or autoimmune disorder.

AZ, eight-year-old female

AZ presented with severe myositis ossificans generalis. We treated her with 1 tsp of MSM liquid orally in split daily doses for nearly two years. The disease process slowed. She is now occasionally out of her wheelchair. AZ belongs to a support group for children with myositis ossificans generalis and their parents. No other child in the group is on MSM, and all of the other children, save AZ, are deteriorating.

LICHEN PLANUS

Lichen planus (LP) is a recurrent, pruritic, inflammatory eruption on the flexor surfaces of the wrists, legs, trunk, genitals, and oral mucosa. The lesions are typically small, discrete violaceous papules that may coalesce into rough scaly patches. The cause of LP is unknown.

JF, 70-year-old female

Onset of this condition may be abrupt or gradual. In JF's case, it was abrupt, immediately following the death of her son-in-law. Her lesions were primarily oral and pretibial. She had a secondary diagnosis of osteoarthritis, which manifested as a degenerative disease of the knee. Her chief complaint was pain caused by the LP eruption in her mouth.

We began treating JF with a three-month trial of oral (1 1/2 tsp BID, swished and swallowed) and topical MSM. Within a month, there were no significant changes evident, although the mucous membranes of her mouth were reportedly "quiet on occasion." After two months, JF was having improvements in her OA pain, and the appearance of her oral lesions were somewhat improved. After eight months of treatment, her LP was resolved and her OA pain was under control. She reported having no LP outbreaks since beginning MSM.

A year and a half after beginning treatment, the patient reported that she was fine as long as she continued the MSM at the original dose. JF's dental hygienist expressed surprise and delight over the appearance of her mouth. Around this time she was also re-evaluated by her dermatologist, who reported that her pretibial and oral LP had cleared and stayed clear. He also confirmed the importance of maintaining her MSM dose; when she fails to do this, biopsy-proven LP returns. Oral examination revealed a fine, lacy dermatitis along the corners of the buccal mucosa, consistent with LP, but the lesion is mild and asymptomatic. The dermatologist recommended that JF continue taking MSM.

RADIATION FIBROSIS

GF, 53-year-old male

Following an abdominoperineal resection and recurrent radiation treatments for cancer of the colon, GF had a 12-year history of fibrosis and pain, particularly from the scar tissue underneath his coccyx. He used NSAIDs, narcotics, and transcutaneous electrical nerve stimulation (TENS) for pain control, but they were inadequate. He continued to have trouble with incapacitating pelvic and coccygeal pain, which kept him from working. He had been to several neurologists and pain specialists prior to visiting our clinic.

GF received a combination of MSM therapy from our clinic and myofascial pain release from a local practitioner. Our therapy consisted of oral and topical MSM in the usual regimen ($1^1/2$ tsp BID oral; twice daily topical applications or more, as needed). Improvement began within a month and gained steadily. After three months of MSM therapy, GF reported a major decrease in pain. This improvement continued until GF was able to discontinue all pain medications and go back to work full-time. The surgeon who performed the surgical resection called it a "remarkable result!"

PLANTAR FASCIITIS

JF, 45-year-old male

JF came to our clinic with a one-year history of plantar fasciitis of the left foot. He experienced severe pain in putting weight on that foot, especially in the morning. He had tried massage and foot soaks without success and was referred to our clinic by an orthopedic surgeon. JF responded well to topical MSM after about a month, after which time he was able to discontinue using it. Two years later, the patient had another case of plantar fasciitis, this time in his right foot. His results with MSM had been excellent, so he wrote to us requesting more topical gel, which we sent to him. No further follow-up is available.

I suffered from plantar fasciitis for six weeks following a crush injury. One month of topical MSM twice daily to both feet relieved the symptoms.

CALCANEAL SPURS

SP, 53-year-old female

SP presented to our clinic with two spurs on her right heel and one on her left. The spurs had been progressive over several years. She was taking diclofenac sodium to control her pain, with little success.

We treated her with foot soaks of 25% DMSO twice daily, oral MSM liquid, and topical MSM gel. Within two weeks, she reported a "slight benefit." In a month she was "feeling pretty darn good." She had been able to take a trip to Disneyland with her family with no limitation in her activity. SP's improvement continued for four months, after which she was lost to follow-up.

NERVE DAMAGE

DL, 53-year-old male

While working with a jigsaw, DL sustained a severe laceration to his left wrist that completely transected the median nerve. The injury was repaired surgically, but the patient was left with decreased sensation in the distribution of the nerve: his left thumb, index finger, and middle finger. He came to our clinic with a chief complaint of pain, numbness, and loss of grip strength. Physical examination showed evidence of denervation to the muscles on the radial aspect of his hand, with decreased mobility. He had a secondary complaint of osteoarthritis in the shoulders and knees.

We treated DL with one week of IV MSM (five infusions per week), as well as oral MSM liquid ($1^1/2$ tsp BID) and topical MSM gel. After one week of therapy, DL did not note improvement in his symptoms of the hand, but there was a "big difference" in his general level of joint pain. Three weeks later, DL reported slow improvement of his injured hand, and continued improvement of his shoulders and knees. After six weeks, DL

said that his hand was at least 30% better since his initial visit, although the numbness in his thumb and fingers was unchanged.

Three months after initiating treatment, the patient reported feeling "great," and believed that the treatment was "really working." Seven months into his regimen, DL had two more IV treatments to speed improvement. He continued to improve over the next several months. At 16 months, DL had not experienced any return of normal sensation to his fingers. However, he did report that his grip strength was much improved and his pain significantly diminished.

MESENTERIC PANNICULITIS

Mesenteric panniculitis is a nonspecific inflammatory and fibrotic disease affecting the fatty tissue of the mesentery. It is called "retractile mesenteritis" when the main component is fibrosis, and "mesenteric lipodystrophy" when the main component is inflammation. The etiology, in most cases, is unknown.

In diagnosing mesenteric panniculitis, one must rule out pancreatitis, inflammatory bowel disease, and extra-abdominal fat necrosis (Weber-Christian disease). Symptoms are variable and include abdominal pain, fever, nausea, vomiting, and weight loss. Symptoms often persist for a year or more. Physical examination may be unremarkable or may reveal abdominal tenderness or a palpable mass.[187]

RG, 59-year-old male

RG had a four-year history of an abdominal mass. He was given IV MSM (30 grams three times weekly), as well as oral ($1^1/2$ tsp BID) and topical MSM. The treatment regimen continued for eight months, during which time the size of the abdominal mass diminished. At the time of this writing, it is three years after initiating therapy. RG's energy level is up, and he has returned to work part time as a supervisor for construction.

19

Veterinary Uses
for MSM

We are not veterinarians and lack the expertise to comprehensively advise veterinarians regarding the therapeutic use of MSM. Veterinarians were frontrunners in the clinical application of MSM and we are grateful for their enormous contribution to our understanding. The use of MSM as a veterinary medicine—particularly for horses, cats, and dogs—is vital and longstanding. There are hundreds of case reports detailing the use of MSM in treating canine arthritis alone. In this chapter, we will share veterinary cases that have been shared with us, cases that have been reported in the veterinary literature and in United States patents on MSM, and some cases that were collected by the late John W. Metcalf, DVM. Most of the cases presented here were not published in peer-reviewed journals. Some appear only in the private letters of Dr. Metcalf or in the MSM patents. We recognize the inherent limitations in this type of reporting and welcome publication of controlled clinical trials in peer-reviewed veterinary journals. In the meantime, however, these are the most instructive cases available to us.

From 1983 until his retirement, Dr. Metcalf, an expert on lameness in horses, used MSM in his practice with impressive results. He found that MSM provided often dramatic resolution of various causes of lameness, including bicipital bursitis, laminitis, myositis, suspected back pain not involving the spinal cord, peptic ulcers, diarrhea problems in young foals, and epiphysitis. Dr. Metcalf even reported stimulation of reproductive capacity in geriatric mares.

Published research in veterinary journals suggests several pharmacological uses of MSM, including moderating allergic reactions from pollens; moderating gastrointestinal tract upset from many causes, including diet and oral drugs; and improving absorption of other nutrients affected by pain and inflammation.[188]

HIP DYSPLASIA

This case was related by DF of Colorado.[189] A large, male German shepherd dog, approximately 8 years old, had always been exceptionally active and "up." However, he gradually developed hip dysplasia, and his pain became evident by the antalgic carriage of his hindquarters. He ceased grooming his hindquarters and would snap at anyone attempting to touch him there. He lost his ability to jump in and out of vehicles and was reticent to walk or run any more than necessary.

His caregivers began giving him $1/2$ teaspoon (2.5 grams) of MSM mixed with his food on a daily basis. Within just a few days, he showed improvement. After approximately three weeks of treatment, the changes in the dog's behavior and attitude were dramatic. He was reportedly bouncing and frolicking "like a puppy" and clearly experienced relief. Nevertheless, the problem was not completely eliminated; the dog has good and bad days, but his caregivers are convinced that MSM clearly benefited him, and the manifestations of his hip dysplasia are notably less severe.

POOR HOOF HEALTH IN HORSES

In a report from a veterinary clinic in England,[190] the authors identify a link between poor hoof health and non-grazing or stabling among horses, and attribute the connection to a lack of naturally occurring MSM in lush pastureland. Horses and foals, when stabled and fed processed, low-protein, or milk replacer feedstuffs, are most liable to be sulfur-deficient. The authors stated:

"Results have been quite revealing to the expressed delight of owners, farriers and ourselves alike. MSM visibly demonstrated rapid resolution in both hoof quality and growth. This reversal to normality was manifest not only from within the coronary band (i.e., the growth center for the hoof) but also showed a dramatic improvement in quality within the hoof wall closer to the bearing surface (i.e., where the shoe is fitted). The reason for this latter curious and unprecedented finding is unknown. One suggestion is that MSM somehow increases moisturization in the hoof wall.

"Taking into account all of the few dozen, and often on-going, cases where MSM feed supplementation has been applied, we have found (almost) without failure that MSM evokes effective hoof resolution. This was brought about far sooner than had been achieved, for example, in past experiences with biotin. Incidentally, at present biotin is the most utilized hoof growth supplement."

These authors reported that horses given daily doses of MSM returned to their sporting, riding, and shoeing activity quicker than the authors had imagined possible. They suggest that other minerals (e.g., zinc, calcium) can be administered concomitantly. Specifically, the authors recommend 2.5 to 10 grams of MSM per day in feed, which is approximately 5 to 10 times what they estimate the animal would obtain naturally from grazing in lush pastureland. A large 1,100-pound (500 kg) horse has an average MSM intake per feeding of 0.5 to 1.0 gram.[191] The authors recommend preventive feeding of MSM to stabled horses and foals "against a fair chance of developing poor hooves later in life."

CHRONIC OBSTRUCTIVE PULMONARY DISEASE IN HORSES

Clinicians at Oregon State University have reportedly used MSM to treat two cases of chronic obstructive pulmonary disease (COPD) in horses.[192] The horses were given 15 grams of MSM orally twice daily for one week. Clinical improvement was noted after one week, with reduction in the maximal change in pleural pressures. The condition of one of the animals, however, regressed when MSM was discontinued.

Researchers from the College of Veterinary Medicine and Biomedical Sciences at Colorado State University evaluated the efficacy of three treatments for COPD in horses: prednisone (400 mg/horse, PO, daily; n = 7), MSM (10 g/horse, PO, q 12 h; n = 6), and clenbuterol hydrochloride (0.4 mg/horse, PO, q 12 h; n = 7).[193] A fourth group acted as controls (n = 6) and was not treated. The treatment period lasted 10 days. Multiple physical and laboratory variables were monitored before, during, and after each 10-day trial period. Changes in lung sounds, respiratory effort, degree of anal movement, nasal discharge, temperature, respiratory rate, or heart rate were not significant. Changes in arterial blood gas tensions, tracheal wash or bronchoalveolar lavage cytologic findings, or phagocyte function were not significant. The authors explain the apparent lack of efficacy of all three treatments to the advanced state of illness in the horses.

APPARENT SULFUR DEFICIENCY

The combination of poor or brittle hooves, poor skin, and/or coat/hair condition led researchers to supplement the feed of approximately 125 horses with MSM.[194] Feed rations were supplemented with approximately 3 to 15 grams of MSM per day. No additional supplements were given, except appropriate medication as indicated in a small minority of horses. Approximately half of the animals had varying degrees of growth defects in the hooves. They reported:

"Remarkable improvement in hoof growth and condition was self-evident. This after only 10–12 weeks of MSM administration. In fact, improvement in growth was becoming noticeable after only 6–8

weeks (summer months). Full restoration and fissure resolution took a little longer; but, in severe cases, results at 10–14 weeks equated with those claimed for Biotin administration after a much lengthier 10–17 months…

"Curiously, the quality improvement in hoof independent of growth, due to MSM, extended to below a line level with the internal blood supply of the foot. Historically, this has never been reported with horses on other feed supplements, including methionine, cystine and biotin…"

A CASE OF THE HEAVES [195]

This horse's asthma had been managed with various corticosteroids and antibiotics (for secondary infections) when he eventually developed a condition of excessive salivation. Sometimes it was thick and streamed from his mouth; other times it was foamy, but it was always colorless. Swallowing the foam caused him to develop colic. After about two weeks of the excessive salivation, the horse developed partial paralysis of his tongue and this interfered with normal feeding. The slobbering was considered a possible side effect of albuterol.

After a steady decline of about six months, the horse was started on MSM, at the recommendation of Dr. Metcalf. The keepers began with 2 heaping tablespoons (a level tablespoon provides approximately 15 grams) per day in the horse's food. They wrote:

"I wish we had before and after pictures. He looks like he could go right into the show ring. He is bright, filled out, glossy and has lost most of his big stomach. He is aggressive and bossy again, his old adorable self, and has taken over leadership of the barn…What a breakthrough this would be for human beings."

The owners reported that the horse was maintained thereafter on a dose of one heaping tablespoon MSM morning, noon and night, increasing the dose when temperature and humidity were high.

Dr. Metcalf confirmed that he has also successfully treated the heaves with MSM.[196]

CANINE ARTHRITIS

After noting desirable benefits of MSM on himself, Dr. Metcalf tried MSM with his 11-year-old black Labrador retriever. She had severe arthritis, particularly involving the hips, and had been maintained on 400 mg of phenylbutazone per day. Her condition has been so severe, she frequently required help getting to her feet. Dr. Metcalf started adding a heaping teaspoon (6 to 7 grams BID) of MSM to her food and discontinued the phenylbutazone. For about a month, there appeared to be no benefit. Then she gradually improved, and eventually got to her feet regularly without help. A similar protocol was applied to four other dogs with similar histories. The consensus of their owners was that MSM "turned back the clock" on all five animals to their healthy state of three to four years prior to treatment.[197]

MSM was evaluated as an additive to the diet of older dogs of various breeds, each suffering from some form of arthritis and in some cases demonstrating other disorders.[198,199] In all cases, MSM was mixed with the animal's food immediately prior to feeding.

In a similar case, a 15-year-old, spayed German shepherd, weighing 36 kg, demonstrated ataxia and virtual immobility with pain and joint stiffness. The animal was not responsive to cortisone or phenylbutazone. She was given 0.5 grams of MSM, BID for seven days, without apparent benefit. The dosage was raised to 1.5 grams per day BID, and within 10 days the dog became freely mobile without evident discomfort or demonstrated ataxia.

A male, black Labrador retriever, weighing 27 kg, demonstrated severe musculoskeletal compromise of the hindquarters with urinary incontinence. This animal, although owned by a veterinarian, had failed to respond to several therapeutic regimens over the previous 12 months. MSM was given to this dog in his food at a dose of 1.5 grams BID for one month. This dog derived no apparent benefit from MSM.

A 14-year-old, spayed German shepherd demonstrated severe arthritis of the back and legs. The dog was mobile but walked with obvious difficulty and discomfort. The animal was refractory to both cortisone and phenylbu-

tazone. MSM was provided in the diet at a level of 0.5 grams twice daily. There was gradual improvement in mobility over the first month. During the third month following MSM supplementation of the diet, the dog demonstrated neither musculoskeletal restriction nor discomfort.

A female mixed-breed terrier, weighing 20 kg, demonstrated severe restriction in mobility and obvious discomfort with movement. The animal had responded to neither cortisone nor phenylbutazone and her condition was deteriorating rapidly. MSM was included in the dog's diet at 1 gram BID. After one week, the dog appeared to be free of pain. This dog received MSM for over six months and remained apparently healthy and frisky, requiring no medication.

BACK PROBLEMS IN HORSES

Dr. Metcalf reports having successfully treated many back and muscle problems in horses with MSM, including in his daughter's jumper, thoroughbreds on the track, event horses, and show horses. These types of competition can strain a horse's back, causing difficult-to-diagnose and difficult-to-treat problems. Dr. Metcalf treated his own horse, a four-year-old hunter-in-training. The horse had been unsuccessful in racing and had a history of chronic muscle soreness. Before MSM was added to his feed he was reluctant to race—throwing his ears back with frequent tail action. This horse, and all other horses studied received 12 to 15 grams BID in their feed. With this horse, it took about a week to see a significant change. He is now a different animal, appearing to enjoy his job.[200]

GAIT DISORDER

Dr. Metcalf conducted a second trial with a yearling filly that exhibited a wobbly disorder of gait. This horse was to be examined shortly for a select thoroughbred yearling sale. The owner was unwilling to allow the work-up required to determine a specific diagnosis. With the hope that it was a herpes involvement, he administered MSM (6 to 8 grams BID). The horse went through inspection and was passed by an exacting inspector.

Dr. Metcalf's rationale for trying MSM in this case stemmed from his success using intravenous DMSO with a few herpes-incoordinate animals. Fifteen percent of DMSO is converted to MSM *in vivo*.[201]

EPIPHYSITIS

Dr. Metcalf reports having treated at least seven horses with confirmed epiphysitis, and each improved much faster with MSM than with conventional therapy. With these young horses, the dosage of MSM in each case was 6 to 8 grams added twice daily in the feed.

His most dramatic epiphysitis case was a filly being prepared for the select sale. When first seen, she appeared extremely sore—with marked reaction on palpation—and was reluctant to come out of the stall. The animal was to be inspected in one week. Her total intake of MSM during this week was roughly 100 grams. Dr. Metcalf reports that the animal was inspected after a week's treatment and passed.[202]

PLEURITIS

A filly foal was seen with marked pleuritis, demonstrating no active infection but extremely noisy lungs. MSM was added to the feed at 12 to 14 grams per day as a split feed addition over five days. No medication was used in conjunction with the MSM. The fibrous pleurisy cleared, and her lungs were clear to auscultation after the fifth day.[203]

GASTROINTESTINAL DISTURBANCES

A yearling filly had an ongoing problem with a history of frequent recurrent digestive tract disturbances beginning when she was a suckling. The horse seemed to respond to treatment with cimetidine, aloe vera, and coating agents. With treatment termination, she demonstrated varying degrees of discomfort within a short time. Dr. Metcalf added MSM to the horse's diet at 12 to 14 grams per day as a split addition for approximately 90 days, and she became problem free. In a related case, a suckling with

signs of acute gastritis was responding well to cimetidine. Symptoms returned, however, when treatment was discontinued for 10 days. The foal had been given a combination of MSM and aloe vera over a 10-day period and soon regained good health.[204]

An Arabian stallion in Georgia developed a severe case of diarrhea that was refractory to treatment. Specialists were consulted to no avail, and the horse became debilitated. The horse was placed on MSM supplementation (in his grain at each feeding); no doses specified per Dr. Metcalf's instructions, and in a matter of days, the feces firmed up, the odor improved, and the horse made a full recovery in six weeks.[205]

OSTEOCHONDROSIS (HORSES)

Dr. Metcalf wrote that there is considerable variation in the degree of pathology evident in different cases of osteochondrosis. If there is major damage to the joint, Dr. Metcalf reports that MSM will provide limited benefit but is nevertheless worth trying. He recommended one ounce (30 grams) twice daily in the feed.[206]

REHABILITATION FROM EXTREME NEGLECT

This following case was submitted to Dr. Metcalf from a client in Little Rock, Arkansas.[207]

My boss…took in two thoroughbred broodmares, one with a foal at side…We sent my vet down to the place they were before we got them and they were so bad that he said he (should) have turned the owner over to the Humane Society, and he said that the horses were both foundered…and that the baby seemed to have some trouble with her stifle joints. The filly (was) approximately 3 months old. He told me that if we made the horses live, he would be surprised…

One of the mares was so foundered that it took 5 minutes to get her to walk about fifty feet to the paddock that we had prepared for her. The other one was in very bad shape and one of her back hooves was at least 12 inches long making the pastern angle extreme. This is the one with

the filly and she just didn't seem to have enough bag to be milking one. The filly was pretty bad but still hobbling around.

We immediately wormed them and gave them baths, I forgot to mention that they both had Rain Rot (I call it the Arkansas Creeping Crud), and proceeded to feed them a little at a time. And of course we got their feet trimmed.

In just about one week (on feed and MSM), the older mare had started walking better, the filly was frolicking around the paddock, and the one with the 12-inch long foot was making better bag and just all around looked better. Their skin was more pliable and their hair coat was almost shiny. When we got them they were so dried out it was hard to see what color they were…

We ran out of MSM and…went about one week without it. My husband came out to the farm on the weekend and asked why the mares looked like they were going down hill when, just last week, we had them looking so much better. The next day, the filly's stifles locked up on her…We received (the MSM three days later) and immediately started everyone mentioned on it again, and in 2 days the filly was once again walking normally, and both of the broodmares seemed to start picking up once again. And the older mare was walking easier also.

I don't mind telling you that I have been in the horse business all of my life and am very familiar with people claiming they have the "Miracle of the Horse Industry" that will cure all evils, etc… I was the skeptic on the farm, and my boss talked me into sending for the MSM. I am (now) a very firm believer in your MSM and am planning to start my Arabian mare and colt on it…

OVERALL HEALTH

Immature laboratory animals, including dogs, consistently gained weight at a greater rate than controls when MSM was included in their water and/or food.[208] This was observed at both low and high dosage levels, from 60 mg to approximately 500 mg/kg body weight per day. In addi-

tion, the fur quality improved and somewhat faster nail growth was noted. Weight increases were not seen with adult animals during comparable feed experiments that did not include MSM.

NAIL GROWTH

To determine the effect of MSM on nail growth, two littermate female Labrador retrievers, aged 8.5 months, were maintained in side-by-side straw bedded cages.[209] Before any testing, impressions were taken of the front paws of each dog.

Each dog was fed dog chow and water ad libitum for 45 days. One of the dogs (animal A) had no change of ration and the other (animal B) was supplied with additional water containing 5% MSM. After 45 days, plaster impressions of the front paws of each dog were repeated. Pre- and post-study castings of each animal were compared. The straw bedding protected both animals from normal nail wear. On visual examination, the nails of animal B were, on average, approximately one-eighth inch longer than those of animal A.

ANIMAL COATS

The coats of animals A and B mentioned above were examined by three individuals. Each judged the coat of animal B to be superior, based on thickness and the shiny appearance generally associated with good health.

In another study, ten 4-week-old guinea pigs were housed in individual metal cages in a standard-temperature room employing a 12-hour light/dark cycle. The animals were acclimated over a five-day period and fed guinea pig chow with water *ad libitum*. On day six, five animals were marked on the belly with red and the other five with blue water-insoluble ink. The marks were not visible when the animals were observed from above. After marking, each animal was returned to its cage and corresponding red or blue tape affixed to the animal's watering bottle. The red-marked bottles were maintained with tap water and the blue-marked bottles were filled with tap water containing 2% MSM by weight. After 28 days on these reg-

imens, the animals were placed in common confinement on a lighted table. Four individuals, totally unfamiliar with the test and its purpose were asked to evaluate the coat of each animal. Animals at each evaluation were removed by the evaluator and placed into one of two groups based on better or poorer quality of the animal's coat without seeing the color on the animal's belly. Three of the four evaluators quickly selected five animals with superior coats, all of which were later determined to be in the MSM-treated group. The fourth evaluator selected three animals with a blue belly mark as having superior coats but concluded he could not distinguish better from the poorer with the remaining seven animals.

EQUINE PLEURITIS

A case has been reported[210] of a breeding mare, treated for a respiratory infection, that developed bilateral fibrinous pleuritis, easily heard with auscultation of the chest. After six weeks of therapy with a combination of conventional antibiotics and anti-inflammatory drugs, there was little improvement. Conventional treatment was terminated and five days of MSM therapy (12 grams BID) was initiated as monotherapy. By the fifth day, the animal reportedly demonstrated no more pain, and the breathing had returned to normal. Auscultation of the chest was normal. The horse remained healthy for a follow-up period of observation lasting two years.

HYPERPARATHYROIDISM WITH EPIPHYSITIS

One study reports on two colts and four fillies,[211] all diagnosed as having hyperparathyroidism secondary to nutritional inadequacy with concomitant epiphysitis. Each animal was provided with 12 grams of MSM BID in a bran/molasses blend mixed with their standard dry feed prior to feeding. The supplemented feed was well accepted.

All signs and symptoms of the disease were corrected by MSM therapy in all animals within 7 to 10 days. Except for the added MSM, there was no change in the diet of these seven horses.

STRESS DEATHS

Stress death is a common phenomenon for some species of animals. In chickens, the deaths are attributed to crowded living and transport conditions and poor handling; turkeys are also susceptible to stress deaths. Tropical species of fish, sold commercially for aquariums, are sensitive to changes in the composition and temperature of their water and may succumb to stress death if not properly housed and fed. MSM is reportedly useful in reducing the incidence of stress-related deaths when administered daily for 7 to 90 days; the preferred dosage, according to one researcher, is between 0.01 and 5 mg/kg body weight per day.[212]

Robert J. Herschler reports conducting a study in which he fed broiler chickens less than a few days old one of two diets: standard feed or standard feed plus 0.2% MSM by weight for 30 days.[213] Herschler reported "a significant difference between the stress death rates in the two lots during that period." In chicks fed unmodified feed, the death rate approached 10%, whereas those fed MSM-modified feed had a death rate of less than 1%.

In another study,[214] 62 two-inch goldfish were divided into two 31-population lots and placed in two acclimated aquariums, maintained at 50°F. On receipt of the fish, two small one-gallon aquariums were filled with tap water and stabilized for five days by aeration with an aerator/filter combination connected to an aquarium air pump. Air delivery during the test period was standardized at 100 milliliters of air per minute. From a one-ounce package of goldfish food, two 10-gram samples were removed. One sample was left untreated, and the other was moistened with about one milliliter of pure ethanol containing 0.2 grams MSM in solution. Both feeds were pulverized to a coarse powder suitable for the feeding of small fishes.

During the acclimatization and test periods one batch of fish (batch A) were fed 0.5 grams of untreated food once daily; batch B fish were fed 0.5 grams of the feed containing MSM. Most of each feeding was consumed in the first five to 10 minutes after delivery. During the fifth day, 25 fish from batch A were transferred to one small aquarium (designated A) and 25 fish from batch B were moved to the other small aquarium (designated B).

Before transfer, the temperature of each aquarium was adjusted with ice to 41°F. The water was allowed to return to 50°F after the fish were added to the tank. The fish from both batches were thus subject to a total of a 9° temperature change, which greatly stressed them. Feeding was resumed after withholding food for one day in the small tanks. By day 10 there had been a total of 11 deaths in aquarium A (control) and one death in aquarium B. The author concluded that addition of 2% MSM to the feed of these fish reduced stress deaths significantly.

PART III

Special
Topics

20

MSM Dosage Protocols

MSM is available in capsule, tablet, powder (flake, microprill,* and crystals), and liquid form. It is available alone and combined with other nutrients (e.g., glucosamine sulfate). MSM is also available in specially designed applicator bottles for intranasal instillation to treat snoring. Topical formulations include creams, lotions, and gels. When properly prepared by qualified pharmacists and administered by trained physicians, MSM may be administered intravenously, intramuscularly, and even intravesically. However, only a limited number of physicians, for the most part practicing in the state of Oregon, are acquainted with these methods of administration. The most common routes of administration are oral and topical.

From the perspective of safety of administration, MSM may be peerless among the agents we have encountered. We have formulated MSM for most routes of administration used in medicine: oral, topical, perioral,

* A microprill is a tiny sphere of pure MSM produced by a proprietary spray-cooling method.

intravaginal, intranasal, and intravenous—all with negligible side effects. Few substances have such a broad range of safe and well-tolerated administration routes.

ORAL MSM

MSM is most commonly taken as a dietary supplement in capsule or tablet form. When we have administered oral MSM in our clinic, it was usually as an oral liquid, or sometimes as MSM powder admixed with water. Typical OTC formulations provide 750 mg or 1,000 mg per tablet or capsule. In our experience, MSM tablets and capsules are best taken twice daily, with breakfast and lunch. Taking MSM before bedtime may cause difficulty with sleep in some cases, as MSM supplementation appears to increase energy levels.

A typical starting dose of oral MSM is 2 grams per day, taken in divided doses. This amount is often doubled after a week, and doubled again after two weeks. A level pharmacist's teaspoon provides approximately 4 grams (flake, microprill, or crystal). A level kitchen teaspoon provides approximately 5 grams. A level tablespoon provides about 15 grams. A four-ounce container of 15% liquid MSM contains 17 grams of MSM. MSM has a slightly bitter taste.

We have had excellent results with liquid oral MSM in a 15% concentration. We combine it with deionized water and dispense it in an 8-ounce bottle. The initial dosage is $1^{1}/2$ teaspoons (about 1 gram MSM) BID, with breakfast and lunch. Liquid MSM can be mixed with any other type of fluid, such as fruit juice, water, soda, milk, and coffee. It should not be mixed with alcoholic beverages. When using the liquid oral form, we recommend swishing it in the oral cavity before swallowing, to enhance sublingual absorption.

Orally administered MSM appears to increase gastrointestinal peristalsis through cholinesterase inhibition. Patients may therefore develop mild GI disturbance or an increased frequency of bowel movements when taking oral MSM. Our policy is to begin with a lower dose, and increase it gradually. We have given individual patients upwards to 16 ounces of 15%

liquid (providing 68 g MSM) per day. On rare occasions, we have administered over 100 g of MSM per day by the oral route with no adverse effects.

For most patients, oral administration of MSM is sufficient to initiate pain relief and amelioration of disease states. Oral administration may be combined with topical use and, if necessary, IV administration if initial pain or disease states are acute.

TOPICAL MSM GEL

MSM is rapidly absorbed through the skin. In some cases—especially when inflammation and pain are present—patients will experience optimal results with a combination of oral and topical MSM. Topical MSM gel dries quickly and may be applied as often as necessary. MSM powder may be used in the whirlpool or bath for the relief of muscle and joint pain. Because of the expense of MSM powder, it is recommended that local soaks or applications be considered. Again, a 15% concentration should not be exceeded, as MSM will precipitate out of solution at approximately 16% or more. To achieve a 15% solution with MSM powder for soaking, 19.2 ounces of MSM powder may be added to each gallon of water used for soaking. For an easier rule of thumb, a pound of MSM per gallon of water may be used. This makes a 12.5% solution. We know of no instance of contact dermatitis or irritation of the skin due to its topical uses.

For topical gel application, we advise patients to apply by hand about 1/2 teaspoon of gel over affected areas at least two times per day. More MSM may be used as needed, and applications can be as frequent as every hour. MSM gel may leave a white residue on the skin, which can be washed off with warm water a few minutes after application. Unlike, DMSO, MSM is not a carrier. DMSO can carry certain low molecular weight compounds across the skin, but it will not carry anything with a molecular weight above 1000 (e.g., viruses and bacteria). Also unlike DMSO, MSM administration by any route produces no body or breath odor.

We have had excellent success using a combination of oral and topical MSM for a host of conditions, including scleroderma (both morphea and systemic sclerosis), lupus, osteoarthritis, rheumatoid arthritis, bursitis, tendonitis, fibromyalgia, carpal tunnel syndrome, whiplash syndrome, and multiple varieties of back pain, including disc-induced discomfort.

INTRAVENOUS ADMINISTRATION

The use of intravenous MSM is always under the care of a qualified physician. In acutely ill patients, dramatic benefits are often obtained by the IV administration of large doses of MSM. For example, acute exacerbations of rheumatoid arthritis may be ameliorated or forestalled with IV MSM. We have observed this even after oral MSM produced equivocal results.

In intensely painful conditions, such as rheumatoid arthritis, advanced osteoporosis, degenerative disc disease, some autoimmune diseases, or pain from cancer metastases, oral MSM may be inadequate for pain relief. However, we have found that IV administration may bring about rapid and profound relief of pain. For this reason, many of our patients have traveled to our clinic from out-of-state to receive IV MSM treatments.

We almost never need to exceed 30 g per day with IV administration of MSM. Typical IV doses range from 0.1 g/kg of body weight to 0.2 g/kg of body weight (based on a 70 kg adult). A typical IV treatment would deliver 15 grams over a period of 12 to 15 minutes.

Because MSM is rapidly excreted, IV administration can be repeated frequently (e.g., on a daily basis, five times per week). IV MSM is compounded as a 7.5% solution in deionized water. The 100 ml vial of 15% MSM should be mixed with 100 ml of 5% dextrose in sterile water (D_5W) and administered over a 12 to 15 minute period. We have not seen allergic reactions to MSM by any route of administration, nor have we seen any side effects except the nuisance ones mentioned previously (i.e., loose stool, mild GI upset). The IV can be given five days a week for many months, if necessary. We have had patients on safe and effective courses of IV MSM for several years.

SUBCUTANEOUS AND INTRAMUSCULAR ADMINISTRATION OF STERILE MSM

The use of intramuscular MSM is always under the care of a qualified physician. The usual dose varies from 6 to 10 ml, with a smaller volume being used for injection into the hand, foot, or facial areas. A 10 cc injection contains 5 cc of 15% sterile MSM and 5 cc of 0.5% xylocaine, making a 7.5% MSM solution. We do not usually administer more than 10 cc subcutaneously. Because of MSM's ability to move rapidly through the tissues, 10 cc subcutaneously is well tolerated. Patients can receive up to three injections, three times weekly. We have observed no serious side effects.

INTRAVESICULAR (UROLOGIC) ADMINISTRATION OF STERILE MSM

The use of intravesicular MSM is always under the care of a qualified physician. Intravesicular MSM is the treatment of choice in our clinic for interstitial cystitis. We have had good success with a mixture of 50 ml of 15% MSM with deionized sterile water. We use a relatively small #10 French rubber catheter with a 60 ml catheter tip syringe. The catheter, coated with 2% lidocaine, is inserted through the urethra for intravesicular instillation of the MSM solution. New, sterile catheters and syringes should be used each time. The MSM is allowed to remain in the bladder until the patient feels the urge to void. This could be a few minutes to several hours.

Intravesicular MSM is dispensed in a 50-ml vial and contains 15% MSM. It is used primarily for interstitial cystitis, prostatitis, and irritable bladder syndrome. While intravesicular MSM may be administered by a healthcare professional as an office procedure, patients may be taught self-instillation using the #10 French catheter with a 60-ml catheter tip syringe. Many IC patients instill it just before bedtime, going to sleep with the MSM remaining overnight in the bladder.

BEST FORM OF MSM

The best form of MSM is that which is most convenient. Capsules and tablets are easiest for low-dose therapy (i.e., 2 to 3 g per day). For

higher doses, patients might find it easier to use powder mixed with distilled water.

We have found IV MSM to be effective for many conditions. It provides a concentrated and effective means to administer large amounts of MSM without gastrointestinal reactions.

TREATMENT OF FIVE TYPICAL PROBLEMS

Scleroderma

Assuming the patient has involvement of the esophagus and other internal organs, he or she should be given five IV MSM treatments per week for six weeks. With this regimen, the patient will generally notice decreased dysphagia and an increased ability to swallow solid foods. At the time the IV MSM is administered, the patient should also be given a topical MSM gel and oral MSM (1 1/2 tsp MSM liquid BID). We used 15% liquid in our clinic. After six weeks the patient may be maintained with two IVs weekly for several months as we gradually increase the oral dosage to the limit of tolerance, up to four to eight ounces a day (approximately 17 to 34 grams MSM). Some people may never go above two ounces per day secondary to minor gastrointestinal side effects. If the veins of a scleroderma patient are difficult to enter, a carefully monitored indwelling catheter may be used.

Rheumatoid arthritis

Animal experiments[215] and our clinical experience have demonstrated that MSM is effective for rheumatoid arthritis. At least 2 grams of oral MSM combined with topical MSM may be used; increase the dose to patient tolerance. We have found, using liquid MSM (15%), that patients frequently tolerate up to 32 grams per day. If the patient can receive one or two IVs weekly, the results will be improved. Do not alter any other regimen (i.e., do not discontinue other medications) the patient is receiving for rheumatoid arthritis until after at least two months of treatment with MSM.

Fibromyalgia

Fibromyalgia is one of the most difficult entities to treat with any modality of therapy. MSM is of value, but, like most chronic problems, a period of at least two months is required before the patient is likely to see any benefit. I would give IV MSM five times a week for two weeks, then decrease to twice-weekly IVs for several months. After the two-week mark, the patient can begin the oral and topical MSM as well. If indicated, injectable MSM with lidocaine may also be administered.

Back pain secondary to disc problems and other causes

Treatment for secondary back pain consists of five IV MSM treatments per week for two weeks. Follow this with an oral (minimum 2 to 8 grams per day) and topical MSM regimen. Increase the oral MSM as tolerated and maintain two IVs weekly for months, if necessary.

Interstitial cystitis

We have seen a high percentage of our IC patients improve with MSM. The regimen we employ consists of five IVs per week for two weeks, followed by at least two months of twice-weekly IVs. In the first month, the patient should also instill or have instilled one 50 ml vial of sterile 15% MSM by catheter into the urinary bladder (intravesicular instillation), five times per week. In the second month, instillations are performed four times weekly. In the third month, instill the MSM three times weekly, and in the fourth month, twice weekly. Then instill once weekly thereafter. Do not discontinue intravesicular instillations until the patient achieves a reasonable comfort level. If possible, maintain instillations once a week indefinitely.

Patients with IC do benefit from additional oral MSM supplementation, which can be started at the first visit. Start with 1 1/2 teaspoons of liquid MSM (15%) BID during the period of IVs. The patient may gradually increase the dosage as tolerated. IC patients should also apply topical MSM gel over the suprapubic area and perineum. Use 2% lidocaine gel on the tip of the catheter for intravesicular instillations. Assuming the patient is self-instilling, all equipment should be discarded after each use. Many patients

with IC may also require antidepressant therapy, such as sertraline, citalo-pram hydrobromide, or other selective serotonin reuptake inhibitors.

FREQUENTLY ASKED QUESTIONS

What is a typical dose of MSM?

The typical oral dose for MSM is 2–8 grams per day, depending on GI tolerance. Severe, deep-seated conditions may require higher doses to provide relief. Under supervision, 40 to 60 grams per day, in divided doses, has been safely used in many patients. We have given doses up to 200 grams per day intravenously and up to 100 grams per day orally without serious toxicity. Patients have been maintained on 2 to 3 grams per day for as long as 25 years with no ill effects. For allergies, the typical dose is 3 to 6 grams per day.

Is MSM therapy associated with any adverse effects?

Very few adverse effects have been reported for MSM. Gastrointestinal upset and bowel tolerance are generally the only limiting factors. Taking MSM after meals can help limit the occurrence of GI upset. We recommend that MSM not be taken at bedtime, as its energizing effect may interfere with sleep.

What precautions should I be aware of with MSM therapy?

DMSO has been shown to antagonize platelet aggregation.[216,217] Although there is no direct laboratory evidence that MSM has similar anticoagulant effects, we have had a few reported cases of blood in the stool when combining MSM with aspirin. We have also had six to eight cases of women reporting that their menstrual flow was heavier while tak-ing MSM. Because of a possible additive effect with anticoagulants (e.g., aspirin, heparin, dicumerol), patients taking these drugs should be close-ly monitored by a healthcare professional, and MSM should be discon-tinued if evidence of bleeding occurs.

DMSO has produced some skin irritation. Although not reported, it is a theoretical possibility that some individuals could be sensitive to topi-cal MSM.

Temporary minor headaches have been reported after starting at too high a dose of MSM. Reduce the dose (i.e., start at 2 to 3 grams per day and then double the dosage after one week).

While not toxic to the liver, therapy with either DMSO or MSM may interfere with the accurate interpretation of enzymatic liver tests (AST, ALT), producing slight elevations in some patients. When patients are withdrawn from MSM, the test results quickly revert to normal. In preparation for liver function tests, patients should withdraw from MSM 14 days prior to the blood draw. Animal testing of MSM showed that it had no effect on AST or ALT and postmortem examination of the animals revealed no liver abnormalities.[218]

Is MSM safe to use during pregnancy?

It is always prudent to discuss the use of any dietary supplement, MSM included, with a physician or other qualified healthcare provider. As a general rule, avoid non-prescription dietary supplements and medications during pregnancy when possible.

MSM AND SULFITE ALLERGIES

People with sulfite allergies can safely take MSM. MSM contains sulfur, not sulfite. Despite claims in some popular nutrition books, there is no clear evidence that additional dietary sulfur increases the production of sulfites. (See Chapter 23: A Critical Examination of MSM Myths, for more details.)

BOWEL TOLERANCE AND GI UPSET

Dosages of MSM may depend upon bowel tolerance and may need to be divided during the day. We have found that, as with ascorbic acid, bowel tolerance varies from individual to individual and may depend on a person's need for the substance. As many physicians know, when a patient is sick, they are often capable of tolerating far greater dosages of vitamin C than when they are healthy. The same appears to be true of MSM. A

healthy person will require far less MSM than a person in a diseased state.

If larger dosages are used, the target amount should be increased slowly over a period of several weeks. Most people supplementing with MSM should use it with breakfast and lunch to avoid taking it on an empty stomach. This will help to alleviate any GI upset when taking larger doses or beginning its use. Occasionally, minor GI discomfort or more frequent stools may develop. If this occurs, the dosage of MSM should be reduced.

The following protocol may be used to increase patients' oral dosages. Be sure to use at least two divided doses and to recommend that MSM be consumed with meals to avoid stomach upset.

Week 1	2 to 3 grams daily by the oral route
Week 2	4 to 6 grams daily by the oral route
Week 3	8 to 12 grams daily by the oral route
Week 4	16 to 24 grams daily by the oral route

Some patients will not tolerate oral doses of MSM in excess of 8 grams per day. It is important, when increasing the oral dosage, to do so gradually.

21

Toxicity, Side Effects and Drug Interactions

Our clinical experience indicates that MSM may be used for prolonged periods without serious toxicity. For more than two decades, thousands of people have come to the DMSO clinic at OHSU and received upwards of 100 grams per day of MSM without serious side effects. In total, I have treated some 18,000 patients with MSM.

In long-term toxicity trials with laboratory animals, MSM showed no toxic effects with oral doses of 8 g/kg/day in rodents—the equivalent of 1.2 pounds per day for an average human adult. Most people take a small fraction of this amount, from 2 to 8 grams total daily, as a dietary supplement. Like water, the LD_{50} of MSM is so large that the concept loses significant meaning.

The toxicology of MSM has been explored in several studies.

ACUTE ORAL TOXICITY STUDY #1

In one animal study, MSM was administered as a 40% suspension in distilled water containing 1% carboxymethyl cellulose as a thickener.[219] Administration was accomplished using a syringe fitted with a hypodermic needle with a ball tip. The needle was bent to permit easy insertion through the mouth and esophagus of the rat, so that the dosage could be placed directly into the animal's stomach (gavage).

Dose levels of 2 to 20 g/kg body weight were given to groups of two to ten rats each. Food was removed 24 hours before injection and replaced immediately following injection. The rats were observed for six days for any abnormal symptoms.

Various organs and tissues were removed from the rat fed the highest dose, as well as from a control rat of the same weight, age, and sex, and were submitted to a pathologist for histopathology. Findings for the active group were negative.

The researchers concluded that under the conditions of this experiment, MSM was relatively nontoxic, since a dose of 20 grams per kilogram body weight failed to kill any of the animals.

ACUTE ORAL TOXICITY STUDY #2

An acute oral toxicity study was conducted, employing albino rats as test animals.[220] The researchers used healthy, young albino rats of the Charles River strain from the Charles River Breeding Laboratories, Inc., of North Wilmington, Massachusetts. They selected dose groups of four rats each (two male and two female), which were intubated with previously calculated doses of MSM in the form of a 25.0% (w/v) aqueous solution. All doses were administered by gavage using a hypodermic syringe equipped with a ball-pointed intubating needle. The animals were observed for 14 days.

Median lethal dose (LD_{50}) was calculated using standard techniques. The acute oral LD_{50} was found to be greater than or equal to 17 g/kg body weight (the equivalent of approximately 2.62 pounds per

day for a 150-pound human). Of the eight rats tested, one died. Necropsy of the animal that died, as well as of all animals sacrificed at the end of the study, revealed no gross pathologic alterations in the tissues and organs examined.

ACUTE ORAL TOXICITY STUDY #3

A study was conducted at the Southern Research Institute in Birmingham, Alabama, to determine the acute toxicity of a single oral dose of MSM (OptiMSM, Cardinal Nutrition, Vancouver, WA) in male and female rats.[221] The study was sponsored by the American Institute for Biosocial and Medical Research in Tacoma, Washington. During a preliminary range-finding phase, no mortality was observed among two male and two female rats administered a single oral dose of 2 g/kg body weight of MSM.

To confirm and extend these results, groups of five male and five female rats were subsequently administered a single oral dose of either 2 g/kg body weight of MSM or vehicle (sterile water for injection, USP). No mortality, adverse effects or clinical signs of toxicity, effect on body weight, or gross lesions were noted for any of the dosed animals. The results of this study indicate that a single oral dose of 2 g/kg body weight (equivalent of 140 grams, or about 5 ounces, in a human adult) of MSM is well tolerated.

SUBCHRONIC ORAL TOXICITY STUDY

A 90-day subchronic oral toxicity study was conducted on 80 Wistar rats (40 males, 40 females) by the Pharmaceutical Control and Development Laboratory in Budapest, Hungary.[222] This was a preclinical toxicology study conducted in compliance with the principles of the Good Laboratory Practice Regulations for Nonclinical Laboratory Studies of the United States Food and Drug Administration and the Hungarian Act of 1998.

A daily dose of 1,500 mg/kg body weight MSM (OptiMSM, Cardinal Nutrition, Vancouver, WA) was chosen for the study. Toxicity was not

expected based on the results of previous acute oral toxicity studies described above, wherein the LD_{50} was 17 g/kg body weight. Human doses of MSM seldom exceed 20 grams per day, which corresponds to approximately 0.3 g/kg body weight per day. Administration was daily for 90 consecutive days by oral gavage.

No deaths occurred during the study. No changes in general state, external appearance, or behavior were observed. Skin, fur, eyes, and visible mucous membranes were similar in the MSM-treated and control groups. No toxic symptoms occurred. There were no alterations in body weight. Animals treated with MSM consumed similar amounts of food compared with control animals. No substance-related hematological effects* were observed. All individual and group mean values were within physiologic ranges. Clinical chemistry data[†] showed no treatment-related alterations at the end of the 90-day treatment period. There were no differences between treated and control animals on urinalysis.[§] Gross pathological examination of the animals at the end of the study revealed no abnormalities. In four female animals, slight accumulation of clear uterine fluid (hydrometra) was observed. The researchers attributed this to the ovarian hormonal cycle of the animals and considered it a "slight individual physiological disorder," with no bearing on the results. All four females were in the control group.

OCULAR IRRITANCY OF MSM

Determining the potential for irritation of skin and eyes is a concern for any chemical compound that is taken orally or used topically. Irritection assays are standardized, *in vitro*, quantitative methods for determining the potential for irritation of skin and eyes. The Irritection Draize Equivalent

*Erythrocyte count, leukocyte count, hemoglobin content, hematocrit, platelets, leukocyte differential, and prothrombin time.

†Aspartate transaminase (AST), alanine transaminase (ALT), alkaline phosphatase, total cholesterol, total protein, albumin, blood glucose, urea nitrogen (BUN), sodium, potassium, chloride, total calcium, and creatinine.

§Appearance, volume, specific gravity (by refractometry), pH, protein, glucose, and blood.

Score has been validated and is widely accepted as a preferred alternative to more invasive animal testing. Irritection assays of MSM (OptiMSM, Cardinal Nutrition, Vancouver, WA) indicate that MSM should be classified as a "minimal irritant" to the eyes.[223] This equates to 0.0 to 12.5 on the Irritection Draize Equivalent scale, the lowest possible score that can be achieved by any compound.

DERMAL IRRITANCY OF MSM

Testing at the same laboratory indicated that MSM (OptiMSM, Cardinal Nutrition, Vancouver, Washington) has a Human Irritancy Equivalent (HIE) score of 0.00 to 0.90 (i.e., a nonirritant). Again, this is the lowest score that can occur and illustrates the nontoxic and non-allergenic properties of pure MSM. These tests were conducted on a brand of MSM that is at least 99.9% pure;[224] the results cannot necessarily be extended to other brands, which may not meet the same purity and quality standards.

DRUG INTERACTIONS

There are no documented interactions between MSM and any pharmaceutical or nutraceutical agents. It should be noted, however, that MSM might have an aspirin-like effect on platelet aggregation, although it does not appear to be as potent as aspirin in this regard. There have been occasional reports of blood in the stool when a patient is taking large doses of aspirin or NSAIDs along with MSM. We have also received six reports from other physicians of heavier menses with MSM supplementation. Patients taking blood-thinning medications, such as aspirin, heparin, or dicumerol may require a lower dose of these substances and should consult with their prescribing physician before using MSM.

HERBAL AND NUTRIENT INTERACTIONS

MSM to date has shown no significant interactions with herbs, vitamins, or minerals.

PREGNANCY

There are no known adverse effects from use of MSM immediately prior to and during pregnancy or during breast-feeding. Women of childbearing age who intend to become pregnant or who are pregnant or breast-feeding should always consult with their physician before taking any supplement or medication, including MSM.

22

Quality Issues

by Jeremy Appleton, N.D.

The Dietary Supplement Health and Education Act (DSHEA) of 1994 was the U.S. Food and Drug Administration's response to the demands of consumers who wanted to retain free access to dietary supplements. Consumers believe these natural agents provide health benefits, and these beliefs are validated by considerable scientific evidence. Congress's stated intent in enacting DSHEA was to meet the concerns of consumers and manufacturers to help ensure that safe and appropriately labeled products remain available to those who want to use them. The provisions of DSHEA granted the FDA authority to establish Good Manufacturing Practice (GMP) regulations.

Although the passage of the DSHEA empowered the FDA to require dietary supplements to meet strict manufacturing requirements, the agency has yet to enforce any such requirements. In 1995, representatives of the dietary supplement industry submitted proposals to the FDA for the development of GMP regulations for dietary supplements. The industry's suggestions were reviewed by the FDA and published for public comment in 1997. So far, the FDA has failed to institute federal GMP guidelines and may not do so for years to come.

As a result of the FDA's lack of implementation and enforcement of GMPs, the dietary supplement industry has been forced to regulate itself. Unfortunately, products labeled with untruthful or misleading claims still proliferate on the market, and consumer confidence suffers as a result. Healthcare practitioners are rightly concerned about patients taking products of inferior quality. No universally accepted quality standards exist in the dietary supplement industry.

In an effort to assist the dietary supplement industry in self-regulation with respect to quality, the National Nutritional Foods Association (NNFA) has established a set of standards for GMPs. Similar standards are likely to be enforced in the future by the FDA and are already being implemented in both Canada and the European Union. As far as such standards go, however, they are unlikely to address manufacturing concerns that are specific to individual products, and they will not necessarily require the most up-to-date analytical screening of products for purity.

QUALITY ISSUES AFFECTING MSM SUPPLEMENTS

Although MSM is a naturally occurring substance, the concentrations present in natural sources (e.g., milk, tomatoes, tea, chard) are too low to permit meaningful isolation and extraction for commercial use. Commercial MSM must, therefore, be manufactured. All supplemental MSM is made by a chemical reaction between dimethyl sulfoxide (DMSO) and hydrogen peroxide (H_2O_2). This reaction yields methylsulfonylmethane ($DMSO_2$ or MSM) and water (H_2O).

$$DMSO + H_2O_2 \rightarrow DMSO_2 + H_2O$$

Water must then be removed, and MSM must be separated from other by-products of the reaction. There are two different separation processes used in the commercial production of MSM: distillation and crystallization. The comparative advantages and disadvantages of these two methods can be summarized briefly: Distillation yields a pure product, but it is more expensive and energy-intensive; crystallization yields

product with varying degrees of purity, but it is a more cost-effective method of production.[225]

MSM SEPARATION PROCESSES: CRYSTALLIZATION

After the reaction phase, the MSM reaction mixture is dissolved in water. The solution is then cooled to crystallize the MSM. (The solubility of MSM in water is almost infinite at elevated temperatures. However, as temperature decreases, solubility greatly decreases, and MSM crystallizes out of solution.) The resulting slurry is centrifuged to separate the MSM crystals from the solvent (water). Wash water may be used to remove impurities, but this adversely affects the yield.[226] At this point in the separation process, the product typically contains about 5 to 10% moisture. The crystallized MSM is then dried using a turbo dryer or a vacuum dryer. Energy use for the crystallization process is low compared with the energy requirements of distillation, although some heat energy may be needed for the final drying after crystallization. As a result, the cost of production is lower for crystallization.

Purity of MSM separated by crystallization is dependent upon the purity of the solvent and the raw materials used in manufacturing, and on the industrial hygiene procedures employed at the plant. As crystals grow in solution, they naturally form pockets, called occlusions, which entrap solvent within the crystalline structure.[227,228,229]

Process by-products and contaminants (e.g., chlorinated hydrocarbons, heavy metals) may therefore be present in the MSM finished product manufactured using crystallization. This is of particular concern when MSM is manufactured in countries where water quality is substandard. At the time of this writing, all MSM manufactured outside of the United States utilized the crystallization technique of separation. Most MSM manufactured by crystallization is imported from China, where water quality is among the worst in the world.[230,231,232] Some imported MSM is also manufactured in India and Japan.

MSM SEPARATION PROCESSES: DISTILLATION

After the reaction of DMSO and H_2O_2 yields MSM and water, the mixture is distilled to separate water and impurities. Distillation uses boiling point differentials to separate the components of a mixture. First, water is vaporized; then MSM is separated from "low boilers" (i.e., components with low boiling temperatures) in a forerun receiver. Further overhead distillation then yields the pure MSM product. Creating a vacuum within the distillation vessel lowers distillation temperatures, and can thus minimize thermal degradation of product during distillation. Components with high boiling temperatures (e.g., heavy metals, salts) remain in the bottom of the distillation vessel and are removed as waste.

Pure, liquid MSM is then either flaked or spray-cooled to produce a fine, white powder. Although the powder has a crystalline appearance, it is more properly described as a flake or, if spray cooled, a microprill.

Distillation is a more expensive process in part because it utilizes more energy. A large heat input is required to vaporize the contents of the distillation vessel. Condensation requires the removal of large quantities of heat, another energy-intensive process. Heat input is also required to keep purified product molten until final processing.

Distillation yields a product of excellent purity. The product is quite dry (typically < 0.05% moisture) when distilled properly, so fewer moisture-related problems occur, such as product degradation and microbial contamination. The less water present in a product, the less water quality is a concern. Moreover, since potential contaminants have unique boiling points that are different from that of MSM, they are all removed by distillation. Purity of distilled MSM is, therefore, not dependent on water quality.

PURITY TESTS

MSM manufacturers should be able to provide valid certificates of analysis, signed individually and by hand, with batch-specific data. Regrettably, some manufacturers do not adhere to GMPs and may even

fabricate certificates of analysis to meet their own product specifications. Therefore, a certain degree of vigilance is required on the part of a buyer to determine the certificate's validity.

The purity of an MSM supplement can be confirmed by many methods. Some are superior to others. We recommend the following:

- Gas chromatography assays the purity of the product. However, it does not demonstrate levels of water or the presence of contaminants with high boiling points (e.g., arsenic, lead, mercury, and cadmium). Therefore, two additional tests are needed.
- Melt point is used to indicate the presence of salts and "high boilers."
- Moisture content should be determined by the Karl Fischer titration method (which uses the Karl Fischer reagent to react quantitatively and selectively with water). Moisture should not be expressed as "loss on drying." Loss-on-drying techniques are performed in an oven or under an infrared heat lamp. Either method evaporates some of the MSM and gives an erroneous reading.

GOOD MANUFACTURING PRACTICES

In the United States, the NNFA GMP certification program is currently the best set of quality assurance regulations available in the dietary supplement industry. NNFA GMP certification is based upon third-party comprehensive audits of member suppliers' GMP programs in the areas of personnel, plant and grounds, sanitation, equipment, quality operations, production and process controls, and warehouse, distribution, and post-distribution practices. The program seeks to review all elements of the manufacturing process, ensuring that processes are sufficiently controlled so that products meet their purported quality.[233]

DEDICATED FACILITY

MSM is produced by several facilities worldwide. Most MSM manufacturers produce the supplement in facilities that are also used to produce DMSO and a variety of other chemicals (including toluenes, benzenes,

xylenes, chlorinated hydrocarbons, and other carcinogens). A manufacturing facility devoted to the sole production of MSM is advantageous because it eliminates the possibility of cross contamination with materials used in the manufacture of other agents.

THIRD PARTY TESTING: HEAVY METALS

MSM is currently produced by distillation in the U.S.A., and by crystallization in several locations worldwide. Industrial hygiene and water quality in these locations vary considerably. It is therefore important that manufacturers of MSM have every batch tested for the presence of heavy metals. Even though distillation removes heavy metals due to their high boiling points relative to MSM, we recommend that manufacturers of MSM for human comsumption assay every batch to provide proof of purity. Minimally, these tests should screen for lead, aluminum, cadmium, mercury, and arsenic.

The United States Pharmacopeia (USP) Method 231 specifies the use of colorimetric analysis for detection of heavy metals. This method first appeared in USP IX, published in 1916. In the colorimetric method, a visual color comparison is made between the sample and a known standard solution, prepared with lead. Although several heavy metals will trigger a reaction similar to that of lead, they are being measured quantitatively by the standard set for lead (10 ppm). A daily intake of 10 ppm of lead should no longer be considered a sufficient screening level; moreover, 10 ppm is far in excess of an acceptable amount of other heavy metals (e.g., mercury). The USP standard is semi-quantitative, nonspecific, and obsolete. It does not satisfy California's Proposition 65 requirements.* One way to determine

* In November 1986, California voters approved an initiative to address growing concerns about exposures to toxic chemicals. That initiative became The Safe Drinking Water and Toxic Enforcement Act of 1986, better known by its original name: Proposition 65. Proposition 65 requires the Governor of California to publish a list of chemicals that are known to cause cancer or reproductive toxicity. This list is updated at least once a year. Proposition 65 imposes intake thresholds that apply to chemicals appearing on this list. If a product sold in California is found to contain amounts of toxic chemicals in excess of the Proposition 65 threshold, and if the label does not disclose the presence of those health risks, the manufacturer faces civil penalties.

whether a particular lab utilizes the colorimetric method is by looking at their analysis, which does not specify content of individual heavy metals and reports heavy metal content "as lead."

A manufacturer should have its batches of MSM tested using methods that specifically identify and quantify each heavy metal. Inductively coupled plasma mass spectrometry (ICP-MS) is a more suitable test and is often used. At the time of this writing, the most sensitive and specific test method for identification and quantification of heavy metals is graphite furnace atomic absorption (GFAA). For the detection of mercury, cold vapor analysis is the test of choice. These testing methods are orders of magnitude more sensitive than either ICP-MS or colorimetric assay.

No standard for the presence of heavy metals in MSM has been suggested or mandated by the FDA. However, California's Proposition 65, which affects products made in the state and imported into the state, has increased vigilance in detecting heavy metals and other contaminants in the nation's food supply. The sensitivity and specificity of GFAA for the determination of heavy metals in dietary supplements permit manufacturers and distributors to specify maximum allowable levels of heavy metals in an MSM raw material that comply with the Proposition 65 standard. Specifically, GFAA permits specifying maximum allowable levels of heavy metals in MSM as follows:

Aluminum	1.00	ppm (ICP-MS also screens to 1 ppm)
Lead	0.01	ppm (ICP-MS screens to 0.05 ppm)
Arsenic	0.01	ppm (ICP-MS screens to 0.1 ppm)
Cadmium	0.005	ppm (ICP-MS screens to 0.05 ppm)

Cold vapor analysis permits specifying a maximum allowable level of mercury in MSM products at 0.001 ppm (ICP-MS screens to 0.1 ppm). For typical daily intakes of MSM (i.e., 2 to 10 grams per day), these levels meet the stringent requirements set forth in California's Proposition 65.

THIRD PARTY TESTING: MICROBIOLOGICAL CONTAMINANTS

Manufacturers of MSM (and other dietary supplements for human consumption) should have every batch tested for microbiological contamina-

tion. Such testing should include a total aerobic plate count, rapid yeast/mold test, and screening for coliforms, *Escherichia coli*, Salmonella species, *Staphylococcus aureas*, and *Pseudomonas aeruginosa*.

Questions to ask your MSM supplier

1. Is your MSM manufactured by distillation or crystallization?

2. Is your MSM made in the USA? Who supplies the raw material? Can you provide me with a certificate of manufacturing origin?

3. What other products are made in the facility where your MSM is made? Is your MSM manufactured in an NNFA GMP-certified facility?

4. Is every batch of your MSM tested for heavy metals and microbiological contaminants? May I see the results of a recent assay?

5. What analytical method does your laboratory use to determine heavy metal content?

23

A Critical Examination
of MSM Myths

When an agent has so broad a range of potential mechanisms of action and therapeutic applications, it is inevitable that misconceptions about it will arise. When that agent is a dietary supplement with research still in its preliminary stages, yet it enjoys a high degree of popularity, many of these misconceptions will be promulgated and compounded (for example, over the Internet). By investigating the biological properties and clinical applications of MSM, and communicating the true and complete results of this research with the public, we wish to clarify the benefits and risks of MSM supplementation and therapy. Our goal is to enable health professionals to dispense or recommend MSM in accordance with its proper indications. In this chapter, we will critically examine some of the commonly held misconceptions, and also the popularized truths, about MSM.

MYTH: MSM AND DMSO ARE BASICALLY THE SAME

Dr. Jacob: The first myth we wish to dispel is that MSM and DMSO are basically the same. We may have added to this confusion when we refer

to DMSO studies as evidence of MSM's potential mechanisms and therapeutic indications. We have found this necessary because DMSO has been the subject of a far greater amount of research than MSM, and because DMSO and MSM do appear to share certain properties. Not all of the DMSO research is applicable to MSM. If it were, this book would be much longer, indeed.

Nevertheless, MSM is *not* the same as DMSO—and this is where we must begin our work on differentiating the two, separating some of the myths and so-called "miracles" mistakenly attributed to the MSM compound due to its close relationship to DMSO.

Distinguishing features between DMSO and MSM:

- **Side effects.** DMSO is somewhat notorious for its side effects of garlicky breath odor, skin drying, itching, and occasional burning. MSM, although a close chemical relative of DMSO, produces none of the odor or burning problems caused by DMSO. In fact, my discovery of MSM's therapeutic properties arose from a deliberate search for a solution to DMSO's odor problem. Patient compliance suffers when side effects are high. I have found that compliance with MSM regimens, on the whole, is far better than compliance with DMSO regimens for this reason.

- **Published research.** There are some 40,000 published studies on DMSO. There are only about 1,000 studies published concerning MSM, only two of which are clinical trials.

- **Molecular weight.** The molecular weight of DMSO is 78 Daltons; the molecular weight of MSM is 94 Daltons.

- **Cryoprotection.** Preservation of cells and tissues at low temperatures requires the presence of effective cryoprotectants with low toxicity to which cells are relatively permeable.[234] DMSO is a very effective cryoprotectant; MSM is not. The lack of cryoprotection in the presence of MSM appears to be due to the precipitation of MSM from solution at subzero temperatures. The observation of reduced cell recovery after freezing with increasing concentrations of MSM implies that cell damage is related to the amount of solid MSM present. Precipitation of MSM occurs both intra- and extracellularly, but it is believed that intra-

cellular precipitation of MSM, with consequent intracellular ice formation, is the damaging phenomenon that makes MSM ineffective as a cryoprotectant.

- **Pharmacology and drug interactions.** In a 1975 report in the *Annals of the New York Academy of Sciences*, the effects of DMSO and MSM were studied in five selected systems in rats and mice.[235] DMSO enhanced both taurine excretion and the lethality produced by aromatic hydrocarbons (e.g., benzene, chlorobenzene) in rats. In mice, DMSO decreased the toxicity of cholinesterase inhibitors (e.g., paraoxon, octamethyl pyrophosphoramide). DMSO also lowered the body temperature of rats and reduced the motor activity of mice. Although MSM did not increase the lethality of solvent hydrocarbons, it seemed to be quite active in other respects. It would be fair to conclude that MSM is less pharmacokinetically and physiologically dynamic than is DMSO. As a therapeutic agent, MSM is tamer and less likely to produce surprises when it comes to drug-nutrient interactions.

- **Antioxidation and free radical scavenging activity.** DMSO is a potent antioxidant and direct free radical scavenger. There is preliminary evidence suggesting that MSM has some ability to scavenge free radicals.[236] Its presence in the body and incorporation into free radical-scavenging sulfur amino acids (e.g., N-acetylcysteine) and its possible incorporation into sulfur-dependent enzyme systems (e.g., glutathione peroxidase) suggest that MSM could possess *indirect* antioxidant properties. However, our experience and testing at OHSU have left us with the impression that MSM is not a significant free radical scavenger.

MYTH: MSM CAN BE EXTRACTED FROM TREES TO MAKE A MORE NATURAL COMMERCIAL PRODUCT

Dr. Appleton: Some companies claim that their MSM is 100% natural and that other brands are synthetic. Is MSM derived from natural sources? What is the "most natural" form of MSM?

The process by which MSM is manufactured is similar to how it is produced in nature (i.e., from oxidation of DMSO). Commercially produced

MSM is a simple molecule that is physically and chemically indistinguishable from a molecule of MSM found in nature. *In all commercial production methods, MSM is manufactured by oxidizing DMSO with hydrogen peroxide (H_2O_2).* This reaction yields $DMSO_2$ (MSM) and water (H_2O).

$$DMSO + H_2O_2 \rightarrow DMSO_2 + H_2O$$

From a chemical standpoint, this is a very simple reaction. But it is a reaction initiated and controlled by *people*, not by nature. Thus, regardless of the source of the raw materials, the product cannot be said to be "natural" if natural means "made by nature"; if natural means "identical to that which is found in nature," then pure MSM is natural. So the question you should be asking is whether or not the product is pure, not if it is "natural."

So-called "natural MSM" is a marketing creation that misrepresents the contribution of pine trees to the MSM production process and erroneously applies carbon 14 dating techniques as a method of validation. To understand this issue, we must first consider the methods by which DMSO can be manufactured.

There are three possible processes by which to manufacture DMSO:

1. Methyl groups (CH_3) for DMSO production can be obtained from "black liquor," a by-product from pulping Southern Pine (i.e., *Pinus palustrus*, *P. taeda*, *P. echinata*, or *P. elliottii*) for the paper industry. The extracted methyl groups are reacted with sulfur to make dimethyl sulfide (DMS). The sulfur does not come from pine trees, as suggested by some manufacturers and retailers. DMS is then reacted with oxygen in the presence of a catalyst—nitrogen tetroxide (N_2O_4)—to yield DMSO. This use of pine tree-derived methyl groups to make DMSO is the basis for so-called "natural MSM."

2. DMSO may also be manufactured by reacting methanol (MeOH) with hydrogen sulfide (H_2S).

3. DMSO may be manufactured by reacting MeOH with carbon disulfide (CS_2).

The latter two processes are often favored because of their high conversion yield, low energy consumption, and independence from a paper mill.

In all three chemical processes, the atmosphere is the source of the oxygen atoms required, and the earth is the source of the sulfur. The carbon atoms come either from trees or from carboniferous deposits in the earth.

There is a fairly constant amount of carbon 14 in the atmosphere (it has a half life of about 5,000 years). When plants take up carbon from the atmosphere, they maintain about the same amount as in the atmosphere. When the plant dies, its carbon 14 content gradually decreases. So the remains of a plant or an animal can be used to determine when it was alive, with accuracy up to about 50,000 years.

If you manufacture MSM from black liquor-derived DMSO, it will have a similar amount of carbon 14 as in nature, because the trees used to make the black liquor were recently cut, and so their carbon 14 content has not declined significantly. If you make MSM from earth product-derived DMSO, there is no carbon 14 left because these products have been in the earth for millions of years. Marketers of "all natural" MSM use carbon 14 dating to justify their claim of a natural product. And marketing is the only thing that makes a tree more "natural" than the carboniferous deposits in the earth.

More important, carbon atoms—as mentioned previously—are only one component of the MSM molecule. The MSM molecule also contains sulfur, which is recycled from fossil sources. Therefore, applying the carbon-dating standard to MSM products is meaningless since the sulfur in every MSM product comes from the earth and not from trees. The use in marketing materials of statements like, "no addition or dilution with fossil fuel-derived material" is plainly misleading.

Trying to reproduce some naturally occurring substances can be a difficult challenge even for the most sophisticated organic chemist. For simple, pure substances like DMSO and MSM, however, commercial synthesis results in exactly the same substance as found in nature. This process also allows products like DMSO and MSM to be made available at reasonable prices. Regardless of which starting materials are used, chemical reactions are required to produce DMSO and MSM. Each process has its advantages and disadvantages, but the resulting product is the same. The origin of the DMSO is not critical in the production of food-grade MSM, provided it

meets certain quality standards. Nor does it make the least bit of difference in terms of health benefits.

The issue of natural vs. synthetic is very complicated, because while all MSM sources are organic, they are not extracted or distilled from currently living plants or trees. Some people define "natural" as a substance that occurs naturally in the body and in plants. By that definition, MSM—like most vitamins and minerals—is natural, despite having been manufactured. The bottom line is that no source is more natural than others. One molecule of DMS is indistinguishable from another, regardless of source; no molecule of DMSO is distinguishable from another, regardless of source. The only difference between one form of commercially available MSM and another is its purity.

Purity of a final MSM product is determined by manufacturing processes (e.g., whether the product was produced by distillation vs. crystallization). See Chapter 22 (Quality Issues) for a discussion of distillation versus crystallization techniques.

MYTH: MSM MAY CAUSE VISION PROBLEMS

Dr. Jacob: Toxic ocular responses to large doses of DMSO have been documented in some animals.[237-242] I was directly involved in conducting some of this research in the late 1960s and early 1970s. Lens nuclear opacities have developed after extended treatment with massive oral doses of DMSO (10g/kg body weight). One review article, published in 1967, suggested that one of the metabolites of DMSO (i.e., MSM or DMS) could be responsible for the lenticular changes that occurred in these studies.[243] However, in 1969, a group of human male volunteers in Vacaville, California, were given DMSO (80% topical gel; 1g/kg body weight per day) for 12 weeks and experienced no ocular abnormalities (i.e., anatomical variations, corneal and lens changes, cycloplegic refraction, visual acuity, peripheral visual fields, etc.) compared with control subjects.

In 1971, Don C. Wood, Ph.D., and colleagues from the Department of Surgery at the University of Oregon Medical School (now OHSU) found that rabbits treated with known metabolites of DMSO—including

MSM—failed to develop the biomicroscopic and retinoscopic changes that had been observed in rabbits after DMSO therapy.[244]

There is no reason to believe that MSM causes visual changes or irritation of any kind. Ocular Irritection assays* of MSM (OptiMSM, Cardinal Nutrition, Vancouver, WA) indicated that MSM should be classified as a "minimal irritant."[245] This equates to 0.0–12.5 on the Irritection Draize Equivalent scale, the lowest score that can be achieved by any compound. In my extensive clinical experience treating thousands of patients with large doses of DMSO and MSM, I have never encountered any visual problems resulting from the use of these agents.

MYTH: MSM REMOVES THE MERCURY FROM SILVER AMALGAM FILLINGS AND DEPOSITS IT INTO YOUR BRAIN

Dr. Jacob: Some radio talk show hosts have claimed that MSM is able to chelate heavy metals, such as mercury, and cause their deposition in brain tissue. There is no evidence for this.

Dr. Appleton: The misunderstanding most likely arose from the observation that the amino acid L-cysteine (a sulfur-containing amino acid) is an avid chelator of methylmercury. Some researchers raised a theoretical concern that cysteine-methylmercury complexes could be carried across the blood-brain barrier (BBB) by an amino acid transport mechanism.[246] A leading expert on mercury-induced neurotoxicity has therefore recommended that people taking nutrients for mercury detoxification use larger sulfur-containing molecules, like N-acetylcysteine or glutathione, to chelate mercury since it is not possible for these larger complexes to be shuttled across the BBB by the neutral amino acid carrier system.[247]

Although it has been shown that MSM crosses the BBB,[248,249] there is no research demonstrating that MSM chelates any heavy metal, or that

*Irritection assays are standardized, *in vitro*, quantitative methods for determining the potential for irritation of skin and eyes, which is a concern for any chemical compound used orally or topically. The test used in this analysis was the Irritection Draize Equivalent Score. It has been extensively validated and is widely accepted as a preferred alternative to more invasive animal testing.

MSM-heavy metal complexes are deposited in the brain or anywhere else in the body.

MYTH: MSM INTERFERES WITH REPRODUCTIVE FUNCTION

Dr. Appleton: There have been no reports of adverse effects of MSM in pregnancy. Concern has been raised based on the results of one *in vitro* study that found meiosis was interrupted in early gametogenesis in the nematode *Caenorhabditis elegans** when it was grown in concentrations of MSM exceeding 1%. Increasing concentrations of MSM impaired the fecundity and viability of treated worms.

The large number and complexity of critical events in normal development *in vivo* limits the usefulness of *in vitro* systems that measure a very narrow range of developmental events, even though such systems may be useful for mechanistic research.[251] In other words, it would be premature to surmise— from a single study in which 1 mm worms were soaked in solutions of MSM ranging in concentration from 0.5% to 10%—that any danger exists for pregnant humans or their fetuses as a result of MSM supplementation. The concentrations of MSM in human blood after oral supplementation do not begin to approach the concentrations of the growth media used in this *in vitro* study.

Dr. Jacob: I am aware of many patients who had been treated with DMSO or MSM while they were unknowingly pregnant. When they discovered they were pregnant, they called me for guidance. While I was never overly concerned, I recommended that they discontinue the DMSO or MSM until after the pregnancy. I also requested that they follow up with me after the baby was born. Most of them did, and not a single baby showed any evidence of abnormality. Bear in mind that the DMSO or MSM was administered during the first trimester of pregnancy, when any teratogenic effects would have taken place.

* *C. elegans* is a small (about 1 millimeter), primitive worm that shares certain essential biological characteristics with humans (e.g., it produces sperm and eggs, reproduces, has a nervous system, etc.). Its short lifespan, rapid development, and easy cultivation under controlled conditions make it a favorite of research scientists as a model for toxicologic assays.

MYTH: MSM CAUSES MOLYBDENUM DEFICIENCY

Dr. Appleton: Sulfur usually enters the body in the form of the sulfur-containing amino acids cysteine and methionine. It may also enter in the form of sulfur-containing foods and, of course, as a component of MSM. Sulfur that enters the body is metabolized in a variety of ways, but it is ultimately excreted by one of two pathways: the sulfur from cysteine is converted in a stepwise fashion to sulfite (toxic), and then to sulfate (nontoxic), and excreted in the urine; or the sulfur is incorporated into taurine, conjugated to bile acids, and excreted in the feces.

Molybdenum is a trace mineral that is required as a cofactor for the enzyme sulfite oxidase. This molybdenum-containing enzyme catalyzes the conversion of sulfite to sulfate, the terminal step in the oxidative degradation of cysteine and methionine.[252] A decrease in activity of sulfite oxidase is harmful for the organism, particularly the nervous system during pre- or postnatal development.

Anomalies in the function of sulfite oxidase are generally inherited and linked to the impaired production of the molybdenum cofactor, an organic molecule complexed to the element in the active site.[253] Molybdenum cofactor deficiency is a rare, autosomal recessive disease, which results in neonatal seizures and other severe neurological symptoms. One case report suggested that a sulfite-sensitive man with asthma could have had a defect specific to the sulfite oxidase protein, rather than the classic sulfite oxidase deficiency that arises as a result of molybdenum cofactor deficiency.[254] Laboratory test results were interpreted to indicate a severe but incomplete deficiency of the molybdenum cofactor. The presence of very low levels of active cofactor, supporting the synthesis of low levels of active sulfite oxidase, could have accounted for the comparatively mild clinical symptoms (sulfite-sensitive asthma) in this individual.

Jonathan V. Wright, M.D., a prominent nutrition expert, has proposed that this less severe, acquired form of sulfite oxidase deficiency is more prevalent than commonly believed, and that it may be diagnosed using a urine sulfite test.[255,256] His treatment of choice for this still-theoretical clinical entity is IV molybdenum. From these observations, it has been

proposed that supplementation with MSM somehow "strips" the body of molybdenum by overtaxing the sulfite oxidase pathway, allowing sulfite to build up and cause symptoms, such as headaches, dizziness, and fatigue.[257,258,259] Because molybdenum is needed as a cofactor for sulfite metabolism to sulfate, it has been argued that people taking MSM require supplemental molybdenum to "restore normal sulfur metabolism." Several supplement manufacturers now include molybdenum in their formulas containing MSM on the basis of this theoretical concern.

It is an interesting theory. However, there is no evidence that MSM supplementation creates a molybdenum deficiency, that long-term use decreases sulfite oxidase capacity, or that MSM supplementation influences sulfite excretion in any way. We have had a few anecdotal reports of people experiencing headaches after initiating MSM supplementation. The etiology of these headaches is unknown. While the possibility exists that such headaches could be due to sulfite accumulation, it is far from proven and could just as easily be a detox reaction.

At least two popular nutrition guides have stated that increased intake of sulfur depletes molybdenum.[260,261] These unattributed statements are likely based on a pair of sheep studies conducted in the 1970s. In the first study, plasma molybdenum in sheep was slightly decreased by dietary sulfur supplements and was unaffected when molybdenum and sulfur supplements were given together.[262] In a later study, sheep demonstrated increased excretion of radiolabeled molybdenum after increased dietary sulfur intake.[263] Neither of these studies documents any ill effect from the changes in plasma levels and excretion of molybdenum caused by the increased intake of sulfur, nor does either study suggest that molybdenum was "depleted" or "deficient" in any animal as a result of sulfur supplementation. Furthermore, sheep are ruminants and probably have higher sulfur requirements than humans.

Supplementing molybdenum as a way of "upregulating" sulfate production is an interesting but flawed concept. Supplementing with a required cofactor does not necessarily increase the activity of the enzyme requiring that cofactor. If it did, think of the deranged synthesis of neurotransmitters that would result from taking B vitamins. It is only when there

is a nutrient deficiency that such supplementation could be expected to restore normal levels of enzyme activity. Apart from the rare instances described above, molybdenum deficiency is not found in free-living humans.[264,265] It is almost never acquired and it has never been demonstrated in people supplementing with MSM. The only reported case of acquired molybdenum deficiency occurred in a patient with Crohn's disease on long-term total parenteral nutrition (TPN) without molybdenum added to the TPN solution.[266,267]

Is there any harm from taking additional molybdenum, "just in case"? Although molybdenum toxicity is rare, it is a heavy metal and excessive intake of molybdenum can produce a conditioned copper deficiency in humans. Increased copper excretion and elevated levels of plasma copper were found in volunteers ingesting 1,540 mcg (1.54 mg) of molybdenum daily.[268] Molybdenum was also reported to cause psychosis in a patient taking 300 to 800 mcg per day for 18 days.[269] A tolerable daily intake of molybdenum has been estimated at around 8 to 9 mcg/kg per day (i.e., 560 to 630 mcg per day for a 70 kg adult).[270,271] Molybdenum is needed by xanthine oxidase to convert purine to uric acid, and excessive intake could, in rare cases, increase uric acid levels and potentially trigger gout. In Armenians, 10 to 15 mg per day of molybdenum (derived from high soil molybdenum) reportedly produced clinical evidence of gout.[272]

Despite claims that our food supply is molybdenum-deficient,[273] molybdenum is ubiquitous in food and water as soluble molybdates. The adult RDA for molybdenum is 50 mcg per day,[274] which is easily met by eating a normal diet that includes legumes and leafy vegetables. The average daily dietary intake of molybdenum is estimated to be approximately 100 to 500 mcg per day, [275,276] far in excess of the RDA.

It is curious that the same people advocating molybdenum supplementation with MSM are apparently unconcerned about supplementation with other sulfur-containing nutrients (e.g., L-cysteine, L-methionine, L-taurine, N-acetylcysteine, glutathione, thiamine, or biotin). Do they also believe that consumption of sulfur-containing foods (e.g., fish, poultry, eggs, milk, legumes, onions, garlic, cabbage, Brussels sprouts, turnips) increases the body's molybdenum requirement? A short trial of molybde-

num therapy could be considered in cases of unresponsive sulfite sensitivity; otherwise, we remain unconvinced that there is any compelling reason to add a molybdenum supplement to the diet.

MYTH: PEOPLE WITH ALLERGIES TO SULFA DRUGS OR SULFITES CANNOT TAKE MSM

Dr. Appleton: It is a common misconception that people with allergies to sulfa drugs or to sulfites are "allergic to sulfur". Of course, it is not possible to be allergic to sulfur. Sulfur is an element, like oxygen or potassium: the tenth most abundant element in the known universe and the fourth most abundant mineral in the human body. A 70-kg human body contains approximately 200 grams of elemental sulfur.

Humans consume large amounts of sulfur each day, most abundantly as the sulfur-containing amino acids cysteine and methionine. Foods are a rich source of dietary sulfur. Sulfur-containing foods include fish, poultry, eggs, milk, legumes, onions, garlic, cabbage, Brussels sprouts and turnips. Sulfur is also a major component of many nutritional supplements, not just MSM. These include cysteine, methionine, taurine, N-acetylcysteine (NAC), glutathione, thiamine, and biotin. Are people with allergies to sulfa antibiotics or sulfites allergic to these sulfur-containing molecules as well? We could not survive without sulfur.

Allergy to sulfa drugs is one of the more common drug allergies. Sulfa drugs are more appropriately termed sulfonamides and are derivatives of para-amino benzoic acid (PABA). A sulfonamide allergy is different from a sulfite allergy because sulfonamides and sulfites are distinctly different chemicals. Similarly, both of these agents are distinctly different from MSM. A person allergic to sulfa drugs is no more likely to be allergic to MSM or sulfites than any other individual. The mechanism of the sulfonamide drug allergy is immune-mediated. When a sulfonamide is metabolized in the body, the drug is capable of attaching to human proteins, forming a larger molecule and possibly launching an immune response.

Sulfiting agents are a group of chemicals that include sulfur dioxide, sulfite salts, and sulfate salts. Sulfur dioxide is considered to be the offend-

ing component in a sulfite allergy. Sulfites and sulfates are metabolized to sulfur dioxide under certain conditions that depend on concentration, heat, and pH.

Some sulfiting agents are FDA-approved preservatives that are added to food and pharmaceuticals. The more common sulfiting agents are sodium sulfite (Na_2SO_3), sodium bisulfite ($NaHSO_3$), and sodium metabisulfite ($Na_2S_2O_3$). Foods containing sulfites include wine, gravies, molasses, lemon and lime juice, fresh shrimp, peppers, onions, pickles, coconut, lettuce, avocadoes, mushrooms, grapes, dried fruits, and many more. Several mechanisms of sulfite sensitivity have been proposed, but no antibody activity has been identified in association with sulfite exposure.

Dr. Jacob: No allergic reactions to MSM have been documented, even though hundreds of our patients with allergies to sulfonamides and to sulfites have taken MSM daily over prolonged periods without incident. Moreover, the only clinical trial of oral MSM to be published in a peer-reviewed scientific journal utilized the compound as a *treatment* for seasonal allergies (see Chapter 16). There is currently no evidence to support a concern that MSM supplementation could trigger reactions arising from sulfa allergy or sulfite sensitivity.

MYTH: DMSO AND/OR MSM CAN CONVERT TO TOXIC SULFATE COMPOUNDS

Dr. Jacob: The case of Gloria Ramirez—who has come to be known as "The Toxic Lady"—received national attention and remains one of the most baffling events in modern medicine. It implied that the DMSO Ramirez was taking oxidized into dimethyl sulfone and then, when exposed to cold air, became dimethyl sulfate.

As Gloria Ramirez lay dying with severe cardiac distress in the emergency room at Riverside General Hospital, the staff treating her began fainting. Some required emergency medical care themselves. Many believed that fumes from the dying woman's body caused their acute illnesses. Some witnesses say there was a strong ammonia smell coming from Ramirez' blood when drawn with a syringe.

Riverside coroner Scotty Hill and a team of pathologists conducted an autopsy of Ramirez wearing airtight contamination suits. Results were not announced until two months after her death. The official cause of Ramirez' demise is listed as cardiac arrhythmia resulting from kidney failure brought on by cervical cancer. No toxic substance was identified that might have played a role in her death or in the illnesses of the attending medical staff.

Nevertheless, as lawsuits by many parties involved were filed against the hospital, deeper explanations for the illnesses were sought. One controversial theory emerged from researchers at the Lawrence Livermore National Laboratory in California.[277] Their hypothetical scenario depends upon the oxidation of DMSO, through MSM, to dimethyl sulfate. Dimethyl sulfate is a volatile and highly toxic agent that can be quite hazardous to humans in small amounts.

Livermore scientists theorized that such a reaction occurred within Ramirez' body—hence, the source of the fumes. The Livermore researchers acknowledged that "dimethyl sulfate was not detected in any analyses pertinent to this event." And while it is true that the addition of two oxygen atoms to MSM yields dimethyl sulfate, most scientific authorities regard the Livermore theorem as impossible, since the conditions for conversion of MSM to dimethyl sulfate are not present in the human body.

Moreover, dimethyl sulfate's toxicity is a somewhat delayed reaction and would have caused a different set of symptoms and, most likely, the deaths of the hospital personnel even at very low concentrations. Finally, the Ramirez family denied she had used DMSO. The official explanation issued by Riverside County Department of Health, and the one most widely accepted, is that the incident was largely a result of "mass hysteria."

MYTH: DIALYSIS PATIENTS SHOULD NOT USE MSM

Dr. Jacob: I have administered intravenous MSM to at least two dozen dialysis patients. We have never observed any problem.

MYTH: MSM CAUSES HIGH BLOOD PRESSURE

Dr. Jacob: There is no evidence that MSM has any effect on blood pressure, either to raise or to lower it.

UNCONFIRMED: MSM CAUSES HEADACHES
BECAUSE IT HELPS DETOXIFY THE BODY

Dr. Jacob: We have observed that MSM may produce mild, transient headaches in up to 5% of people after they begin using MSM. The etiology has not been determined. With continued use of the supplement, the headaches usually disappear within a couple of weeks.

UNCONFIRMED: MSM IS A BLOOD THINNER

Dr. Jacob: There have been occasional reports of blood in the stool when a patient is taking large doses of aspirin or NSAIDs along with MSM. We have also received six to eight reports of heavier menses with MSM supplementation.

DMSO has been shown to inhibit platelet aggregation.[278-281] MSM probably has slight anti-aggregatory effects, but this has not been confirmed by laboratory studies. The apparent anti-aggregatory effect of MSM appears to be less pronounced than that of DMSO.

We speculate that a daily dose (2-8 g) of MSM might have platelet effects comparable to those of a child's aspirin tablet. We recommend that patients taking anticoagulants or large doses of aspirin or NSAIDs discontinue MSM supplementation if there are any signs of abnormal platelet function (e.g., abnormal bleeding, ecchymosis).

DOES MSM IMPROVE THE GROWTH OF HAIR AND NAILS?

Dr. Jacob: We have observed that MSM speeds the rate of growth of the hair, but this has not been confirmed in scientific research. It also appears to harden the nails. In Chapter 19 (Veterinary Uses), we describe cases of

improved hoof condition with MSM supplementation. In humans, we have observed an improved condition of the nails. In scleroderma patients, we have observed softening of the skin, a move towards more normal color, and regrowth of hair. Although MSM is used in cosmetics, and we think that these may be legitimate applications, scientific data are lacking.

DOES MSM AFFECT ONE'S DREAMS?

Dr. Jacob: I've had perhaps a few dozen patients tell me that when they take MSM close to bedtime, they dream more frequently. The content of the dreams does not appear to be affected. This is something we have seen only rarely.

Glossary of Technical Terms and Abbreviations

Note: This book was originally intended for doctors and other healthcare practitioners. It contains medical and technical words and phrases, many of which can be found in standard reference texts. The following glossary is not comprehensive. It does not, for example, define the names of drugs or diseases. Nevertheless, it should offer some clarification for the non-scientist of many terms used in this book. —J.A.

A

Abdominoperineal resection—Surgical removal of areas of the abdomen and **perineum.**

Abductor pollicis longus—A muscle that abducts and assists in extending thumb

Acetabular—Pertaining to the acetabulum.

Acetabulum—Hip joint.

Acetylcholine—A chemical found in vertebrate nerve cells that carries information across the space between two nerve cells.

Acute—Having a short and relatively severe course. *Contrast* **Chronic**. Also, sharp or poignant.

Ad libitum—In accordance with desire.

Adenoidectomy—Surgical removal of the **adenoids**.

Adenoids—A normal collection of lymph tissue in the **nasopharynx**. Also called 'pharyngeal tonsils.'

Aerobic—Growing, living or occurring in the presence of oxygen. Bacteria that require oxygen to survive.

ALT—Alanine transaminase. A liver function test.

Analgesia—Pain relief or insensitivity to pain while conscious.

Aneurysm—A sac formed by the dilatation of the wall of an artery, a vein or the heart.

Ankylosis—Fusion of bones across a joint. A complication of **chronic** inflammation.

Anterior—Toward the front or in front of.

Antibody—A protein substance produced in the blood or tissues in response to a specific **antigen**, that destroys or weakens bacteria and neutralizes poisons, thus forming the basis for immunity.

Antigen—A substance capable of eliciting specific immune responses and of reacting with the products of those responses (e.g., an **antibody**).

Antihistamine—An agent that counteracts the action of **histamine**.

Antinuclear antibodies (ANA)—**Antibodies** that react against components of the cell nucleus such as DNA or RNA.

Antioxidant—The quality of preventing or delaying deterioration by action of oxygen in the air. A compound possessing such a quality (e.g., vitamin C).

Antispasmodic—An agent that relieves spasm (the sudden, violent, involuntary contraction of a muscle or a group of muscles).

Apnea—*See* **sleep apnea**.

Arrhythmia—A variation from the normal rhythm of the heart beat.

Arterial blood gas tension. The pressure at which blood is oxygenated in the lungs.

Arthralgia—Joint pain.

Arthritides—Plural of arthritis.

Articular—Of or relating to the joints.

Assay—The determination of the amount of a particular constituent of a mixture, or of the biological or pharmacological potency of a drug.

AST—Aspartate serum transaminase. A liver function test.

Ataxia—Failure of muscular coordination, irregularity of muscular action.

Atelectasis—Partial or complete collapse of the lung.

Atheroma—A cyst-like growth containing curdy matter, produced by the thickening and fatty degeneration of the inner coat of the arteries.

Auscultation—Listening, usually through a stethoscope.

Autologous—Derived from one's own tissues or DNA.

Autosomal recessive—Mutation carried on a non-sex determining chromosome that is deleterious only in homozygotes (organisms with identical forms of one or more specific genes).

B

B cell—A type of **lymphocyte** normally involved in the production of antibodies to combat infection.

Bacteriostatic—Inhibiting the growth or multiplication of bacteria.

Balneotherapy—Sulfur baths.

Basement membrane—**Extracellular matrix** characteristically found under the cells that cover internal and external surfaces of the body (epithelial cells).

Beq—Becquerel. A measurement unit of radioactivity.

Bicipital—Pertaining to the biceps; having two heads.

BID—Twice daily.

Bilateral—On both sides (i.e., of the body).

Bioavailability—The physiological availablity of a substance or drug (as distinct from its potency).

Biomarker—A specific biochemical in the body possessing a molecular feature that makes it useful for measuring the progress of disease or the effects of treatment.

Biopsy—A procedure that involves obtaining a tissue specimen for microscopic analysis to establish a precise diagnosis.

Black liquor—A by-product of the processing of trees for paper.

Blood-brain barrier (BBB)—A protective barrier formed by the blood vessels and supportive tissue of the brain. It prevents some substances in the blood from entering brain tissue.

Bowel tolerance—The limit past which a substance affects bowel function (e.g., by causing loose stools).

Bronchiectasis—An irreversible bronchial dilatation, usually accompanied by **chronic** infection.

Bronchoalveolar lavage—Washing out of the lungs with saline or other agents for diagnostic or therapeutic purposes.

Broodmare—A mare kept for breeding.

BUN—Blood Urea Nitrogen. A metabolic by-product (in the liver) from the breakdown of blood, muscle and protein.

C

C fiber—A type of nerve fiber, lacking a myelin (insulating) sheath, sometimes involved in the conduction of pain impulses.

Cachexia—A profound and marked state of constitutional disorder, general ill health and malnutrition. Wasting.

Calcaneal—Pertaining to the calcaneus, or heel bone.

Calculus/calculi—A calcium salt concretion that forms a deposit (e.g., on teeth) or stones (e.g., kidney stones). 'Calculi' is the plural form.

Capillary lumen—The open space within a **capillary**.

Capillary—A tiny blood vessel that connects the arterial and venous systems, forming a network in nearly all parts of the body.

Carbon 14—A radioactive substance with a half-life of 5715 years, widely used as a tracer in studying various aspects of metabolism; naturally occurring carbon 14, arising from cosmic ray bombardment of the earth, is used to date relics containing natural carbonaceous materials.

Carboniferous—A period that occurred from about 360 to 286 million years ago during the late Paleozoic Era.

Cardiorespiratory—Pertaining to the heart and lungs.

Carpal—Relating to the wrist.

Catalyze—To accelerate a chemical reaction without being consumed or changed in the process.

Catheter—A tubular, flexible, surgical instrument for withdrawing fluids from (or introducing fluids into) a cavity of the body, especially one for introduction into the bladder through the urethra for the withdrawal of urine.

cc—Cubic centimeter.

Centrifuge—A laboratory apparatus that separates mixed samples into homogenous component layers by spinning them at high speed; to spin using a centrifuge.

Cerebellar—Pertaining to the cerebellum, a portion of the hindbrain.

CH$_3$—*See* **Methyl group**.

Chelate—Combine with a metal in complexes in which the metal is part of a ring.

Chemofulguration—The use of chemical agents to destroy cancerous tissue and/or control bleeding. *Compare* **electrodesiccation**.

Chemokine—Proteins secreted by white blood cells in response to inflammation that mediate chemical activity between cells.

Chemotaxis—A response by self-propelled cells in which the direction of movement is affected by the chemical concentration gradient, such that the cells move either toward or away from a particular chemical stimulus.

Choanal atresia—Congenital bony or membranous occlusion of one or both openings to the **nasopharynx**.

Cholinesterase—An enzyme that breaks down **acetylcholine** to halt its action.

Chondrocyte—Cell responsible for secretion of **extracellular matrix** of cartilage.

Chondromalacia patella—The progressive erosion of cartilage in the knee joint.

Chronic—ersisting over a long period of time. *Contrast* **Acute**. *Compare* **Subchronic**.

Cisternogram—Injection into the cerebrospinal space of **contrast media** followed by imaging of the cranium at four intervals.

Citric acid cycle—The central cycle involved in cellular respiration (i.e., oxidation and the production of energy). *Also known as* Krebs cycle or tricarboxylic acid cycle.

Coccygeal—Pertaining to the **coccyx**.

Coccyx—The last bone of the spinal column, sometimes referred to as the vestigial tail.

Coenzyme—An organic non-protein molecule, frequently a derivative of a water-soluble vitamin, that binds with a protein molecule to form an active **enzyme**.

Coenzyme A—A derivative of adenosine triphosphate (ATP) and pantothenic acid (vitamin B5) that is involved in many metabolic pathways, for example the **citric acid cycle**.

Cofactor—Inorganic complement of an **enzyme** reaction, usually a metal ion.

Coliforms—A class of bacteria commonly found in the gastrointestinal tract.

Collagen—The protein substance of the white fibers of skin, tendon, bone, cartilage and all other connective tissue. It is converted into gelatin by boiling.

Collagenase—An **enzyme** that breaks down **collagen**.

Colorimetry—A way of determining the concentration of a chemical in a solution by its color. The intensity of the color is measured and related to the concentration of the solution.

Comedones—Plural of "comedo." Blackheads.

Conformational structure—The third level of structure of a **macromolecule**.

Conjugate—To join.

Contraindication—Any condition, especially any condition of disease, which renders some particular treatment undesirable.

Contrast media—Substances, such as barium or air, used in x-ray to increase the contrast of an image.

Control group—A group of subjects participating in the same experiment as another group of subjects, but which is not exposed to the agent or variable under investigation.

COPD—Chronic obstructive pulmonary disease.

Cortisone facies—Roundness of the face due to increased fat deposition caused by drug therapy with cortisone. Also called "moon facies".

CPAP—Continuous positive airway pressure.

C-reactive protein (CRP)—A blood test used as an indicator of acute inflammation.

Creatinine—A waste product of protein metabolism that is found in the urine. Also measured in the blood as an indicator of kidney function.

Cross-section—A transverse cut through a structure or tissue.

Cryoprotectant—A substance that is used to protect from the effects of freezing, largely by preventing large ice crystals from forming.

Crystallization—A lab technique used to purify a substance, to remove a solvent (a liquid that a substance is dissolved in) from the substance, or to separate two or more components in a liquid mixture. This is done by cooling a solution into a slurry, spinning it to separate crystals form solvent (water), and then washing the crystals to remove impurities. *Compare* **distillation**.

CS—Chondroitin sulfate.

CS$_2$—Carbon disulfide.

CT scan—Computed tomography scan. A special technique that uses a computer to assimilate multiple X-ray images into a 2 dimensional **cross-sectional** image.

Cycloplegia—Paralysis of the tiny muscles that move the eyeball.

Cystometry—A method for measuring the pressure/volume relationship of the bladder.

Cystoscopy—Direct visual examination of the urinary tract with an optical instrument.

Cytochrome P-450 enzyme system—Highly conserved **enzymes** involved in detoxification pathways in the liver.

Cytology—The study of cells, typically by microscopy.

Cytotoxic—Directly toxic to cells, preventing their reproduction or growth.

D

Dalton—A unit of measurement of atomic weight.

Dialysis—The process of separating crystals and colloids in solution by the difference in their rates of diffusion through a semi-permeable membrane. Crystals pass through readily, colloids very slowly or not at all. *See* **Renal dialysis**.

Dietary supplement—A product (other than tobacco) intended to supplement the diet that bears or contains one or more of the following dietary ingredients: a vitamin, mineral, amino acid, herb or other botanical; or a dietary substance for use to supplement the diet by increasing the total dietary intake; or a concentrate, metabolite, constituent, extract, or combination of any such ingredient; and intended for ingestion in the form of a capsule, powder, liquid, softgel, or gelcap, and not represented as a conventional food or as a sole item of a meal or the diet

Diplopia—Double vision.

Disease claim—A statement regarding the effects of a **dietary supplement** or drug on a disease. Such statements, with some exceptions, are not permitted to appear on dietary supplement labels. *Contrast* **structure-function claim**.

Distal—Remote, farther from any point of reference, usually the centerline of the body. *Contrast* **proximal**.

Distillation—A lab technique used to purify a substance, to remove a solvent (a liquid that a substance is dissolved in) from the substance, or to separate two or more components in a liquid mixture. Ideally, this is done by taking advantage of the fact that the different chemicals have different boiling points. The temperature is raised so chemicals with lower boiling points boil first and their vapors are shunted out of the distillation vessel into a different container. Then the desired substance is similarly removed, leaving substances with higher boiling points to remain in the distillation vessel as 'still bottoms.' *Compare* **crystallization**.

Disulfide bond—A single chemical bond between two **sulfur** atoms.

Divided dose—A fraction of a full dose; given at intervals so that the full dose is taken within a specified period, usually one day.

DMS—Dimethyl sulfide.

DMSO—Dimethyl sulfoxide. An organic **sulfur** compound with skin penetrant properties. Chemical formula: C_2H_6OS.

Double-blind trial—A type of clinical study in which neither the participants nor the person administering treatment know which treatment any particular subject is receiving. Usually the comparison is between an experimental drug and a **placebo** or standard comparison treatment. This method is believed to achieve the most accuracy because neither the doctor nor the patient can affect the observed results with their psychological bias. *Compare* **Single-blind trial**, **Open-label trial**, and **Randomized Controlled Trial (RCT)**.

DSHEA—Dietary Supplement Health and Education Act of 1994.

Dysautonomia—Severe symptomatic tachycardia (rapid heart rate) and occasional hypotension (low blood pressure).

Dysmetria—Impairment in the ability to control the distance, power, and speed of movement, usually of cerebellar origin. A type of **ataxia**.

Dysphagia—Difficulty in swallowing.

Dysplasia—Abnormal alteration in size, shape and organization of mature cells.

Dysuria—Painful urination. *See also* **Frequency**, **Nocturia**, and **Urgency**.

E

Ecchymosis—Bruising.

Echocardiography—A diagnostic test that uses ultrasound waves to make images of the heart chambers, valves and surrounding structures.

ECM—*See* **Extracellular matrix**.

Electrodesiccation—Use of an electric current to destroy cancerous tissue and/or control bleeding. *Compare* **chemofulguration.**

Electroencephalography—The recording of the electric currents developed in the brain, by means of electrodes applied to the scalp, to the surface of the brain, or placed within the substance of the brain.

Electromyography—A test that measures muscle response to nerve stimulation.

Endogenous—Developing or originating within the body.

Enzyme—A protein molecule produced by living organisms, that accelerates chemical reactions of other substances without itself being destroyed or altered upon completion of the reactions.

Epicondylitis—Inflammation of the epicondyle, a bony projection on the inner side of the **distal** end of the humerus (upper arm bone).

Epidemiology—The study of health-related states and events in populations.

Epiphysitis—Inflammation of the epiphysis, the part of a long bone from where growth occurs.

Erythema—Redness.

Erythrocyte sedimentation rate (ESR)—A test that measures the rate at which red blood cells settle through a column of liquid. A nonspecific index of inflammation.

Erythrocyte—Red blood cell.

ESR—*See* **Erythrocyte sedimentation rate**.

Etiology—The cause or origin of a disease.

Expiration—Breathing out. *Contrast* **inspiration**.

Extensor carpi radialis brevis/longus—Muscles that extend and abduct the wrist in the direction of the thumb.

Extensor pollicis brevis—A muscle that extends and abducts the thumb.

Extra-abdominal—Outside the abdomen.

Extracellular Matrix (ECM)—Material produced by cells and secreted into the surrounding medium. ECM can influence the behavior of cells significantly and is required for cell-to-cell communication.

Extracellular—In the space outside of or between cells.

F

Farrier—A person who shoes horses.

Fasciculation—A small local contraction of muscles, visible through the skin.

Fasciitis—Inflammation of the fascia (the lining tissue under the skin that covers a surface of underlying tissues).

Faucial pillars—The arches connecting the back of the tongue and throat, respectively, to the palate. Also called 'tonsillar pillars.'

FDA—Food and Drug Administration of the United States.

FEF 25-75—Forced Expiratory Flow between 25 and 75 % of **forced vital capacity** (FVC). A lung function test that measures the average rate of airflow during the mid-portion of the FVC. This is reduced in obstructive and restrictive lung disorders.

Fibroblast—Connective tissue cell that secretes building block components of connective tissue.

Filly—A young female horse, usually less than four years old.

Flexion contracture—A bent finger, usually at the middle joint of the finger, that one cannot straighten using one's own muscle power or with the help of the opposite hand.

Forced Vital Capacity (FVC)—The total volume of air exhaled after a full inhalation.

Frequency (urinary)—Increased number of urinations per day. *See also* **Dysuria**, **Nocturia**, and **Urgency**.

G

g—Gram. There are approximately 28 grams in an ounce.

Gametogenesis—Process leading to the production of gametes, specialized cells involved in sexual reproduction.

Gas chromatography—A separation method involving flow of a fluid carrier over a stationary, absorbing phase. In gas chromatography, the stationary phase is solid while the mobile phase is gaseous.

Gastroduodenal—Pertaining to the stomach and the duodenum (first part of the small intestine).

Gastroesophageal reflux—The return of stomach contents back up into the esophagus. This often causes heartburn because of irritation of the esophagus by stomach acid.

Gavage—Administration of a medicine directly into the stomach through a tube or syringe.

Gel electrophoresis—Separation of ionic molecules, (principally proteins) by the differential migration through a gel according to the size and ionic charge of the molecules in an electrical field.

GFAA—Graphite furnace atomic absorption.

GI—Gastrointestinal.

Glomerulus/glomeruli—A bundle of **capillary** blood vessels that help make up the nephron (functional unit) in the kidney. Glomeruli (pl.) are actively involved in the filtration of the blood.

GLP—Good Laboratory Practices.

Glycine—The simplest amino acid. It is a common component of proteins, especially **collagen**.

Glycosaminoglycans (GAGs)—Large molecules, consisting networks of long, braided chains of repeating units, that are significant components of connective tissue (e.g., joint cartilage).

GMP—Good Manufacturing Practices.

Granulation tissue—Highly vascularized (filled with blood vessels) tissue that replaces the initial clot in a wound.

Gross—Obvious, overt, readily perceived. As in "gross hematuria." *Contrast* **occult**.

GS—Glucosamine sulfate.

H

h—Hour. For example, "q 12 h" means every 12 hours.

H_2O—Water.

H_2O_2—Hydrogen peroxide.

H_2S—Hydrogen sulfide.

Half-life—The length of time over which the concentration of a specified chemical or drug takes to fall to half its original concentration.

Hematological—Of or pertaining to the blood and its constituents.

Hematuria—The appearance of blood in the urine.

Hepatosplenomegaly—Enlargement of the liver and spleen.

Histamine—A potent pharmacological agent acting through receptors in smooth muscle and in secretory systems. Stored in mast cells and released by **antigen**.

Histocompatibility antigen—A set of glycoproteins on the surface of all nucleated cells that are crucial for **T-cell** recognition of **antigens**. They are of prime importance in determining compatible organ donors for a specific transplantation procedure. Each person has unique histocompatibility antigens.

Histology—The study of cells and tissue on the microscopic level.

Histopathology—The science of microscopic changes in diseased tissues.

Hyaluronic acid—A **macromolecule**—composed of repeating units—that forms the core of complex proteoglycan aggregates found in **extracellular matrix**.

Hydrocephalus—A condition marked by dilatation of the cerebral **ventricles**, most often occurring due to obstruction of the cerebrospinal fluid pathways and accompanied by an accumulation of cerebrospinal fluid within the skull.

Hydrodistention—Enlargement, usually of the urinary bladder, with water.

Hydrometra—Accumulation of clear fluid in the uterus.

Hydroxyl radical—A pair of atoms (one oxygen and one hydrogen) that has one unpaired electron.

Hydroxyproline—An amino acid produced during the hydrolysis (breakdown) of **collagen**.

Hyperdistention—Extreme distention.

Hypomobility—Decreased ability to move.

Hypothalamic-Pituitary-Adrenal (HPA) Axis—The interface of a triad of endocrine organs that regulate a wide array of physiologic and metabolic functions, particularly by modulating hormone levels.

Hysterectomy—Surgical removal of the uterus.

I

ICP-MS—Inductively coupled plasma mass spectrometry.

IM—*See* **Intramuscular**.

In situ—In the natural or normal place, confined to the site of origin without invasion of neighboring tissues.

In vitro—In an artificial environment (e.g., a test tube) outside a living organism.

In vivo—Within a living organism.

Incontinence—The inability to control excretory functions, as defecation (fecal incontinence) or urination (urinary incontinence). *See also* **stress incontinence**.

Infarct—An area of tissue death due to a local lack of oxygen.

Infusion—The therapeutic introduction of a fluid other than blood (e.g., saline solution) into a vein.

Insoluble—Not soluble. *Contrast* **soluble**.

Inspiration—Breathing in. *Contrast* **expiration**.

Instillation—To drop in; to pour in a little at a time; to impart gradually; to infuse slowly.

Interstitial—Pertaining to or situated between parts, or in the interspaces of a tissue.

Intracellular—Within a cell.

Intramuscular (IM)—Within a muscle or muscles.

Intranasal—Within the nose.

Intra-ocular—Within the eye.

Intraperitoneal—Within the **peritoneum**.

Intrathecal—Within a sheath, for example, cerebrospinal fluid that is contained within the dura mater (the outermost, toughest and most fibrous of the three membranes covering the brain and spinal cord.)

Intravaginal—Within the vagina.

Intravenous (IV)—Within a vein or veins.

Intravesicular—Within the urinary bladder.

Intubation—Insertion of a tube into a body canal or hollow organ, (e.g., the trachea or stomach.)

IV—*See* **Intravenous**.

J-K

Keloids—Elevated, irregularly shaped, progressively enlarging scars caused by the excessive formation of **collagen** during connective tissue repair.

Keratin—A protein that is a primary constituent of hair, nails and skin.

Keratinization—Formation of **keratin**, or development of a horny layer

(e.g., hardening on the surface of the skin).

Keratolytic—Producing a loosening or shedding of **keratin**, the horny layer of the epidermis.

Keratoplastic—Having the power to give form or fashion to keratin, the horny layer of the epidermis.

kg—Kilogram. 2.2 pounds.

Krebs cycle—*See* **Citric acid cycle**.

L

L or l—Liter.

Laminectomy—A surgical procedure designed to relieve pressure on the spinal cord or nerve root that is being caused by a slipped or herniated disk.

Laminitis—A veterinary term referring to inflammation of the fleshy plates along the coffin bone of a horse. Lameness in the foot of a horse, occasioned by inflammation.

Lavage—Washing.

Lenticular—Pertaining to the crystalline lens of the eye.

Lesion—Any abnormal or traumatic discontinuity of tissue or loss of function of a part.

Leukocytes—White blood cells.

Leukopenia—Low number of white blood cells.

Liter—About 34 ounces.

Lower respiratory—Pertaining to the lower air passages (e.g., the lungs and trachea). *Compare* **upper respiratory**.

Lumen—The open space or channel within a tube or tubular organ.

Lymphadenopathy—Swelling of the lymph nodes.

Lymphocyte—A white blood cell derived from lymph tissue.

Lysosome—A membrane-bound cell **organelle** that contains a variety of hydrolytic enzymes that can be released.

M

Macroglossia—Excessively large tongue.

Macromolecule—A biological term pertaining to large molecules including proteins, nucleic acids and carbohydrates.

Magnetic resonance spectroscopy—Detection and measurement of the resonant spectra (bands of wavelengths of electromagnetic vibrations) of molecular species in a tissue or sample.

Meatus—A natural passage or canal; an opening. *As in* **urethral meatus**.

Menorrhagia—Excessive uterine bleeding occurring at the regular intervals of menstruation.

MeOH—Methanol.

Mesenteric—Pertaining to the mesentery.

Mesentery—The membranes (and related enclosed tissues) that connect the intestines and their appendages with the real wall of the abdominal cavity.

Meta-analysis—A quantitative study that systematically combines the results of previous research studies in order to arrive at a conclusion about a body of literature.

Metabolic—Of or pertaining to **metabolism**.

Metabolism—Physical and chemical processes by which living organisms are maintained and the transformations by which energy is made available for the uses of the organism.

Metacarpal—One of the five bones going to each finger of the hand.

Metacarpophalangeal—Pertaining to the joint(s) connecting the **metacarpal** bones to the fingers.

Metastasis—The transfer of disease from one organ or part to another not directly connected with it. Usually used in reference to cancer.

Metatarsal—One of five bones that go out to each toe of the foot.

Metatarsophalangeal—Pertaining to the joint(s) that connect the **metatarsal** bones to the toes.

Methyl group—A $-CH_3$ group on a larger molecule. A carbon that is single-bonded to three hydrogens, and has one free bond to the rest of the molecule.

Methylation—Addition of **methyl groups**.

mg—Milligram. One thousandth of a gram.

Micrognathia—A lower jaw that is abnormally small in size. *Compare* **retrognathia**.

Microprill—A tiny sphere.

Mitochondria—A small **intracellular organelle** that is responsible for energy production.

mL or ml—Milliliter. One thousandth of a liter. About three-hundredths of an ounce, or one-fifth of a teaspoon.

Mole—The amount of a substance that contains as many atoms, molecules, ions, or other elementary units as the number of atoms in 0.012 kilograms of carbon 12. The number is 6.0225×10^{23}, or Avogadro's number. The mass in grams of this amount of a substance, numerically equal to the molecular weight of the substance.

Monotherapy—Therapy with just one medicinal agent.

Morbidity—A diseased condition or state, the incidence of a disease or of all diseases in a population.

Morphea—A skin lesion that is characterized by the presence of localized, hard, slightly depressed areas of thickened tissue. It may be white or yellow in color and surrounded by a pink or purplish halo.

MSM—Methylsulfonylmethane; dimethyl sulfone; $DMSO_2$. An organic **sulfur** compound made by oxidizing DMSO (dimethyl sulfoxide) with hydrogen peroxide (H_2O_2). Chemical formula: $C_2H_6O_2S$

Mucopolysaccharide—A group of complex sugars with high molecular weight that often form complexes with protein. *See also* **glycosaminoglycan**.

Mucosa—A mucous membrane. The lubricated inner lining of the mouth, nasal passages, vagina and urethra; any membrane or lining that contains mucous-secreting glands.

Multifactorial—Referring to multiple factors or influences.

Murine—Pertaining to mice.

Myalgia—Muscle pain.

Myocardial fibrosis—The formation of fibrous tissue in the heart muscle.

Myocardial infarction—Heart attack.

Myositis—Inflammation of a voluntary muscle.

N

n—The number of participants in a study (e.g., n=7).

N_2O_4—Nitrogen tetroxide.

NAC—N-acetylcysteine.

NADPH—Nicotinamide adenine dinucleotide phosphate; the reduced form of the coenzyme that acts as an electron and hydrogen carrier in some oxidation-reduction reactions.

Nasopharyngeal—Pertaining to the **nasopharynx**.

Nasopharynx—The connected anatomical structures of the nose and throat.

Natural history—The study and description of organisms and natural objects, especially their origins, evolutions and interrelationships. Often used to describe the course of an untreated disease.

Necropsy—A **postmortem** examination or inspection; an autopsy.

Necrosis—Tissue death.

Nematode—A simple worm consisting of an elongated stomach and reproductive system inside a resistant outer skin. Most nematodes are so small, between 400 micrometers to 5 mm long, that a microscope is needed to see them. Their small size, resistant covering, and ability to adapt to severe and changing environments have made them one of the most abundant types of parasites on earth.

Neoplastic—Relating to new and abnormal growth of tissue, which may be benign or cancerous.

Nerve conduction velocity—The rate of impulse conduction in a peripheral nerve or its various component fibers, generally expressed in meters per second.

Neurotransmitter—A chemical released in the nervous system that travels across a **synapse** and excites or inhibits a target cell.

Neutrophil—A granular-looking white blood cell. Also called a granulocyte.

ng—Nanogram. One billionth of a gram.

nmole—Nanomole. One billionth of a **mole**.

NNFA—National Nutrition Foods Association.

Nocturia—Increased urination at night. *See also* **Dysuria**, **Frequency**, and **Urgency**.

Nonspecific resistance—Innate immunity. Immunity that results from a person's genetic constitution or physiology and does not arise as a response to previous infection or vaccination.

NSAID—Non-steroidal anti-inflammatory drug.

Nutraceutical—A nutritional supplement produced in accordance with pharmaceutical standards.

O

OA—Osteoarthritis.

Occult—Hidden. Not perceptible on visual inspection. As in "occult blood in the stool." *Contrast* **gross**.

Ocular—Of or pertaining to the eye.

Open-label trial—A study in which both researchers and participants know what drug a person is taking and at what dose. *Compare* **Double-blind trial**, **Single-blind trial**, and **Randomized Controlled Trial (RCT)**.

Opsonized zymosan—Zymosan (an **insoluble** carbohydrate from the cell wall of yeast) that has been made more susceptible to the action of **phagocytes**.

Organelle—A structurally discrete component of a cell.

Organosulfur—A carbon-based compound that also contains **sulfur**.

Oropharynx—The structures of the mouth and throat (i.e., soft palate, posterior **faucial pillars** of the tonsils, and the uvula).

Osteoarticular—Pertaining to bones and joints.

OTC—Over-the-counter. Refers to medications available without a doctor's prescription.

P

PABA—Para-amino benzoic acid.

Panniculitis—An inflammatory reaction of the **subcutaneous** fat.

Pannus—A membrane of **granulation tissue** covering the normal surface of joint cartilage in rheumatoid arthritis.

Papule—A small circumscribed, superficial, solid elevation of the skin.

Parenteral—Not through the digestive tract but rather by injection through some other route. *As in* **total parenteral nutrition**.

Paresthesia—Numbness, pain, burning, tingling or other abnormal nerve sensation.

Pastern angle—The angle of the part of a horse's foot extending from the fetlock to the top of the hoof.

Pathogenesis—The origin and development of disease.

Pathophysiology—Disturbance of function seen in disease; alteration in function as distinguished from structural defects

Pedicle flap—A tube of skin surgically created from either the flank or lower abdomen.

Peer-review—Scrutiny by one's peers (equals). Peer-reviewed articles appearing in medical journals have been scrutinized by members of the biomedical community before publication.

Periarticular—Around the joints.

Pericardial effusion—A collection of fluid or blood in the pericardial space (inside the sac surrounding the heart.)

Perineal—Pertaining to the **perineum.**

Perineum—The region between the thighs: in the female between the vulva and the anus; in males between the scrotum and the anus.

Perioral—Around the mouth.

Periosteum—The membrane of fibrous connective tissue that closely surrounds all bones except at the joint surfaces.

Periostitis—Inflammation of the **periosteum.**

Peristalsis—Waves of muscular contraction that move contents through the digestive tract.

Peritoneum—The smooth membrane that lines the cavity of the abdomen and, turning back, surrounds the internal organs, forming an enclosed sac.

Phagocyte—A cell that is capable of engulfing particulate matter, like bacteria or cell fragments for the purposes of immune protection.

Pharmacokinetics—The action of drugs in the body over a period of time, including the processes of absorption, distribution, metabolism and excretion.

Pharynx—The cavity, at the back of the mouth, that opens on to the esophagus.

Phase I liver biotransformation—Enzymatic reactions in the liver that make foreign compounds (e.g., toxins, hormones) more water-soluble, making them easier to excrete.

Phase II liver biotransformation—Coupling reactions in the liver in which products from Phase I are combined with agents that decrease toxicity and promote excretion.

Placebo—An inactive substance used as a control in an experiment or test to determine the effectiveness of a treatment, usually a drug or **dietary supplement**. A substance with no medicinal properties, which causes a patient to improve because of his belief in its efficacy.

Plantar—Of or pertaining to the sole of the foot.

Plasma cell—An **antibody**-producing **lymphocyte** derived from a **B cell** upon reaction with a specific **antigen**.

Plasma—The clear, yellowish fluid portion of the blood in which cells are suspended.

Plasmapheresis—Blood that has been removed from the body is spun in a **centrifuge** to separate the cellular elements from the **plasma**.

Platelet aggregation—The attachment of platelets to each other. This clumping together is part of the mechanism leading to clot formation.

Pleomorphic—Having different forms at different stages of the life cycle.

Pleural effusion—A collection of fluid in the pleural space (in one side of the chest cavity around the lung).

Pleurisy—Inflammation of the delicate connective tissue membranes covering the lungs, usually with discharge of fluid (exudation) into its cavity and over its surface.

Pleuritis—*See* **pleurisy**.

PO—*Per os*; by mouth (e.g., to take a medicine orally).

Poikiloderma—A wasting, multicolored area of skin with too much pigmentation and **telangiectasia**.

Polyp—A growth, usually benign, protruding from a mucous membrane.

Postmortem—After death.

Postsynaptic—Relating to the area on the **distal** side of a **synapse**.

ppm—Parts per million.

Prepatellar—In front of the kneecap.

Pretibial—Situated in front of the tibia (leg bone).

Prolapse—The falling down or sinking of an organ or part.

Prostaglandin—A powerful hormone-like substance that mediates a range of physiological functions within the body, such as **metabolism** and nerve transmission.

Prostaglandin E$_2$ (PGE$_2$)—The most common and most biologically active **prostaglandin**.

Prostatitis—Inflammation of the prostate gland.

Protease—An **enzyme** that breaks down protein.

Proteoglycan—A **mucopolysaccharide**, bound to protein chains that occur in **extracellular matrix**.

Proximal—Nearest to, closer to any point of reference, usually the centerline of the body. *Contrast* **distal**.

Pruritis/pruritic—Itching/itchy.

Ptosis—The drooping of the upper eyelid from paralysis or loss of nerve supply.

Purine—A component of DNA.

Pyridoxine—Vitamin B$_6$.

Q

q—Every. For example, "q 12 h" means every 12 hours.

QD—Each day; once daily.

R

RA—Rheumatoid arthritis.

Radiolabel—To use a mildly radioactive molecule to tag another molecule (such as a protein) so that it can be identified as it goes through some kind of biochemical process.

Radiology—The study of x-rays in the diagnosis of a disease.

Randomized controlled trial (RCT)—A study or scientific test to determine what effect a treatment has by comparing it with another treatment, treatments or a **placebo**. In a RCT people are randomly put into one of the treatment groups. It is considered the best quality research of a **monotherapy**. *Compare* **Double-blind trial**, **Open-label trial**, and **Single-blind trial**.

RBC—Red blood cell.

Reflux—A backward or return flow. *As in* **gastroesophageal reflux**.

Refractory—Not readily responsive to treatment.

Renal dialysis—A medical procedure that uses a machine to filter waste products from the bloodstream and restore the bloods normal constituents.

Renal—Of or pertaining to the kidney.

Resection—Surgical removal or excision of a portion or all of an organ or other structure.

Retinoscopy—The study of the retina of the eye by means of the ophthalmoscope.

Retrocalcaneal—Behind the heel bone, at the Achilles tendon.

Retrognathia—A lower jaw that is abnormally set back from the upper jaw. *Compare* **micrognathia**.

Retrospective study—A study used to test a hypothesis about the **etiology** of a disease. In retrospective studies, inferences about an exposure to supposed causal factors are derived from data relating to people under study or to events or experiences in their past. The essential feature is that some of the people being studied have the disease or outcome of interest, and their characteristics are compared with those who are unaffected.

RF—Rheumatoid Factor.

Rheumatoid nodule—Nodules under the skin seen in 20-30% of rheumatoid arthritis patients. They may arise anywhere on the body, but are most frequently found over the bony prominences.

Ruminant—Grazing, cud-chewing mammals with four stomachs. Examples include camels, deer, antelopes, goats, sheep, and cattle.

S

Saline—Salty; a salty solution.

SAMe—S-adenosylmethionine.

SAR—Seasonal Allergic Rhinitis.

Scintigraphy—The process of obtaining a two-dimensional record of the distribution of a radioactive tracer in a tissue or organ.

Sclerodactyly—A tapering deformity of the bones of the fingers.

Sclerosis—Hardening (e.g., of tissues).

Semi-ovale lacunae—Normal, lake-like, anatomical projections into the white matter core of the cerebral hemispheres.

Septal deviation—Abnormal displacement of the inner dividing wall between the nostrils.

Serology—A blood test that detects the presence of **antibodies** to a particular **antigen** (e.g., **RF**, HIV test).

Seropositive—The state of an individual whose **serum** suggests that they have experienced a particular infection in the past.

Serum—The clear liquid that separates from blood on clotting.

-SH—*See* **Sulfhydryl group**.

Shunt—A surgically created opening between two normally separate spaces or organs.

Single-blind trial—A method in which either the observer(s) or the subject(s) is kept ignorant of which participants are receiving **placebo** and which are receiving active treatment. *Compare* **Double-blind trial**, **Open-label trial**, and **Randomized Controlled Trial (RCT)**.

Sleep apnea—Temporary stoppage of breathing during sleep, often resulting in daytime sleepiness. Usually occurs in overweight or obese individuals.

Soluble—Capable of being dissolved in liquid, or of going into solution. *Contrast* **insoluble**.

Spinal fusion—A procedure that involves fusing together two or more vertebrae in the spine using either bone grafts or metal rods.

Spur—A spine or projection from a bone.

Stress incontinence—The inability to control excretory functions, as defecation (fecal incontinence) or urination (urinary incontinence) upon physical stresses such as coughing or laughing.

Structure-Function Claim—A statement regarding the effects of a dietary supplement on the structure or function of the human body. Such statements are permitted to appear on dietary supplement labels. *Contrast* **disease claim**.

Subacromial—Underneath the acromion, the lateral triangular projection of the scapula that forms the point of the shoulder and joins with the clavicle.

Subarachnoid—A layer of tissue situated between the fibers and delicate membranes overlaying the brain and spinal cord.

Subchondral—Beneath or below the cartilage.

Subchronic—Not yet **chronic**, but persisting over a moderate period of time (e.g., 30 days).

Subcutaneous—Under the skin.

Subdeltoid—Beneath the deltoid muscle of the arm.

Sublingual—Under the tongue.

Subperiosteal—Situated under the **periosteum**.

Sulfate—A salt or ester of sulfuric acid.

Sulfation—Addition of **sulfate** groups to preexisting molecules.

Sulfhydryl group (-SH)—A pair of atoms (one **sulfur** and one hydrogen) that has one unpaired electron and is very reactive with other biomolecules.

Sulfoxidation—The addition of a sulfinyl group (SO) to a preexisting molecule.

Sulfur—The sixteenth element on the periodic table. A non-metallic, pale yellow, odorless, brittle solid. Sulfur is **insoluble** in water but **soluble** in carbon disulfide. Sulfur is essential to life. It is a constituent of fats, body fluids, and skeletal minerals.

Sulfur cycle—The transport of volatile **sulfur** compounds from marine, coastal and estuarine environments to the troposphere; from the troposphere to the earth; and back to the oceans.

Superoxide—A harmful derivative of oxygen capable of destroying cell components.

Supinator longus/brevis—Muscles that rotate the forearm to a palm-up position.

Suprapubic—Above the pubic bone.

Synapse—The junction of two nerve cells, or of a nerve cell and a muscle cell, where a signal is transmitted by release from one membrane of a chemical transmitter that binds to a receptor in the second membrane. Such signals only pass in one direction.

Synovial fluid—Joint fluid; viscous fluid that lubricates the joint.

Synovitis—Inflammation of the synovial space (i.e., the fluid-filled space surrounding the joint.)

T

T cell—A class of **lymphocytes**, derived from the thymus gland.

T Helper cells—Sets of **lymphocytes** that specifically are involved in the formation of **antibody**-secreting cells.

T4 cells—A subset of **lymphocytes** that secrete various **cytokines** that regulate the immune response. T4 cells are targets for HIV infection. Also known as 'CD4 cells.'

T8 cell—A type of immune cell that shuts down the immune response after it has destroyed invading organisms.

Telangiectasia—Small red spots on the skin of the fingers, face, or inside of the mouth.

Thenar—Of or relating to the palm of the hand.

Therapeutant—A therapeutic or medicinal agent.

Thymectomy—Surgical removal of the thymus gland.

TID—Three times daily.

Tinnitus—Ringing in the ears.

Titration—A chemistry lab technique used to determine the concentration of a substance by slowly putting in a known amount of another substance that can neutralize the effects of the unknown substance.

Tonsillar pillars—*See* **faucial pillars**.

Tonsillectomy—Surgical removal of the tonsils.

Total parenteral nutrition (TPN)—A diet taken entirely by means other than the oral route, usually by intravenous infusion.

Toxicity—The quality of being poisonous.

TPN—*See* **Total parenteral nutrition**.

Transdermal—Entering through the dermis or skin.

Transect—To cut across.

Transforming Growth Factor (TGF)—Proteins secreted by transformed cells that can stimulate growth of normal cells.

Trigonitis—Inflammation of the trigone area of the urinary bladder (the triangular area on the inner surface surrounded by the openings to the ureters and the **urethra**.)

Trimester—A period of 3 months; one-third the length of a pregnancy.

Troposphere—The lowest layer of the Earth's atmosphere.

tsp—Teaspoon.

Tumor Necrosis Factor (TNF)—A **cytokine** that preferentially kills tumor cells in vivo.

U

Ulnar deviation—Involuntary angling of the wrist such that the fingers point toward the side of the forearm opposite the thumb.

Upper respiratory—Pertaining to the upper air passages (e.g., nose and throat). *Compare* **lower respiratory**.

Upregulate—To improve function or stimulate activity (e.g., of an enzyme system.)

Urethra—The tube that carries urine from the bladder to the outside of the body.

Urethral—Pertaining to the **urethra**.

Urethral meatus—The opening of the **urethra** to the outside of the body.

Urgency (urinary)—Increase in the perceived urge to urinate. *See also* **Dysuria**, **Frequency**, and **Nocturia**.

Uric acid—A nitrogen waste product excreted in the urine.

Urologic—Of or pertaining to the urinary system (i.e., the kidneys, ureters, bladder, and urethra.)

USP—United States Pharmacopeia.

Uvulopalatopharyngoplasty (UPPP)—Surgical resection of redundant tissue of the palate and **oropharynx** in selected cases of snoring, with or without **sleep apnea**.

V

Valsalva maneuver—A maneuver performed by holding the breath and bearing down, as in a bowel movement or coughing.

Vasculitis—Inflammation of a vessel. Also known as 'angiitis.'

Vasoconstriction—A state of decreased diameter of the blood vessels. *Contrast* **vasodilation**.

Vasodilation/Vasodilatation—A state of increased diameter of the blood vessels. *Contrast* **vasoconstriction**.

Ventricular—Pertaining to the ventricles (i.e., the muscular chambers in the heart, or the spaces within the brain).

Vertebrobasilar insufficiency—Inadequate blood flow through the arteries that supply blood to the base of the brain.

Villus/Villi—A tiny finger-like projection on certain membranes. "Villi' is the plural form.

Violaceous—Resembling violets in color; bluish purple.

Visual Analog Scale (VAS)—A method of evaluating pain or discomfort in which a patient makes a mark on a straight line, one end of which is meant to represent the worst pain imaginable and the other end to represent no pain at all. The position of the mark is then precisely measured and a score is assigned.

Volar—Of or pertaining to the palm of the hand or the sole of the foot.

Volatile—Subject to evaporation.

W-X

WBC—White blood cell.

Xanthine oxidase—An **enzyme** involved in the breakdown of **purines** and the formation of **uric acid**.

Xenobiotic—A completely synthetic chemical compound that does not naturally occur on earth; a compound foreign to the body (e.g., an environmental toxin).

Y-Z

Yearling—An animal that is one year old, or in its second year of age.

References

1 Blendon RJ, DesRoches CM, Benson JM, et al. Americans' views on the use and regulation of dietary supplements. *Arch Intern Med* 2001;161:805–10.

2 Lovelock JE, Maggs R J, Rasmussen RA. Atmospheric dimethyl sulphide and the natural sulphur cycle. *Nature* 1972: 237:452–3.

3 Pearson TW, Dawson HJ, Lackey HB. Natural occurring levels of dimethyl sulfoxide in selected fruits, vegetables, grains and beverages. *J Agric Food Chem* 1981;29:1019–21.

4 Williams KIH, Burstein SH, Layne DS. Dimethyl sulfone: isolation from cows' milk. *Proc Soc Exp Biol Med* 1966;122:865–6.

5 Lakota J, Fuchsberger P. Autologous stem cell transplantation with stem cells preserved in the presence of 4.5 and 2.2% DMSO. *Bone Marrow Transplant* 1996;18:262–3.

6 Jacob SW, Bischel M, Herschler RJ. Dimethyl sulfoxide (DMSO): A new concept in pharmacotherapy. *Curr Ther Res Clin Exp* 1964;86:134–5.

7 Jacob SW, Bischel M, Herschler RJ. Dimethyl sulfoxide: Effects on the permeability of biologic membranes (preliminary report). *Curr Ther Res Clin Exp* 1964;29:193–8.

8 Linder MC. Nutrition and metabolism of the major minerals. In: Linder MC, ed. *Nutritional Biochemistry and Metabolism With Clinical Applications*, 2nd ed. Norwalk, CT: Appleton & Lang, 1991, 191–214.

9 Richmond VL. Incorporation of methylsulfonylmethane sulfur into guinea pig serum proteins. *Life Sci* 1986;39:263–8.

10 Morris ME, Levy G. Serum concentration and renal excretion by normal adults of inorganic sulfate after acetaminophen, ascorbic acid, or sodium sulfate. *Clin Pharmacol Ther* 1983;33:529–36.

11 Ibid.

12 Ibid.

13 Hoffman DA, Wallace SM, Verbeeck RK. Circadian rhythm of serum sulfate levels in man and acetaminophen pharmacokinetics. *Eur J Clin Pharmacol* 1990;39:143–8.

14 Plesofsky-Vig N. Pantothenic Acid. In: Shils ME, Olsen JA, Shike M, Ross AC, eds. *Modern Nutrition in Health and Disease*, 9th ed. Baltimore: Williams & Wilkins, 1999, 423–32.

15 Sipes IG, Gandolfi AJ. Biotransformation of toxicants. In: Casarett LJ, Amdur MO, Klaassen CD, eds. *Casarett and Doull's Toxicology*, 5th ed.: McGraw Hill Text, 1995, 88–126.

16 Waring RH, Emery P. The genetic origin of responses to drugs. *Br Med Bull* 1995;51:449–61.

17 Mitchell SC, Waring RH, Haley CS, et al. Genetic aspects of the polymodally distributed sulphoxidation o S-carboxymethyl-L-cysteine in man. *Br J Clin Pharmacol* 1984;18:507–21.

18 Scharschmidt BF, Lake JR. Impaired sulfoxidation in patients with primary biliary cirrhosis. *Hepatology* 1989;9:654–5.

19 Scadding GK, Ayesh R, Brostoff J, et al. Poor sulphoxidation ability in patients with food sensitivity. *BMJ* 1988;297:105–7.

20 Seideman R, Ayesh R. Reduced sulphoxidation capacity in D-penicillamine induced myasthenia gravis. *Clin Rheumatol* 1994;13:435–7.

References

21 Emery P, Bradley H, Gough A, et al. Increased prevalence of poor sulphoxidation in patients with rheumatoid arthritis: effect of changes in the acute phase response and second line drug treatment. *Ann Rheum Dis* 1992;51:318–20.

22 Emery P, Bradley H, Arthur V, et al. Genetic factors influencing the outcome of early arthritis—the role of sulphoxidation status. *Br J Rheumatol* 1992;31:449–51.

23 Lewis S, Crossman M, Flannelly J, et al. Chondroitin sulphation patterns in synovial fluid in osteoarthritis subsets. *Ann Rhem Dis* 1999;58:441–5.

24 Gordon C, Bradley H, Waring RH, Emery P. Abnormal sulphur oxidation in systemic lupus erythematosus. *Lancet* 1992;339:25–6.

25 Patel DD, Koopmann W, Imai T, et al. Chemokines have diverse abilities to form solid phase gradients. *Clin Immunol* 2001;99:43–52.

26 American Hospital Formulary Service. Sulfur. In: McEvoy GK, Litvak K, Welsh OH, eds. *AHFS 95 Drug Information*. Bethesda: American Society of Health System Pharmacists, Inc., 1995:2466–8.

27 Sukenik S. Balneotherapy for rheumatic diseases at the Dead Sea area. *Isr J Med Sci* 1996;32(Suppl 3):16–9.

28 Pfiffner JJ, North HB. Dimethyl sulfone: A constituent of the adrenal gland. *J Biol Chem* 1940;134:781–2.

29 Budavari S, O'Neil MJ, Smith A, et al (eds). *The Merck Index*, 12th edition. Whitehouse Station, NJ: Merck & Co., Inc., 1996, 551.

30 Gaylord Chemical Corporation, personal communication.

31 [No authors listed]. DMSO2: Dimethyl sulfone technical bulletin. James River Corporation, Camas, Washington.

32 Cowan B. MSM is natural. Unpublished document. Oct. 27, 1999.

33 Martin W. [Natural occurrence of DMSO and DMSO2 in the human organism.] In: Jacob SW, Kappel JE, eds. *DMSO International DMSO Workshop*, Hannover, Germany, September 19, 1987. San Francisco: W. Zuckschwerdt Verlag, 1987, 71–7.

34 Pratt SE, Clarke AF, Riddolls L, McKee S. A study of the absorption of OptiMSM (methylsulfonylmethane) in horses. March, 2001. Equine Research Centre, Guelph, Ontario, Canada.

35 Layman DL, Jacob SW. The absorption, metabolism and excretion of dimethyl sulfoxide by Rhesus monkeys. *Life Sciences* 1985;37:2431–7.

36 Garretson SE, Aitchison JP. Determination of dimethyl sulfoxide in serum and other body fluids by gas chromatography. *J Anal Toxicol* 1982;6:76–81.

37 Hucker HB, Miller JK, Hochberg A, et al. Studies on the absorption, excretion and metabolism of dimethylsulfoxide (DMSO) in man. *J Pharmacol Exp Ther* 1967;155:309–17.

38 Herschler RJ. Personal communication.

39 Personal communication.

40 Richmond, op. cit., reference 9.

41 Personal communication.

42 Rose SE, Chalk JB, Galloway GJ, Doddrell DM. Detection of dimethyl sulfone in the human brain by in vivo proton magnetic resonance spectroscopy. *Magn Reson Imaging* 2000;18:95–8.

43 Lin A, Nguy CH, Shic F, Ross BD. Accumulation of methylsulfonyl-methane in the human brain: identification by multinuclear magnetic resonance spectroscopy. *Toxicol Lett* 2001;123:169–77.

44 Phillis JW, Estevez AY, O'Regan MH. Protective effects of the free radical scavengers, dimethyl sulfoxide and ethanol, in cerebral ischemia in gerbils. *Neurosci Lett* 1998;244:109–11.

47 Shimizu S, Simon RP, Graham SH. Dimethylsulfoxide (DMSO) treatment reduces infarction volume after permanent focal cerebral ischemia in rats. *Neurosci Lett* 1997;239(2-3):125–7.

46 Plotnikov MB, Avdoshin AD, Chernyshova GA, Saralikov AS. Dimethyl sulfoxide as a corrector of the cerebral hemodynamic oxygen and carbohydrate metabolism and lipid peroxidation disturbances in early period after intracerebral hemorrhage. *Biulleten Eksperimentalnoi Biologii i Meditsiny* 1990;109:357–9 [in Russian].

47 Albin MS, Bunegin L, Helsel P. Dimethyl sulfoxide and other therapies in experimental pressure induced cerebral focal ischemia. *Ann N Y Acad Sci* 1983; 411:261–8.

48 McGraw CP. Treatment of cerebral infarction with dimethyl sulfoxide in the Mongolian gerbil. *Ann N Y Acad Sci* 1983;411:278–85.

49 Kassell NF, Sprowell JA, Boarini DJ. Olin JJ. Effect of dimethyl sulfoxide on the cerebral and systemic circulation of the dog. *Neurosurgery* 1983;12:24–8.

50 De la Torre JC. Role of dimethyl sulfoxide in prostaglandin-thromboxane and platelet systems after cerebral ischemia. *Ann N Y Acad Sci* 1983;411:293–308.

51 Mullan S, Jafar J, Hanlon K, Brown F. Dimethyl Sulfoxide in the Management of Postoperative Hemiplegia. In: *Cerebral Arterial Spasm, Session V, Vasospasm: Prevention and Treatment.* Baltimore: Williams & Wilkins, 1980, 646–53.

52 de la Torre JC, Kawanaga HM, Hill PK, et al. Experimental therapy after middle cerebral artery occlusion in monkeys. *Surgical Forum* 1975;26:489–92.

53 Gerhards E, Gibian H. The metabolism of dimethyl sulfoxide and its metabolic effects in man and animals. *Ann N Y Acad Sci* 1967;141:65–76.

54 Mayer JH 3rd, Anido H, Almond CH, Seaber A. Dimethyl sulfoxide in prevention of intestinal adhesions. *Arch Surg* 1965;91:920–3.

55 Scherbel AL, McCormack LJ, Poppo MJ. Alteration of collagen in generalized scleroderma (progressive systemic sclerosis) after treatment with dimethyl sulfoxide. *Cleve Clin Q* 1965;32:47–56.

56 Scherbel AL, McCormack LJ, Layle JK. Further observations on the effect of dimethyl sulfoxide in patients with generalized scleroderma. (Progressive systemic sclerosis). *Ann N Y Acad Sci* 1967;141:613–29.

57 Engle MF. Indications and contraindications for the use of DMSO in clinical dermatology. *Ann N Y Acad Sci* 1967;141:638–45.

58 Berliner DL, Ruhmann AG. The influence of dimethyl sulfoxide on fibroblastic proliferation. *Ann N Y Acad Sci* 1964;141:159–64.

59 Ashley FL, Johnson AN, McConnell DV, et al. Dimethyl sulfoxide and burn edema. *Ann N Y Acad Sci* 1967;141:463.

60 Formanek K, Kovac W. DMSO bei experimentellen Rattenpfotenodemen. In Laudahn G, Gertich K, eds. *DMSO Symposium*, Vienna, 1966. Berlin: Saladruck, 1966, 18–24.

61 Preziosi P, Scapagnini U. Action of DMSO on acute inflammatory reactions. *Curr Ther Res* 1966;8:261.

62 Gorog P, Kovacs IB. Effect of dimethyl sulfoxide (DMSO) on various experimental inflammations. *Curr Ther Res Clin Exp* 1968;10:486–92.

63 Gorog P, Kovacs IB. Effect of dimethyl sulfoxide (DMSO) on various experimental cutaneous reactions. *Pharmacology* 1969;2:313–9.

64 Weissman G, Sessa G, Bevans V. Effect of DMSO on the stabilization of lysosomes by cortisone and chloroquine in vitro. *Ann N Y Acad Sci* 1967;141:326–32.

65 Carlson, RP [study director]. Cardinal Nutrition rat carrageenan air pouch model No. 1. White Eagle Toxicology Laboratories, 2003 Lower State Road, Doylestown, PA 18901, March 1, 2001. WEL Study No. 01-005.

66 Carlson RP [study director]. Cardinal Nutrition rat carrageenan air pouch model No. 1. White Eagle Toxicology Laboratories, 2003 Lower State Road, Doylestown, PA 18901, April 27, 2001. Appendix to WEL Study No. 01-005.

67 Barrager E, Veltmann JR, Schauss AG, Schiller RN. A multi-centered, open label trial on the safety and efficacy of methylsulfonlymethane in the treatment of seasonal allergic rhinitis. *J Altern Complement Med* 2002;8:167–74.

68 Sams WM Jr. The effects of dimethyl sulfoxide on nerve conduction. *Ann N Y Acad Sci* 1967;141:242–7.

69 Shealy CN. The physiological substrate of pain. *Headache* 1966;6:101–8.

70 Shealy CN. Personal communication. June 5, 1969.

71 Haigler HJ. Comparison of the analgesic effects of dimethyl sulfoxide and morphine. *Ann N Y Acad Sci* 1983;411:19–27.

72 Basch H, Gadebusch HH. In vitro antimicrobial activity of dimethyl sulfoxide. *Appl Microbiol* 1968;16:1953–4.

73 Chan JC, Gadebusch HH. Virucidal properties of dimethyl sulfoxide. *Appl Microbiol* 1968;16:1625–6.

74 Seibert FB, Farrelly FK, Shepherd CC. DMSO and other combatants against bacteria isolated from leukemia and cancer patients. *Ann N Y Acad Sci* 1967;141:175–201.

75 Kamiya S, Wakao T, Nishioka K. Studies on improvement of eye drops. Bacteriological consideration of DMSO. *Jpn J Clin Opthalmol* 1966;20:143–52.

76 Ghajar BM, Harmon SA. Effect of dimethyl sulfoxide (DMSO) on permeability of Staphylococcus aureas. *Biochem Biophys Res Commun* 1968;32:940–4.

77 Gillchriest WC, Nelson PL. The molecular biology mechanism of dimethyl sulfoxide bacteriostasis. *Biophys J* 1969;9 (pt. 2):A-133 [abstract TPM-J5].

78 Elstein W. Topical deodorized polysulfides. Broadscope acne therapy. *Cutis* 1981;28:468–72.

79 Strauss JS, Goldman PH, Nacht S, Gans EH. A reexamination of the potential comedogenicity of sulfur. *Arch Dermatol* 1978;114:1340–2.

80 Sams WM, Carroll NV, Crantz PL. Effects of dimethyl sulfoxide on isolated innervated skeletal smooth and cardiac muscle. *Proc Soc Exp Biol Med* 1966;122;103–7.

81 Raettig H. Die Moglichkeiten des DMSO in der experimentellen immunogie. In Laudahn G, Gertich K, eds. *DMSO Symposium*, Vienna. Berlin: Saladruck, 1966, 51–6.

82 Adamson JE, Horton CE, Crawford HH, Ayers WT. Studies on the action of dimethyl sulfoxide on the experimental pedicle flap. *Plastic Reconstructive Surg* 1967;39:142–6.

83 Adamson JE, Horton CE, Crawford HH, Ayers WT. The effects of dimethyl sulfoxide on the experimental pedicle flap: A preliminary report. *Plastic Reconstructive Surg* 1966;37:105-10.

84 Roth CA. Effects of dimethyl sulfoxide on pedicle flap flow and survival. *J Am Med Women's Assoc* 1968;23:895–8.

85 Kligman AM. Topical pharmacology and toxicology or dimethyl sulfoxide (DMSO). Part 1. *J Am Med Assoc* 1965;193:796–804.

86 Kligman AM. Topical pharmacology and toxicology of dimethyl sulfoxide (DMSO). Part 2. *J Am Med Assoc* 1965;193:923–8.

87 Leon AS, White FC, Bloor CM, Saviano MA. Reduced myocardial fibrosis after dimethylsulfoxide (DMSO) treatment of isoproterenol-induced myocardial necrosis in rats. *Am J Med Sci* 1971;261:41–5.

88 Birkmayer W, Danielczyk W, Werner H. DMSO bei spondylogenen neuropathien. In Laudahn G,Gertich K, eds. *DMSO Symposium*, Vienna. Berlin: Saladruck, 1966, 134–6.

89 Deutsch E. Beeinflussung der Blutgerinnung durch DMSO und Kombinationen mit Heparin. In Laudahn G, Gertich K, eds. *DMSO Symposium*, Vienna. Berlin: Saladruck, 1966, 144–9.

90 Gorog P. Personal communication. May 10, 1969.

91 Beilke MA, Collins-Lech C, Sohnle PG. Effects of dimethyl sulfoxide on the oxidative function of human neutrophils. *J Lab Clin Med* 1987;110;91–6.

92 Layman DL. Growth inhibitory effects of dimethyl sulfoxide and dimethyl sulfone on vascular smooth muscle and endothelial cells in vitro. *In Vitro Cellular & Developmental Biology* 1987;23:422–8.

93 Alam SS, Layman DL. Dimethyl sulfoxide as a cholesterol-lowering agent in cultured fibroblasts exposed to low density lipoproteins. *Biochim Biophys Acta* 1982;710:306–13.

94 Martin W. [Natural occurrence of DMSO and DMSO2 in the human organism.] In: Jacob SW, Kappel JE, eds. *DMSO International DMSO Workshop*, Hannover, Germany, September 19, 1987. San Francisco: W. Zuckschwerdt Verlag, 1987, 71–7 [in German].

95 Perry GH, Smith MJ, Whiteside CG. Spontaneous recovery of the joint space in degenerative hip disease. *Ann Rheum Dis* 1972;31:440–8.

96 Bland JH, Cooper SM. Osteoarthritis: a review of the cell biology involved and evidence for reversibility. Management rationally related to known genesis and pathophysiology. *Semin Arthritis Rheum* 1984;14:106–33.

97 Newman NM, Ling RS. Acetabular bone destruction related to non-steroidal anti-inflammatory drugs. *Lancet* 1985;2:11–4.

98 Brooks PM, Potter SR, Buchanan WW. NSAID and osteoarthritis—help or hindrance? *J Rheumatol* 1982;9:3–5.

99 Giordano N, Battisti E, Fortunato M, et al. [No Title listed]. *Clin Ter* 2001;152:179–82.

100 Gencosmanoglu BE, Eryavuz M, Dervisoglu S. Effects of some non-steroidal anti-inflammatory drugs on articular cartilage of rats in an experimental model of osteoarthritis. *Res Exp Med* (Berl) 2001;200:215–26.

101 Franchimont P, Gysen P, Lecomte-Yerna MJ, Gaspar S. [In vitro incorporation of radioactive sulfur into proteoglycans of cartilage. Effects of various nonsteroidal anti-inflammatory agents]. *Rev Rhum Mal Osteoartic* 1983;50:24–53 [in French].

102 Morris, et al., op. cit., reference 10.

103 Hoffman, et al., op. cit., reference 13.

104 Silver FH, Bradica G, Tria A. Relationship among biomechanical, biochemical, and cellular changes associated with osteoarthritis. *Crit Rev Biomed Eng* 2001;29:373-91.

105 Smith RL. Degradative enzymes in osteoarthritis. *Front Biosci* 1999;4:D704-12 [review].

106 Rizzo R, Grandolfo M, Godeas C, et al. Calcium, sulfur, and zinc distribution in normal and arthritic articular equine cartilage: a synchrotron radiation-induced X-ray emission (SRIXE) study. *J Exp Zool* 1995;273:82–6.

107 Richmond, op. cit., reference 9.

108 Sukenik S, Flusser D, Codish S, Abu-Shakra M. Balneotherapy at the Dead Sea area for knee osteoarthritis. *Isr Med Assoc J* 1999;1:83–5.

109 Sukenik S. Balneotherapy for rheumatic diseases at the Dead Sea area. *Isr J Med Sci* 1996;32 Suppl:S16–9 [review].

110 Elkayam O, Ophir J, Brener S, et al. Immediate and delayed effects of treatment at the Dead Sea in patients with psoriatic arthritis. *Rheumatol Int* 2000;19:77–82.

111 Sukenik S, Baradin R, Codish S, et al. Balneotherapy at the Dead Sea area for patients with psoriatic arthritis and concomitant fibromyalgia. *Isr Med Assoc J* 2001;3:147–50.

112 Neumann L, Sukenik S, Bolotin A, et al. The effect of balneotherapy at the Dead Sea on the quality of life of patients with fibromyalgia syndrome. *Clin Rheumatol* 2001;20:15–9.

113 Lawrence RM. Methylsulfonylmethane (M.S.M.) A double-blind study of its use in degenerative arthritis. *Int J Anti-Aging Med* 1998;1(1):50 [abstract].

114 Lawrence RM. Lignisul MSM (Methylsulfonylmethane): A double-blind study of its use in degenerative arthritis. (A preliminary correspondence). http://www.msm.com/ PDF/DegenerativeArthritisStudy.pdf [Accessed April 23, 2002].

115 [No authors listed]. Rheumatoid Arthritis. In: Beers MH, Berkow R, eds. *The Merck Manual of Diagnosis and Therapy*, 17th ed. Whitehouse Station, NJ, Merck & Co., Inc., 1999, 416–23.

116 [No Authors Listed]. Rheumatoid Arthritis. Healthnotes Online, version 7, 2001. http://www.healthnotes.com.

117 Moore RD, Morton JI. Diminished inflammatory joint disease in MRL/1pr mice ingesting dimethylsulfoxide (DMSO) or methylsulfonylmethane (MSM). Federation of American Societies for Experimental Biology 69th Annual Meeting, Anaheim, California, April 21–26, 1985: Abstract 692.

118 Eisenberg DM, Davis RB, Ettner SL, et al. Trends in alternative medicine use in the United States, 1990-1997. Results of a Follow-up National Survey. *JAMA* 1998;280:1569–75.

119 Evans MS, Reid KH, Sharp JB Jr. Dimethyl sulfoxide (DMSO) blocks conduction in peripheral nerve C fibers: a possible mechanism of analgesia. *Neurosci Lett* 1993;150:145–8.

120 Mayer M, Avi-Dor Y. Interaction of solvents with membrane and soluble potassium ion-dependent enzymes. *Biochem J* 1970;116:49–54.

121 Jacob SW, Herschler R. Pharmacology of DMSO. *Cryobiology* 1986;23:14–27 [review].

122 Birkmayer W, Danielczyk W, Werner H. DMSO bei spondylogenen neuropathien. In Laudahn G, Gertich K, eds. *DMSO Symposium*, Vienna. Berlin: Saladruck, 1966, 134–6.

123 Rosenbaum WM, Rosenbaum EE, Jacob SW. The use of dimethyl sulfoxide (DMSO) for the treatment of intractable pain in surgical patients. *Surgery* 1965;58:258–66.

124 Hess D. Employee perceived stress. Relationship to the development of repetitive strain injury symptoms. *AAOHN J* 1997;45:115–23.

125 Bureau of Labor Statistics, US Department of Labor. OS NR 12/12/2000 News Release: Workplace injuries and illnesses in 1999. http://www.bls.gov/iif/oshwc/osh/os/osnr0011.txt (Accessed 11/20/01).

126 Ellis JM, Azuma J, Watanbe T, Folkers K. Survey and new data on treatment with pyridoxine of patients having a clinical syndrome including the carpal tunnel and other defects. *Res Comm Chem Path Pharm* 1977;17:165–77.

127 Ellis JM. Vitamin B6 deficiency in patients with a clinical syndrome including the carpal tunnel defect. Biochemical and clinical response to therapy with pyridoxine. *Res Comm Chem Path Pharm* 1976;13:743–57.

128 D'Souza M. Carpal tunnel syndrome: clinical or neurophysiological diagnosis. *Lancet* 1985;i:1104–5.

129 Driskell JA, Wesley RL, Hess IE. Effectiveness of pyridoxine hydrochloride treatment on carpal tunnel syndrome patients. *Nutr Rep Internat* 1986;34:1031–9.

130 Ellis JM. Treatment of carpal tunnel syndrome with vitamin B6. *South Med J* 1987;80:882–4.

131 Browning DM. Carpal tunnel syndrome: clinical or neurophysiological diagnosis? *Lancet* 1985;i:1104–5 [letter].

132 Smith GP, Rudge PJ, Peters TJ. Biochemical studies of pyridoxal and pyridoxal phosphate status and therapeutic trial of pyridoxine in patients with carpal tunnel syndrome. *Ann Neurol* 1984;15:104–7.

133 Amadio PC. Pyridoxine as an adjunct in the treatment of carpal tunnel syndrome. *J Hand Surg* 1985;10A:237–41.

134 Stransky M, Rubin A, Lava NS, Lazaro RP. Treatment of carpal tunnel syndrome with vitamin B6: a double-blind study. *Southern Med J* 1989;82:841–2.

135 [No authors listed]. Tendinitis and tenosynovitis. In: Beers MH, Berkow MD, eds. *The Merck Manual of Diagnosis and Therapy*, 17th ed. Whitehouse Station, NJ, Merck & Co., Inc., 1999, 479–81.

136 [No authors listed]. Lateral epicondylitis. In: Beers MH, Berkow MD, eds. *The Merck Manual of Diagnosis and Therapy*, 17th ed. Whitehouse Station, NJ, Merck & Co., Inc., 1999, 505–7.

137 [No authors listed]. Bursitis. In: Beers MH, Berkow MD, eds. *The Merck Manual of Diagnosis and Therapy*, 17th ed. Whitehouse Station, NJ, Merck & Co., Inc., 1999, 478–9.

138 Beers MH, Berlow R, eds. *The Merck Manual of Diagnosis and Therapy*. Whitehouse Station, NJ: Merck & Co., 1999, 431–3.

139 Jacob SW. Personal communication.

140 Scherbel AL, Layle JK. Further observations on the effect of dimethyl sulfoxide in patients with generalized scleroderma (progressive systemic sclerosis). *Ann N Y Acad Sci* 1967;141:613–29.

141 Engel MF. Dimethyl sulfoxide in the treatment of scleroderma. *South Med J* 1972;65:71.

142 Morton JI, Moore RD. Lupus nephritis and deaths are diminished in B/W mice drinking 3% water solutions of dimethyl sulfoxide (DMSO) or dimethyl sulfone (DMSO2). *J Leukocyte Biol* 1986;40(3):322 [abstract #198].

143 Nitze M. *Lehrbuch der Cystoskopie: Ihre Technik und Klinische Bedeutung.* Berlin: J.E. Bergman, 1907.

144 Hunner GL. A rare type of bladder ulcer in women: Report of cases. *Transact South Surg Gynecol Assoc* 1914;27:257.

145 Interstitial Cystitis Association Web site. http://www.ichelp.org. Accessed December, 2001.

146 Rovner E, Propert KJ, Brensinger C, et al. Treatments used in women with interstitial cystitis: the interstitial cystitis data base (ICDB) study experience. The Interstitial Cystitis Data Base Study Group. *Urology* 2000;56:940–5.

147 Pranikoff K, Constantino G. The use of amitriptyline in patients with urinary frequency and pain. *Urology* 1998;51(5A Suppl):179–81.

148 Hanno PM. Amitriptyline in the treatment of interstitial cystitis. *Urol Clin North Am* 1994;21:89–91 [review].

149 *Physicians' Desk Reference* (PDR®), 55th ed. Montvale, NJ: Medical Economics Company, 2001, 627.

150 Stewart BH, Persky L, Kiser WS. The use of dimethyl sulfoxide (DMSO) in the treatment of interstitial cystitis. *J Urol* 1967;98:671–2.

151 Stewart BH, Branson AC, Hewitt CB, et al. The treatment of patients with interstitial cystitis, with special reference to intravesicular DMSO. *J Urol* 1972;107:377.

152 Perez-Marrero R, Emerson LE, Feltis JT. A controlled study of dimethyl sulfoxide in interstitial cystitis. *J Urol* 1988;140:36–9.

153 Shirley SW, Stewart BH, Mirelman S. Dimethyl sulfoxide in the treatment of inflammatory genitourinary disorders. *Urology* 1978;11:215–20.

154 Biggers RD. Self-administration of dimethyl sulfoxide (DMSO) for interstitial cystitis. *Urology* 1986;28:10–1.

155 Personal communication, 1993, cited in: Childs SJ. Dimethyl sulfone (DMSO2) in the treatment of interstitial cystitis. *Urol Clin North Am* 1994;21:85–8.

156 Childs SJ. Dimethyl sulfone (DMSO2) in the treatment of interstitial cystitis. *Urol Clin North Am* 1994;21:85–8.

157 Wolfe F, Smythe HA, Yunus MB, et al. The American College of Rheumatology 1990 criteria for the classification of fibromyalgia: report of the multicenter criteria committee. *Arthritis Rheum* 1990;33:160–72.

158 Wolfe F, Ross K, Anderson J, Russell IJ. Aspects of fibromyalgia in the general population: sex, pain threshold, and fibromyalgia symptoms. *J Rheumatol* 1995;22:151–6.

159 Wolfe F, Ross K, Anderson J, et al. The prevalence and characteristics of fibromyalgia in the general population. *Arthritis Rheum* 1995;38:19–28.

160 Croft P, Rigby AS, Boswell R, et al. The prevalence of chronic widespread pain in the general population. *J Rheumatol* 1993;20:710–3.

161 Croft P, Schollum J, Silman A. Population study of tender point counts and pain as evidence of fibromyalgia. *BMJ* 1994;309:696–9.

162 Simms RW. Fibromyalgia syndrome: current concepts in pathophysiology, clinical features, and management. *Arthritis Care Res* 1996;9:315–28.

163 Croffort LJ, Pillemer SR, Kalogeras KT, et al. Hypothalamic- pituitary-adrenal axis perturbations in patients with fibromyalgia. *Arthritis Rheum* 1994;37:1583–92.

164 Ahles TA, Khan SA, Yunus MB, et al. Psychiatric status of patients with primary fibromyalgia, patients with rheumatoid arthritis, and subjects without pain: a blind comparison of DSM-III diagnoses. *Am J Psychiatry* 1991;148:1721–6.

165 Burckhardt CS, O'Reilly CA, Wiens AN, et al. Assessing depression in fibromyalgia patients. *Arthritis Care Res* 1994;7:35–9.

166 Kirmayer L, Robbins J, Kapusta M. Somatization and depression in fibromyalgia syndrome. *Am J Psychiatry* 1988;145:950–4.

167 Hudson JI, Pope HG Jr. Fibromyalgia and psychopathology: is fibromyalgia a form of "affective spectrum disorder"? *J Rheumatol Suppl* 1989;19:15–22.

168 Boisset-Pioro MH, Esdaile JM, Fitzcharles M-A. Sexual and physical abuse in women with fibromyalgia syndrome. *Arthritis Rheum* 1995;38:235–41.

169 Simms RW. Fibromyalgia syndrome: current concepts in pathophysiology, clinical features, and management. *Arthritis Care Res* 1996;9:315–28.

170 Carrette S, McCain GA, Bell DA, Fam AG. Evaluation of amitriptyline in primary fibrositis: a double-blind, placebo-controlled study. *Arthritis Rheum* 1986;29:655–9.

171 Goldenberg D, Mayskiy M, Mossey C, et al. A randomized, double-blind crossover trial of fluoxetine and amitriptyline in the treatment of fibromyalgia. *Arthritis Rheum* 1996;39:1852–9.

References

172 McCain GA, Bell DA, Mai FM, Halliday PD. A controlled study of the effects of a supervised cardiovascular fitness training program on the manifestations of primary fibromyalgia. *Arthritis Rheum* 1988;31:1135–41.

173 Deluze C, Bosia L, Zirbs A, et al. Electroacupuncture in fibromyalgia: results of a controlled trial. BMJ 1992;305:1249–52.

174 Simms RW. Treatment of fibromyalgia syndrome. *Rheumatol Musculoskel Med Primary Care* 1998;1(1):[no page numbers listed].

175 [No authors listed]. Myasthenia gravis. In: Beers MH, Berkow R, eds. *The Merck Manual of Diagnosis and Therapy*, 17th ed. Whitehouse Station, NJ, Merck & Co., Inc., 1999, 1497–99.

176 [No authors listed]. Bronchiectasis. In: Beers MH, Berkow R, eds. *The Merck Manual of Diagnosis and Therapy*, 17th ed. Whitehouse Station, NJ: Merck & Co., Inc., 1999, 584–9.

177 Barrager, op. cit., reference 67.

178 Lugaresi E, Cirignotta F, Montagna P. Snoring: Pathogenic, Clinical and Therapeutic Aspects. In: Kryger MH, Roth T, Dement WC, eds. *Principles and Practice of Sleep Medicine*, 3rd ed. Philadelphia: WB Saunders, 2000.

179 Leung AK, Robson WL. The ABZzzs of snoring. *Postgrad Med* 1992;92:217–22.

180 Beers MH, Berkow R, eds. Sleep apnea syndromes. In: *The Merck Manual of Diagnosis and Therapy*, 17th ed. Whitehouse Station, NJ: Merck & Co., Inc., 1999, 1415–7.

181 Palomaki H, Partinen M, Erkinjuntti T, Kaste M. Snoring, sleep apnea syndrome, and stroke. *Neurology* 1992;42(7 Suppl 6):75–81;discussion 82 [review].

182 Douglas NJ. ABC of sleep disorders. The sleep apnoea/hypopnoea syndrome and snoring. *BMJ* 1993;306:1057–60.

183 Wali SO, Kryger MH. Medical treatment of sleep apnea. *Curr Opin Pulm Med* 1995;1:498–503.

184 Douglas, op. cit., reference 182.

185 Low WK, Willatt DJ. Submucous resection for deviated nasal septum: a critical appraisal. *Singapore Med J* 1992;33:617–9.

186 Jacob SW. Pharmacologic management of snoring. United States Patent # 5,569,679. October 29, 1996.

187 Rose DI, Braver JM. Mesenteric panniculitis. Department of Radiology at Brigham and Women's Hospital, a nonprofit teaching affiliate of Harvard Medical School. Teaching case database. http://brighamrad.harvard.edu/ Cases/bwh/hcache/198/full.html [Accessed 2/12/02].

188 Jones WE. MSM reviewed. *J Equine Vet Sci* 1987;7(2) [review]. http://www.redwings.org/HTMLarts/msmreva.htm [Accessed 2/13/02].

189 Personal letter to John Ewing Company, La Salle, CO. April 29, 1985. Copied to Dr. Metcalf.

190 Larkins N, Gaugas JM. Could this mean the end to many hoof problems? *The Western Horse* 1990;(37):14–5.

191 Herschler RJ. MSM: A nutrient for the horse. *Equine Veterinary Data* 1986;7(17):268–9.

192 Pearson E. Equine practice: Extralabel drug use in large animals. *Veterinary Med* 1989;April:424.

193 Traub-Dargatz JL, McKinnon AO, Thrall MA, et al. Evaluation of clinical signs of disease, bronchoalveolar and tracheal wash analysis, and arterial blood gas tensions in 13 horses with chronic obstructive pulmonary disease treated with prednisone, methyl sulfonmethane, and clenbuterol hydrochloride. *Am J Vet Res* 1992;53:1908–16.

194 Gaugas JM, Larkins N. Dietary supplementation with MSM (methylsulphonylmethane) in horses with symptoms of sulphur deficiency. John W. Metcalf, DVM, Personal communication, October 10,1989.

195 Personal letter from Fremont, Nebraska. July 18, 1988. Copied to Dr. John Metcalf.

196 Snallow L. MSM—An aid from nature. *The Blood Horse* 1987, June 6:3459–62.

197 Metcalf JW. MSM—A dietary derivative of DMSO. *Equine Veterinary Science* 1983, September.

198 Herschler RJ. Methylsulfonylmethane in dietary products. United States Patent No. 4,616,039. October 7, 1986.

199 Herschler RJ. Use of methylsulfonylmethane to relieve pain and relieve pain and nocturnal cramps and to reduce stress-induced deaths in animals. United States Patent No. 4,973,605. November 27, 1990.

200 Metcalf, op. cit., reference 197.

201 Metcalf, op. cit., reference 197.

202 Metcalf, op. cit., reference 197.

203 Metcalf, op. cit., reference 197.

204 Metcalf, op. cit., reference 197.

205 Snallow, op. cit., reference 196.

206 Metcalf JW. Personal letter. August 10, 1987.

207 Personal letter to Dr. Metcalf from Little Rock, Arkansas. August 19, 1987.

208 Herschler, op. cit., reference 199.

209 Herschler, op. cit., reference 198.

210 Herschler, op. cit., reference 198.

211 Herschler, op. cit., reference 198.

212 Herschler, op. cit., reference 198.

213 Herschler, op. cit., reference 198.

214 Herschler, op. cit., reference 198.

215 Moore & Morton (1985), op. cit., reference 117.

216 Deutsch E. Beeinflussung der Blutgerinnung durch DMSO und Combinationen mit Heparin. In Laudann G, Gertich K, eds. DMSO Symposium, Vienna, 1966. Berlin: Saladruck, 1966, 144–9 [in German].

217 Lehuu B, Curtis-Prior PB. Effects of dimethyl sulphoxide (DMSO) on aggregation of human blood platelets. *J Pharm Pharmacol* 1987;39:62–3.

218 Horváth K, Noker PE, Somfai-Relle S, et al. Toxicity of methylsulfonylmethane in rats. *Food Chem Toxicol* 2002;40:1459-62.

219 [No authors listed]. Acute intragastric toxicity (LD-50). Dimethyl sulfone (methylsulfonylmethane, MSM). Laboratory of Vitamin Technology, Inc., Chicago, Illinois, August 21, 1958.

220 Schoenig G. Acute oral toxicity of sample No. 751, dimethyl sulfone 1 BT No. A6409. Industrial BIO-TEST Laboratories, Inc., Northbrook, Illinois, September 19, 1968.

221 Noker PE, Richter WR. Acute oral toxicity study of methylsulfonyl-methane in rats. Southern Research Institute, Birmingham, AL: 2000.

222 Horváth K, op. cit., reference 218.

223 Ocular and dermal irritation assay for OptiMSM™ brand of methyl-sulfonylmethane. Flora Research Laboratories, 32158 Camino Capistrano, Suite A-435, San Juan Capistrano, CA 92675. On file.

224 Methyl Sulfonyl Methane (MSM) purity by high resolution gas chro-matography. Flora Research Laboratories, 32158 Camino Capistrano, Suite A-435, San Juan Capistrano, CA 92675. On file.

225 Moyers CG, Rousseau RW. Crystallization operations. In: Rousseau RW, ed. *Handbook of Separation Process Technologies.* New York: John Wiley & Sons, 1987, 578–638.

226 Treybal RE. The less conventional operations. In: *Mass-Transfer Operations*, 2nd ed. New York: McGraw-Hill Book Company, 1968, 678–9.

227 King CJ. *Separation Processes*, 2nd ed. New York: McGraw-Hill Book Company, 1980, 732–3.

228 Bennett RC, Corder WC, Finn RK, et al. Miscellaneous separation processes. In: Perry RH, Chilton CH, eds. *Chemical Engineer's Handbook*, 5th ed. New York: McGraw-Hill Book Company, 1973, 17-1 to 17-58.

229 Van Hook A. *Crystallization: Theory and Practice.* New York: Reinhold Publishing Corporation, 1963, 192–237.

230 Wu C, Gottleib M, Davis D. Regional profile: China's health and envi-ronment. World Resources Institute, 1998–99, 115–26.

231 WHO/UNICEF Joint Monitoring Programme for Water Supply and Sanitation. Global Water Supply and Sanitation Assessment: 2000 Report. Geneva, Switzerland: World Health Organization and United Nations Children's Fund, 2000, 47–53.

232 Frank A. Hazardous waste and urban water scarcity in China. In: Frank A, Matthew CS, Metrick C, eds. China Environment Series. Washington, DC: Woodrow Wilson Center, Environmental Change and Security Project, 1998, 52–4.

233 National Nutritional Foods Association. NNFA GMP certification program overview. http://www.nnfa.org/services/science/gmp.htm [accessed March 25, 2002].

234 McGann LE, Walterson ML. Cryoprotection by dimethyl sulfoxide and dimethyl sulfone." *Cryobiology* 1987;24:11–6.

235 Kocsis JJ, Harkaway S, Snyder R. Biological effects of the metabolites of dimethyl sulfoxide. *Ann N Y Acad Sci* 1975;243:104–9.

236 Beilke, op. cit., reference 91.

237 Wood DC, Wirth NV. Weitere untersuchungen zur wirkung von dimethylsulfoxyd am kaninchenauge. In: DMSO Internationales Symposium, Wien, 1966. Berlin:Saladruck, 58–67.

238 Wood DC, Sweet D, Van Dolah J, et al. A study of DMSO and steroids in rabbit eyes. *Ann N Y Acad Sci* 1967;141:347–80.

239 Rubin LF, Barnett KC. Ocular effects of oral and dermal application of dimethyl sulfoxide in animals. *Ann N Y Acad Sci* 1967;141:333–45.

240 Kleberger KE. An ophthalmological evaluation of DMSO. *Ann N Y Acad Sci* 1967;141:381–5.

241 Kleberger E. [A lens with double focus (bull's eye lens) caused by toxic doses of dimethyl sulfoxide (DMSO) in dogs]. *Albrecht Von Graefes Arch Klin Exp Ophthalmol* 1967;173:269–81 [in German].

242 Wood DC, Palmquist MA, Jacob SW. Eye lens changes with dimethyl sulfoxide (DMSO): an in vitro system. *Physiol Chem Phys* 1973;5:43–8.

243 Rammler DH, Zaffaroni A. Biological implications of DMSO based on a review of its chemical properties. *Ann N Y Acad Sci* 1967;141:13–23.

244 Wood DC, Wirth NV, Weber FS, Palmquist MA. Mechanism considerations of dimethyl sulfoxide (DMSO)-lenticular changes in rabbits. *J Pharmacol Exp Ther* 1971;177:528–35.

245 Analytical Report. Flora Research Laboratories, 32158 Camino Capistrano, Suite A-435, San Juan Capistrano, CA 92675. Unpublished.

246 Quig D. Cysteine metabolism and metal toxicity. *Altern Med Rev* 1998;3:262–70.

247 Michael Aschner, Ph.D.. Department of Physiology and Pharmacology, Wake Forest University School of Medicine, personal communication, 1998.

248 Lin, et. al., op. cit., reference 43.

249 Rose SE, et. al., op. cit., reference 42

250 Goldstein P, Magnano L, Rojo J. Effects of dimethyl sulfone (DMSO2) on early gametogenesis in Caenorhabditis elegans: ultra-structural aberrations and loss of synaptonemal complexes from pachytene nuclei. *Reprod Toxicol* 1992;6:149–59.

251 Schwetz BA. In vitro approaches in developmental toxicology. *Reprod Toxicol* 1993;7 Suppl 1:125–7.

252 Kisker C, Schindelin H, Pacheco A, et al. Molecular basis of sulfite oxidase deficiency from the structure of sulfite oxidase. *Cell* 1997;91:973–83.

253 Neve J. [The nutritional importance and physiopathology of molybdenum in man]. *Pharm Belg* 1991;46:189–96 [review] [in French].

254 Johnson JL, Wuebbens MM, Mandell R, Shih VE. Molybdenum cofactor deficiency in a patient previously characterized as deficient in sulfite oxidase. *Biochem Med Metab Biol* 1988;40:86–93.

255 Wright J, Littleton K. Defects in sulphur metabolism. *Intl Clin Nutr Rev* 1989;9:118–9.

256 Wright JV, Kirk FR. Defects in Sulphur Metabolism II: Apparent failure of sulphate conjugation. *Intl Clin Nutr Rev* 1989;9:182–4.

257 Wright JV. Clinical Tip 4: MSM and molybdenum. *Nutrition & Healing* 1998;5:10.

258 Wright JV. Natural response. *Nutrition & Healing* 2000;7(9):8.

259 Wright JV. How to successfully metabolize MSM for pain relief. *Nutrition & Healing* 2001;8(3):8.

260 Griffith HW, Levinson D. Complete Guide to Vitamins, Minerals & Supplements. Cambridge, MA: Fisher Books, 1998.

261 Garrison Jr. RH, Somer E. *The Nutrition Desk Reference.* New Canaan, CT:Keats Publishing, Inc., 1995.

262 Suttle NF. The role of organic sulphur in the copper-molybdenum-S interrelationship in ruminant nutrition. *Br J Nutr* 1975;34:411–20.

263 Mason J, Lamand M, Tressol JC, Lab C. The influence of dietary sulphur, molybdate and copper on the absorption, excretion and plasma fraction levels of 99Mo in sheep. *Ann Rech Vet* 1978;9:577–86.

264 Sardesai VM. Molybdenum: an essential trace element. *Nutr Clin Pract* 1993;8:277–81.

265 Institute of Medicine. Dietary reference intakes for vitamin A, vitamin K, boron, chromium, copper, iodine, iron, manganese, molybdenum, nickel, silicon, vanadium, and zinc. Washington, D.C.: National Academy Press, 2001, 11–1 to 11–18.

266 Abumrad NN, Schneider AJ, Steel D, Rogers LS. Amino acid intolerance during prolonged total parenteral nutrition reversed by molybdate therapy. *Am J Clin Nutr* 1981;34:2551–9.

267 [No author listed]. Molybdenum deficiency in TPN. *Nutr Rev* 1987;45:337–41.

268 Deosthale YG, Gopalan C. The effect of molybdenum levels in sorghum (Sorghum vulgare Pers.) on uric acid and copper excretion in man. *Br J Nutr* 1974;31:351–5.

269 Momcilovic B. A case report of acute human molybdenum toxicity from a dietary molybdenum supplement—a new member of the "Lucor metallicum" family. *Arh Hig Rada Toksikol* 1999;50:289–97.

270 Miller RF, Price NO, Engel RW. The microelement (Al, Mn, Cu, Molybdenum, and Co) balance of 7-9-year-old girls. *Fed Proc* 1959;18:538.

271 Vyskocil A, Viau C. Assessment of molybdenum toxicity in humans. *J Applied Toxicol* 1999;19:185–92.

272 Kovalskii VV, Jarovaja GA, Shmavonyan DM. Changes in purine metabolism in man and animals in various molybdenum-rich biogeochemical provinces. *Zh Obshch Biol* 1961;22:179–91 [in Russian].

273 Wright JV. Clinical Tip 4: MSM and molybdenum. *Nutrition & Healing* 1998;5:10.

274 Food and Nutrition Board, Panel on Micronutrients, Subcommittees on Upper Reference Levels of Nutrients and of Interpretation and Use of Dietary Reference Intakes, and the Standing Committee on the Scientific Evaluation of Dietary Reference Intakes. *Dietary Reference Intakes for Vitamin A, Vitamin K, Arsenic, Boron, Chromium, Copper, Iodine, Iron, Manganese, Molybdenum, Nickel, Silicon, Vanadium, and Zinc.* National Academy Press, 2001.

275 Barceloux DG. Molybdenum. *J Toxicol Clin Toxicol* 1999;37(2):231–7 [review].

276 Friberg L., Lener J. Molybdenum. In: Friberg L, Nordberg GF, Vouk VB, eds. *Handbook on the Toxicology of Metals*, Vol II. Elsevier Science, Ltd., 1986, 446–61.

277 Grant PM, Haas JS, Whipple RE, Andresen BD. A possible chemical explanation for the events associated with the death of Gloria Ramirez at Riverside General Hospital. *Forensic Sci Int* 1997;87:219–37.

278 Saeed SA, Karimi SJ, Suria A. Differential effects of dimethyl sulfoxide on human platelet aggregation and arachidonic acid metabolism. *Biochem Med Metab Biol* 1988;40:143–50.

279 Pace DG, Kovacs JL, Klevans LR. Dimethyl sulfoxide inhibits platelet aggregation in partially obstructed canine coronary vessels. *Ann N Y Acad Sci* 1983;411:352–6.

280 Holtz GC, Davis RB. Inhibition of human platelet aggregation by dimethylsulfoxide, dimethylacetamide, and sodium glycerophosphate. *Proc Soc Exp Biol Med* 1972;141:244–8.

281 Deutsch E. Beeinflussung der Blutgerinnung durch DMSO und Kombinationen mit Heparin. In Laudahn G, Gertich K, eds. DMSO Symposium, Vienna. Saladruck: Berlin, 1966:144–9.

Index

Index